The
Third
Gilmore Girl

The
Third
Gilmore Girl

KELLY BISHOP

with Lindsay Harrison

G

Gallery Books

New York London Toronto Sydney New Delhi

Gallery Books
An Imprint of Simon & Schuster, LLC
1230 Avenue of the Americas
New York, NY 10020

First Gallery Books hardcover edition September 2024

GALLERY BOOKS and colophon are registered trademarks of Simon & Schuster, LLC

Simon & Schuster: Celebrating 100 Years of Publishing in 2024

For information about special discounts for bulk purchases, please contact Simon & Schuster Special Sales at 1-866-506-1949 or business@simonandschuster.com.

The Simon & Schuster Speakers Bureau can bring authors to your live event. For more information or to book an event, contact the Simon & Schuster Speakers Bureau at 1-866-248-3049 or visit our website at www.simonspeakers.com.

Interior design by Jaime Putorti

Manufactured in the United States of America

10 9 8 7 6 5 4 3 2 1

Library of Congress Control Number: 2024938167

ISBN 978-1-6680-2377-8
ISBN 978-1-6680-2379-2 (ebook)

To Lee Leonard,

who knew me better than anyone else on earth

and loved me anyway

Foreword

by Amy Sherman-Palladino

"I'll know her when she walks in."

That's what I kept saying.

It was the fall of 1999. I had just had a pilot script picked up by the WB network, with its dancing frog mascot and executive offices in a trailer that could be hooked up to a car and towed away at any second. At the time, they were specializing in shows for the young—*Dawson's Creek, Felicity, Buffy the Vampire Slayer*, etc. My script was called "The Gilmore Girls." (The original title had a "the" in it. The network had a heart attack. No one would watch something called *The Gilmore Girls*. Too girly. Men won't think there's sex. Boys won't think anyone gets punched. They insisted we change the name. They did some "testing," and the brilliant decision was to drop the "the.")

Now, my show had a lead in her thirties, which was a thousand in WB world. I knew if this was going to work, the family unit had to work. It had to resonate with everyone. Each piece of casting was crucial. It was out of the WB's comfort zone. So, I assembled a

murderers' row of actors. Lauren Graham was our Lorelai Gilmore. Ed Herrmann was her father, Richard Gilmore. Alexis Bledel was Lorelai's daughter, Rory. One vital piece left . . .

Emily Gilmore, the moneyed matriarch of the Gilmore clan. I know exactly who she's supposed to be in my head. I see it. I see her swagger. Her icy stare. Her cutting humor. Her elegance. Her deep hurt and vulnerability, which she covers with sarcasm and Chanel suits. It's as clear as day in my brain. All I have to do is find the actress to play her.

Gilmore Girls is my very first hour-long show. No one thinks I know what the hell I'm doing. We've been seeing every actress over fifty in (what felt like) the entire world. Wonderful actresses with wonderful credits come in and read for us. And after each one leaves, my director and my producing partner, sitting on either side of me, look at each other hopefully. "Well, she was good. Bring her back?" And the angel of death sitting in the middle says, "No. That's not Emily." Now, I have to say, I sympathize with them. We've been sitting in this grim room for weeks. We feel like we might die in here. My producing partner starts to get annoyed. "All these good actors come in, and you just keep saying no. What the hell are you looking for?" I shrug like the dick I am. "I'll know her when she walks in."

Three days later, more women. More good auditions. More good credits. There are now whispers behind my back. Huddling in corners. I feel a *Lord of the Flies* moment heading my way. They are conspiring to kill me. I get it. I might help them. This is driving me insane as well. We sit down and prepare ourselves for another round of "Nope. Not the one." The door opens—

And then she walked in.

Kelly Bishop, formerly known as Carole Bishop, stormed the barricades. (By the way, ask her why she changed her first name to Kelly from Carole *after* she won the Tony. She's told me the story at least twice. I still don't understand it.) Kelly was regal, with a whiskey voice and perfect comic timing. She sat down, crossed her fabulous dancer's legs, and opened her mouth. Three words in—I knew it. This was Emily. There were no second choices. I would not die today.

So, *Gilmore Girls* became *Gilmore Girls*. Without Kelly it never would've worked. Without Kelly I never would've been able to have a room completely dedicated to hats in the middle of New York City.

If she hadn't walked in . . .

Show business is very weird. You work extremely closely with people for years, the show goes down, and you never speak to them again. All the promises of regular dinners, and cocktails, and anniversaries to be celebrated disappear. The whole show becomes a memory. A fever dream where you were younger, and thinner, with tons of friends to sing "Happy Birthday" to you and you thought that moment was never going to end. Showbiz friends are not necessarily friend-friends. But, from the moment she walked into that drab, sad room smelling of bad coffee and desperation, Kelly Bishop has been a fixture in my life. I did another show with her after *Gilmore*—*Bunheads* (which I wrote for her in spite of the fact that she was not available due to being on Broadway. I ignored that. It's Kelly or no one). She was on *The Marvelous Mrs. Maisel* (a few

times—not enough, but you try getting her out of Jersey). She will be in my next show. And my next. She will be in anything I do for as long as I have a coherent thought in my head. But, even more important, she will be my bawdy pal, my Joe Allen's drinking buddy, my favorite broad in the world, for the rest of my life.

Her story is wild. Her career is vast. I've been pestering her to write her memoirs forever. Thank God she finally listened.

Ladies and Gentlemen, may I present—Carole Bishop!

Sorry. *Kelly*. Crap. Why did you change your name again?

Who cares? I love you.

Amy

The
Third
Gilmore Girl

Chapter
One

Looking back, it still fascinates me how a single, seemingly ordinary phone call changed my life. It wasn't accompanied by a heavenly chord from a choir of angels, or a sudden beam of sunlight bursting through the overcast sky into my apartment window, not so much as a twinge of awareness on my part that something huge was happening, just a call from my old friend Tony Stevens.

It was 1974, a typical cold, bleak January day in New York City. I'd been working as a chorus dancer in New York and around the country since 1962. I was very good at it, and while the money wasn't great, shows had come along steadily enough that, unlike so many of my fellow dancers, I'd never had to supplement my income with side jobs as a waitress or a cashier or an office temp.

I'd been in love with the joy and the freedom of dancing since I was eight years old. Now I was just weeks away from my thirtieth birthday, and the average shelf life of a chorus dancer was right around thirty-five years. I was yearning to make the transition into acting, into principal roles playing actual characters with

actual names—actresses, after all, could keep working as long as their health held out and someone was writing parts for them. I'd given myself a two-year deadline to start turning down chorus work and either broaden my skills as a performer or say goodbye to show business and move on to something else. And with my marriage disintegrating at the same time, I was ready to move pretty much anywhere except where I'd already been, when I picked up the phone and heard Tony's voice.

"Michon Peacock and I have an idea I'd like to run by you," he said. Tony and Michon were Broadway dancers. I'd worked with Michon and liked her, and I knew Tony very well. He was a terrific human being and a terrific dancer who'd also done some choreography, a fun, funny, energetic guy who loved being around other really good dancers. Whatever idea those two had come up with, I was already interested.

Broadway was struggling in 1974. Shows were becoming more and more expensive to produce, many of them flopped, and backers were looking elsewhere for places to invest their money. As a result, a lot of wonderful dancers were out of work through no fault of their own. Tony and Michon had been talking about that, and about the fact that whether a show was succeeding or failing, Broadway producers were the ones who historically called all the shots, made all the money, and got all the credit, while we dancers were, to quote Tony, "the blue-collar workers of the performing arts." The question was what, if anything, could be done to shake things up, level the playing field a little, and maybe even get some control of our lives.

"So what Michon and I would like to do," he told me, "is gather

a group of gifted, experienced Broadway dancers and see if we could organize some kind of company in which everyone gets a chance to explore their other interests in the business—writing, directing, set design, costume design, whatever completes the sentence, 'I've been dancing for years, but I've always been curious about exploring (fill in the blank).' We'd love for you to be a part of that group, just to get together, throw some ideas around, and see what comes of it. What do you think?"

Thinking wasn't necessary. "Tell me when and where, and count me in."

Tony had already secured access to a dance studio called the Nickolaus Exercise Center on East Twenty-Third Street, so we'd be meeting there, and he'd call me back with a date and time.

Still no choir of angels, no ethereal beam of sunlight pouring through my apartment window, just the thought that it was nice to have something potentially productive to look forward to and distract me from being unemployed and headed for a divorce that should probably have happened months, maybe even years ago.

Tony called back a couple of days later. The meeting was set for Saturday, January 26, at 11:00 p.m.—a few of the nineteen dancers who were coming were doing shows, and they couldn't be there until after their shows let out.

I was writing it in my calendar when he casually added, "By the way, Michael Bennett heard about this, so he'll be there too, just as an observer."

Oh God.

Michael Bennett was well on his way to becoming a Broadway legend as a writer, director, dancer, and choreographer. He was brilliant. We liked each other, and we admired each other's talent. We'd also butted heads over the years. In my opinion, Michael was a master manipulator, someone who could instinctively spot and play on people's vulnerabilities and get them to do whatever he wanted. I sensed that from the moment I met him, I saw it in action, and I wasn't having it. He resented me for that, but I think he kind of begrudgingly respected me for it too, and appreciated the challenge.

Michael and I first met in 1967, when I auditioned for a chorus job in a show he was choreographing, a first-class production called *Promises, Promises*—music by Burt Bacharach, lyrics by Hal David, book by Neil Simon, starring a fantastic singer/actor named Jerry Orbach. Michael had already established himself as a respected Broadway dancer and choreographer in the 1960s, and I was excited to be introduced to him. He was nearly a year older than I was; maybe five foot eight; with dark hair and a sexy, impish face; very flirtatious, with a twinkle in his eye. I remember thinking, *I want to work for this guy*, and I was excited when the call came that I got the job.

Promises, Promises had its Broadway opening at the Shubert Theatre on December 1, 1968. It was hard work, I loved it, and Michael and I were getting along glitch-free—until one day, a few weeks into the run, during what's called a "clean-up rehearsal" (when you've been doing the same show for a while, eight times a week, repeating the same steps over and over, you can tend to get a little sloppy, sloughing off a step here and a step there to make it easier on your-

self). Michael and his assistant, a lovely guy named Bob Avian, were standing at the lip of the stage, watching us do a dance number called "Turkey Lurkey Time" that ended the first act, when I saw Michael look at me, lean over and say something to Bob, and then point at me and laugh.

I immediately stopped dancing, while the other dancers and the pianist kept going, and planted myself at a dead standstill, staring at Michael. He noticed and stared back at me, confused.

"Is there a problem?" I asked him.

He was caught off guard, clearly not accustomed to being confronted. He mumbled some version of "What?" In the meantime, the dancing and the music had gradually trailed off until the only sound on the stage was me, demanding an answer from Michael Bennett to my perfectly reasonable question.

"You're standing there six feet in front of me, you whisper something to Bob and point at me, and then you laugh. You have a correction to give me? Give it. You want to tell me I'm doing something wrong? I'm all ears. But don't point at me and laugh and expect me not to mind."

He was visibly embarrassed. So was Bob. Neither of them said a word; they just stared down at the floor, so the other dancers and I picked up where we left off, and the rehearsal resumed. Michael and I ended the day as if nothing had happened, but that brief little face-off set the tone for the relationship between us.

Testy as that moment was, it never stopped the two of us from deeply respecting each other's work. He even hired me when he was choreographing the *Milliken Breakfast Show*, an annual two-week

event held at the Waldorf Astoria on Park Avenue. Every spring since 1956 the Milliken manufacturing company had been staging musicals for its buyers to launch a new season. They spared no expense, sometimes spending more than the cost of a Broadway show and hiring major stars like Ginger Rogers, Ann Miller, Tommy Tune, and Donald O'Connor. It was a very big deal, very prestigious, paid very well, and Michael did an extraordinary job. It was the first time I noticed a new quirk of his during rehearsals—he'd walk up behind a dancer, get very close, and lean in to quietly say something in their ear. One afternoon it was my turn. He walked up behind me, leaned in, murmured, "Talent turns me on," and walked away. I'm not sure what response he was going for, but all he got from me was a subtle eye roll and a casual "Okay, thanks."

And now he was coming to Tony and Michon's gathering, "just as an observer." I didn't buy that for one second. Michael never "just observed." If he weren't intending to be God by the time we were through, he couldn't be bothered.

I actually considered not going. But then I thought, *You know what? You're in a good place; you're getting a handle on your life; you're a fool if you let Michael Bennett stand in your way.* Besides, I'd made a commitment to an old friend, and I wasn't about to let him down.

Saturday, January 26, 1974, 11:00 p.m. The Nickolaus Exercise Center. We unemployed dancers did some warming-up exercises while we waited for the working dancers to arrive. They eventually filtered into the room, along with Michael Bennett, who settled in

on the floor with a reel-to-reel tape recorder. People he'd worked with a lot, like Donna McKechnie and Priscilla Lopez, who loved and were devoted to him, quickly gathered around, and before long a large circle of about twenty-five or thirty of us had formed. I headed straight for the opposite side of it, the six o'clock position to Michael's twelve, and nestled in among another group of friends, all of us feeling the curious excitement that was building in the room. None of us had a clue where, if anywhere, this gathering might lead, but I was already glad I hadn't given in to my impulse to back out and stay home.

Michael kicked things off with a speech about dancers' lives being so interesting and worth telling that we might even be able to make a show out of this. Whether that happened or not, it was imperative that we be wide open and honest with one another. He followed that up by asking us to go around the circle: "Say your name, your real name if it's different, where you were born, and when." Then he added, "Although you girls don't have to give your ages."

I couldn't let that pass without speaking up. "Wait a minute, Michael," I said, "you just told us how important it is that we all be open and honest tonight, and then you follow it up with the women not having to give our ages. So which is it?" Even in 1974, it got on my nerves that the female singers in shows were referred to as "women," while we dancers were "girls."

Point taken. He changed the instruction to: "Okay, *everyone* say their birth name, birthplace, and their birth date and year."

And for the most part, we all did. A couple of the women were a

year or two older than they'd always claimed to be, but in a dancer's life, a year or two can really make a difference.

Once that preliminary roll call was over, the meeting gradually evolved into one of the most unforgettable nights of my life. We'd all worked together over the years, we were comfortable with one another, and God knows we had a whole lot in common. We just started talking. Our dreams beyond being dancers led into how we became interested in dancing in the first place. Our families. Our childhoods. Our joys. Our heartbreaks. Our private fears and insecurities. Growing up abused and neglected and abandoned. Tragedies. Loss. Divorces. What we liked about ourselves. What we wanted to change about ourselves. No subject was off-limits, and there was no judgment or criticism in that room, just tears and laughter and learning a lot about friends and colleagues we'd been sure we already knew.

The story that moved me the most that night came from Nicholas Dante, a beautiful Puerto Rican dancer and writer who grew up in Spanish Harlem. He'd always been insecure about his sexuality, which ultimately led him to become a drag queen in a touring company of female impersonators called the Jewel Box Revue. He kept that part of his life from his parents, until one night when the revue was about to go on tour and they showed up at the venue where the revue was appearing. Nicholas came onstage "dressed as Anna May Wong," I think he told us, and was horrified to see his parents sitting in the audience, gaping back at him. By the time he got to the end of the story, when his father turned to some other drag queen in the revue and said, "Take good care of my son," Nicholas was weeping, and so was everyone else in the room.

That first tape session was so compelling, and so moving, that I was completely unaware of how many hours had passed, until I heard church bells ringing somewhere in the distance and realized that somehow, impossibly, it was morning out there. When we finally wandered out into bright sunlight to head home, we were all in a state of what I can only describe as wonder and fulfillment. It felt incredible.

A few weeks later there was a second session, also on tape, mostly the same people, along with a handful of other dancers who hadn't been available for the first session. We practically raced into that room and threw ourselves on the floor, excited and eager to get started. Oddly, we found ourselves slogging back out of there three or four hours later, with a whole new understanding of the word "anticlimactic." It seemed as if none of us had anything more to add after the almost spiritual magic of that first session. The newcomers were coming in cold and didn't seem to have given the concept a lot of thought, if any. The organic spontaneity and flow of the first session didn't exist, and the conversation never got off the ground. It was very disappointing, but disappointment wasn't exactly unfamiliar to any of us, and learning to move on was simply an inevitable part of the business.

(To the best of my knowledge, by the way, tapes of those sessions have never been released in their entirety, and the reel-to-reel tapes themselves have been preserved among Michael Bennett's papers at Yale's Beinecke library in New Haven, Connecticut.)

<center>*　　*</center>

All of which led to . . . nothing. For more than a month. I had kind of given up, although there was nothing definitive to give up *on*, when I got a call that Michael Bennett wanted to do a five-week workshop, based on the tapes of those sessions. Apparently he'd listened to them over and over again and started thinking that we'd spent all those hours essentially "auditioning our lives" for him. Out of that came his unformed concept of putting a stage show together based on dancers' experiences and their audition processes. Once the idea had taken enough shape for him to articulate it, he called Joseph Papp, founder of the New York Shakespeare Festival and a huge theatrical producer and director. By then, Michael had already won two Tony Awards, so Papp was more than happy to take Michael's call. Once Michael had described the Broadway talent he'd assembled for that first tape session and the concept that had evolved from it, Papp was intrigued by Michael's idea and gave him enough workshop time to see if he could organize those random puzzle pieces into a viable project.

With the prestige and gravitas of Joseph Papp's support in his hip pocket, Michael was able to round up a world-class team to give that viable project its best chance. Nicholas Dante and playwright/author James Kirkwood Jr. to put together a story from the interviews. Bob Avian, who'd worked with Michael on the European tour of *West Side Story*, to help with the choreography. And Academy Award–winning composer Marvin Hamlisch to write the score with lyricist Ed Kleban for a show that many, many months later would be given the working title *A Chorus Line*.

I remember the first time I heard that name. I asked Michael, "Why not just *Chorus Line*?"

"Because," he patiently replied, with a subtext of *duh*, "when an alphabetical list of Broadway shows is published in newspapers and trade magazines, *A Chorus Line* will come first."

I would never have thought of that. Occasional clashes aside, the man really was a genius at what he did, and we were lucky that Michael "Just an Observer" Bennett had decided to get involved.

The group of twenty-five or so dancers who had attended that marathon tape session was reduced to a dozen of us or so for the first workshop. It was an exhilarating five weeks. The material was still in an extremely rough-draft stage, but it was impossible not to get excited about the potential of *A Chorus Line*.

So when Michael announced after that first workshop that he had to shut down the project until he could raise some money to keep it going, it was like having the rug pulled out from under me, in more ways than one.

I related to the need to raise money all too well. My marriage was limping toward the finish line, and my soon-to-be-ex-husband, a compulsive gambler—and not a good one—had cleaned me out. All I had left to my name was two weeks of unemployment, which would have been more than enough if my cats, my German shepherd, and I hadn't become so attached to little luxuries like eating and having a rented roof over our heads. I literally couldn't afford to sit by the phone with my fingers crossed, waiting for Michael to call and say that the show was funded and it was time to get back to work. I was frightened, and I had to do something, sooner rather than later, like it or not.

Many months earlier I'd been asked to audition for the national tour of a show called *Irene*. Debbie Reynolds was playing the title role, and they'd be touring the major markets around the country—San Francisco, Chicago, Boston, et cetera—after rehearsing in Los Angeles. I went to see the show and the part I'd be auditioning for, one of Irene's two best friends. To be honest, it seemed like an old, tired musical to me, something I would undoubtedly hate doing, and I passed on even auditioning or giving it another thought.

Then, not long after the workshop ended, the *Irene* team called again. This time they wanted me to audition for that same role in a second touring company of *Irene*, now starring Jane Powell instead of Debbie Reynolds and playing in lesser markets like Denver, Houston, Flint, et cetera. My first thought was *Oh God, please, no*, immediately followed by my second thought: *It's the dead of winter. Nothing's happening in New York City. No shows, no auditions, no nothing, and you're flat broke. You have no business saying no to the possibility of a paycheck right now, so pull on your big-girl pants and deal with it.*

So off I trudged to an audition in a cold, barren rehearsal hall. There were only two other dancers in the waiting room. Obviously there wasn't a real stampede going on for the opportunity to play this role. I was pleasantly surprised, though, to see the wonderfully talented Peter Gennaro there, replacing Gower Champion as the choreographer of this *Irene* tour. I went in, did some dancing, struggled through a few bars of a song despite my lack of singing talent, went through the motions of whatever they asked me to do, and sure enough, they offered me the job. I was dreading it, but I was

also relieved to know I'd be making a touring wage of, I think, $550 a week and wouldn't have to sell everything I owned to feed my pets and myself after all.

A friend offered to take my two cats to live with her until I came home, and I took my German shepherd, Venus, with me. I admit it, given a choice, with a handful of exceptions, I tend to prefer the company of animals to the company of people. Animals are honest—there's not a hint of pretense about them, they just unapologetically are who they are, and their capacity to love and be loved outshines ours by about a million. Venus was the most perfect travel buddy I could have asked for, with the effortless power to transform even the barest, bleakest hotel room into "home" when I was on the road.

We rehearsed in Los Angeles, and then we were off to Denver for two weeks of previews. Venus and I got there at about 6:00 p.m. It was dark. It was freezing cold. And it was Christmas Eve. I grew up in Denver, so I wasn't surprised to find that almost everything was closed, giving the city a certain ghost town atmosphere. I managed to find a little bodega near the hotel and pick up a couple of days' worth of food for Venus and me before we settled into our room. We ate some dinner and took a walk past several blocks of perfunctory holiday decorations. I kept wanting to feel some sense of "home," but I didn't. I kept wanting to feel some sense of hope and satisfaction that at least I was finally working again, but I didn't. Instead, I can still feel a deep, hollow place in the pit of my stomach when I think back to what I'm sure was the most depressing Christmas Eve, possibly even the most depressing night, of my thirty-year life.

The rest of the cast and crew arrived the day after Christmas, we rehearsed, and we performed previews to appreciative audiences. I never fell in love with my character, or with the show itself, but playing Irene's funny sidekick wasn't awful. What was awful was that during those two weeks in Denver, I started hearing rumors, something about Michael Bennett putting together a workshop in New York that might turn into rehearsals for a new show. *Oh my God*, I thought, *he found the money for* A Chorus Line, *they're going ahead with it, and I'm being left behind on the road, under contract to a show I couldn't care less about.*

Devastating as the idea of that apparent probability was, I mentally propped myself up as best I could. After all, this *Irene* job came along just when I needed it. I took it because I had to. I had no right to complain. In fact, I had to be grateful for it, and trust that for some reason I was exactly where I was supposed to be. I had no business feeling sorry for myself. I had to suck it up and say thank you. I had those talks with myself so often that they almost became a mantra, and they helped. Sometimes. Other times, not so much.

The rumors about *A Chorus Line* were getting more and more intense, and harder and harder to ignore, by the time we moved on to Houston. I admit I was preoccupied with them, to the point where I thought I was imagining things when Venus and I got back from a postshow walk one night and the hotel clerk handed me a note on my way past the front desk.

It simply read, "Call Michael Bennett."

My heart was pounding when I dialed the phone in my room, trying unsuccessfully not to get my hopes up.

Michael answered quickly and, as always, got right to the point. "Where are you?"

"Houston," I said.

"What are you doing in Houston?"

"*Irene.*"

There was an audible groan in his response to that, quickly followed by "How long is your contract?"

I hated saying it. "Six months." Getting out of tour contracts back then was hard to do, not to mention expensive—you had to reimburse the production company your whole salary for the length of your contract. If you signed on to a tour, you'd better mean it.

He asked where we were going next.

"Flint, Michigan."

He groaned again. Then, after a brief silence, he offered a desperately needed sliver of hope when he added, "Okay, let me see what I can do."

It wasn't something I could count on, but it meant I hadn't been forgotten about after all. I'm sure Venus wondered what prompted me to dance her around our hotel room that night.

Poor Flint, Michigan. It was economically depressed in the mid-1970s, and I knew exactly how it felt. All of us in the company found it hard to keep our spirits up. It helped, though, that we seemed to be showing our audiences a good time.

We were at the end of our first week in Flint when I found

another message waiting for me at the hotel: "Call Howard Feuer." Howard was the producer of *Irene*, a nice young guy I liked.

The minute I got to my room, I grabbed the phone and called Michael instead.

"I just got a message to call Howard Feuer. What's going on?"

"I think I got you out of it."

In the time it took me to realize that yes, I'd heard him correctly, he went on to say, "You know, I don't mind what it's going to cost to buy you out of that show. What I do mind is that now I owe Howard Feuer a favor."

I explained to him that I was dead broke when I got the *Irene* offer, and *A Chorus Line* was no guarantee, so I'd just done what I had to do.

"You could have borrowed money from me and spared me all this," he shot back.

Not a chance. I'd been married to a gambling addict. I'd watched him get caught up in a vicious cycle of borrowing money to repay gambling debts until he owed pretty much everyone in town; he was financially drowning, and he was pulling me under with him. I knew more about debt than I ever wanted to know and, as I told Michael, "I don't borrow money. I have to earn it."

That settled, I hung up and returned Howard Feuer's call. Bless his heart, he'd been on the receiving end of Michael Bennett's powers of manipulation an hour or two earlier, and he almost sounded apologetic when he assured me, "I would never do anything to hurt your career."

And with that, the necessary arrangements were made, and it was farewell to Flint and good night, *Irene*. Venus and I grate-

fully went home to New York, and I returned to work on what I'll always think of as the show that opened the door to the rest of my life.

Thanks to money from the Shakespeare Festival and an extraordinary patron of the arts named LuEsther Mertz, *A Chorus Line* was reenergized and in full swing when I reunited with my friends and castmates. Our second workshop turned very quickly into rehearsals, and I immersed myself in the transition from chorus dancer to a principal role—my first real, long-awaited acting role—of Sheila Bryant, one of the "chorus line" hopefuls vying for a job in an upcoming Broadway musical. Sheila was very much me, with a lot of added sassiness and tough-girl attitude, and I loved her.

Another personal statement about that transition happened the day that Michael interrupted a rehearsal to have us take paper and pens, sit in the Shakespeare Festival Public Theater seats, and spend a half hour or so writing our biographies for the playbill, something we chorus people were routinely asked to do. I sat there looking around at my sixteen castmates. Other than Priscilla Lopez ("Diana Morales"), Pam Blair ("Val"), and Donna McKechnie ("Cassie"), they were dancers who, like me, were experiencing their first principal role in a theatrical production.

Everyone else was writing away like crazy, while I sat there trying to imagine listing all my chorus jobs since 1962, when it suddenly hit me. none of that mattered. That was then, this was now. As of 1975, I wasn't a chorus dancer anymore. I was an actor, and it

was time to own it. I picked up my pen and paper and completed the assignment in less than a minute.

Michael took one look at it and laughed. "That's Sheila Bryant right there," he said, and, to my absolute delight, he published it in the playbill exactly as I'd written it:

"Carole Bishop (Sheila) has survived in show business for twelve years."

Working on the Sheila Bryant character was a joy and a challenge. I knew I was one hell of a dancer. Now I had my heart set on becoming one hell of an actor. The last thing I wanted was for audiences who knew my work to walk out of the theater after the show saying things like "Oh, well, she tried" or the dreaded "She wasn't half bad."

In the original script of *A Chorus Line*, Sheila had a monologue, much of it taken from what I'd talked about in that first tape session. I worked for weeks and weeks on that monologue. It was beautifully written, and a lot of it was *me*. I wasn't about to short-change it, or myself. That opportunity I'd been praying for to really act was right in front of me. Blowing it wasn't an option.

Which made it all the more horrifying when Michael came up to me one day and broke some awful news: with Marvin Hamlisch and Ed Kleban involved, they were understandably adding songs to the show.

"So we're trimming your monologue a lot, turning it into a dialogue instead, and then Sheila's going to sing a song called 'At the Ballet.'"

I gaped at him while every drop of blood drained from my face. I came as close as I've ever come to begging as I reminded him, "Michael, you and I both know I don't have a good singing voice. You might want to rethink this. . . ."

He gave me a minute to get my panic out of my system before he calmly added, "It's going to be a trio."

Oh. There would be other people singing with me. That was better. A little.

"Okay," I finally conceded, "I guess that will work."

And then, for the first time, I heard "At the Ballet."

Daddy always thought that he married beneath him. . . .
When he proposed he informed my mother
He was probably her very last chance.
And though she was twenty-two . . .
She married him.

Life with my dad wasn't ever a picnic
More like a "Come as you are."
When I was five I remember my mother
Dug earrings out of the car.
I knew they weren't hers, but it wasn't
Something you'd want to discuss.
He wasn't warm.
Well, not to her,
Well, not to us.

But everything was beautiful at the ballet.
Graceful men lift lovely girls in white. . . .
I was happy . . . at the ballet.
That's when I started class . . .
Up a steep and very narrow stairway
To the voice like a metronome . . .
It wasn't paradise . . .
But it was home.

Mother always said I'd be very attractive
When I grew up . . .
"Diff'rent," she said, "with a special something
"And a very, very personal flair."
And though I was eight or nine,
Though I was eight or nine,
I hated her. . . .

"Diff'rent" is nice, but it sure isn't pretty.
"Pretty" is what it's about.
I never met anyone who was "diff'rent"
Who couldn't figure that out.
So beautiful I'd never live to see.
But it was clear
If not to her,
Well, then to me
That . . .
Everyone is beautiful at the ballet.

Every prince has got to have his swan . . .
I was pretty . . .
I was happy . . .
At the ballet.

I was mesmerized. That exquisite music carried those hauntingly familiar lyrics right into my soul, and it took my breath away. They weren't just lyrics. Many of them, maybe even most of them, were quotes—my quotes—word for word, from that first long, intimate tape session over a year ago. I hadn't lost my beautiful monologue after all. It had simply evolved into something far more beautiful and far more memorable.

Impossible as it seemed, Marvin Hamlisch and Ed Kleban had written a song called "At the Ballet" that told the story of my childhood.

Chapter
Two

To get the technicalities out of the way: I was born Carole Jane Bishop in Colorado Springs, Colorado, on February 28, 1944. We moved to Denver not long after I was born, and that's where I grew up.

My mother, Jane Lenore Bishop (née Wahtola), was a remarkable woman and my best friend.

My older brother was and is a really good guy.

My father, Lawrence Bishop, could make a great pot of chili, and . . . uh . . . in spite of being a detached, mean, alcoholic bully, he never actually hit me.

One of the most remarkable things about my mother was that, in a lot of ways, she had no business being remarkable.

My grandmother Louise (not "Grandma," not "Nana," just "Louise" to me) got pregnant with my mom about two months after her sixteenth birthday. According to family lore, Mom's father was a drifter who passed through Colorado Springs just long enough to fleece people in poker games, impregnate Louise, and marry her

for a few minutes. He disappeared when Louise was three months pregnant, never to be seen again, setting the bar incredibly low for my mother when it came to choosing a husband.

Mom grew up with the insecurity and embarrassment of being very poor, and the deep ache of knowing she'd been an unwanted, inconvenient accident. She never made an issue of it, or indulged in a lifelong drama-queen victim act about it. Instead, to spare us that same pain, she always made sure my brother and I never doubted for a moment that we were planned, we were wanted, and we were loved. She was shy and pretty and tiny, and so smart that she graduated from high school a year early and, presumably thanks to a scholarship, since there was no money, went right on to Colorado College in the mid-1930s, a time when women in college were somewhat a rarity. That's where she graduated with a bachelor's degree in English and met my dad.

My mother confided in me from the time I was a little girl. She probably told me things I was too young to hear. When she talked about meeting my father, she never once mentioned falling in love, or romance, or being swept off her feet. It was the late 1930s when she and this Lawrence Bishop person started seeing each other; they were just over twenty years old, and they were at a culturally appropriate age to get married and start a family.

When he proposed he informed my mother
He was probably her very last chance.
And though she was twenty-two . . .
She married him.

Dad made no secret of the fact that "he always thought that he married beneath him," but after a couple of years, in 1941, they had a son. I came along two years and three months later, and mission accomplished—such as it was, we were a family.

Dad was a large man, and very bright. He was successful at various jobs with the airlines, from taking tickets to handling baggage, marshalling private planes, and running Sky Chefs and airport restaurants. You name it, he did it, and he did it well.

He was also a bully, an alcoholic, and a mean drunk. I guess I should add, just to be thorough, that his younger sister, my aunt May, said to me once, "I don't understand what happened to him. We had a good childhood. We were treated very well. I guess it was the alcohol." Mom, my brother, and I were scared of him, and we'd scatter like cockroaches when he came lumbering through the door. Luckily, he worked a lot, he traveled a lot, and he was an indiscreet, unapologetic philanderer, which kept him away from home even more.

When I was five I remember my mother
Dug earrings out of the car.
I knew they weren't hers, but it wasn't
Something you'd want to discuss.

But like the countless other good reasons Mom had to pack up my brother and me and leave Dad, she let his infidelity slide. Confronting him about that, or about anything else, would have accomplished nothing but more raging and bullying from him, and she

didn't have the resources or the self-confidence to support herself and two children on her own. Besides, in that era, divorced women were generally looked down on as scandalous hussies who might as well have walked around with large scarlet A's on their chests, and between her mother and her husband, I'm sure Mom was already dealing with all the relentless disapproval she could handle.

There was also the fact that when Dad wasn't around, our lives were safe, happy, and peaceful in our little brick one-story house. As siblings go, different as we were, my brother and I liked each other, and he let me play with him and the other little boys in the neighborhood—not sports, which didn't interest me one bit, but I'd be the packhorse if they played cowboys and Indians, or the army nurse if they played war. Most of the time, though, I preferred being by myself in our finished basement, reading my favorite books about little girls and their horses, or playing soundtracks on the record player. We had three soundtrack albums: *Annie Get Your Gun, Oklahoma!,* and *South Pacific,* and I knew every word of every song on every one of them. I'd act them out and whirl around the room to them and let them transport me out of my ordinary life to impossibly beautiful faraway places where I could be anyone I wanted.

In the meantime, Mom was busy being one of the greatest homemakers in homemaker history. She was a fantastic cook who did all those bonus kitchen-y things like making her own jelly and canning the fresh fruits and vegetables from the garden she and Dad planted and tended to in our backyard, the only activity I ever saw them do together. One of my fondest childhood memo-

ries was sitting on a stool beside Mom's ironing board while she starched and pressed Dad's shirts and just talking, about anything and everything.

One of the many comments during those "ironing talks" that really stuck with me was her observation—not a complaint, simply her truth—"Once you have children, you'll never be free again." Apparently, even as a little girl, I sensed that freedom was going to be an essential part of my life, because when she told me that, my first and only thought was, *Well, then, no children for me.*

This was years before I was old enough to know how children were created in the first place, but looking back, I'm pretty sure I'd already decided that I wasn't interested in having them anyway. Whatever maternal instincts I was born with were exclusively limited to taking care of animals. Other than that, no thanks. I even hated playing with dolls, so much so that on the rare occasions when I'd get stuck playing dolls with the little girl up the street, in our made-up story, I insisted on being the father who always had to leave for work.

And then there was this thing on the news people couldn't stop talking about called "overpopulation." From what I understood, there were countries all over the world that had too many people and not enough food, and I wasn't about to contribute to that problem by adding another child to make things even worse.

From childhood on, not wanting children was as unapologetic a fact about me as my ethnicity, and I was just as unapologetic about it as an adult which put me on the receiving end of such mystifying reactions as "You don't really know what it's like to be a woman

until you have children" and "Are you a lesbian?" Well, yes, I do, and no, I'm not, so take it or leave it.

I've been that strong-willed about what worked for me and what didn't for as long as I can remember, even as early as when I started kindergarten. My brother had already been in school for a couple of years, and he loved it. He was adorable and popular and athletic, one of those boys all the girls had crushes on and all the boys wanted to hang out with on the playground, so I was probably looking forward to it, until I got there. I immediately hated it. From the very first day right on through my senior year, I *hated* school. And since I resented having to spend a single minute there, I didn't go out of my way to make friends, with the predictable result that my brother's academic and social successes completely eluded me.

So Mom, finding herself with a disengaged, unstimulated eight-year-old daughter, got creative and came up with an idea that, as luck or fate would have it, lit a fire in me that ended up defining my future. She'd taken dance lessons when she was younger and fallen in love with ballet, and she started teaching me and four or five other little girls a few basics in our linoleum-floored basement to see if I liked it.

She made ballet look beautiful, and it came naturally to me. It was fun, and it was easy; and I had the added advantage of having inherited her strong, limber legs and "ballet feet," with deep arches, sharply pointed toes, and a curved instep. In the basement we didn't have barres, those handrails to support dancers while they execute

various exercises, so we held on to the backs of chairs instead. Mom taught us basic, beginner ballet steps—demi-pliés, grand pliés, relevés, battement tendus—all of which felt like such graceful, pretty things to do with my body. Unlike the tree-climbing and playing horses I'd spent my childhood doing, ballet had structure and discipline. It was a skill, with plenty of room for me to improve and grow, which appealed to me. I never had to be encouraged to practice. I even loved wearing pointe shoes so much that I used to put them on and run around the neighborhood on my toes.

Finally, this was something I cared about, something I could wake up every morning looking forward to, something I could learn to be good at and be proud of. What do you know, maybe there was something special about life, and about me, after all.

Mom was thrilled. Not only had she managed to share one of her passions with her little girl, but her little girl showed some real promise at it. After a few weeks of working with me and seeing that I was genuinely enchanted with it, she asked Dad if he'd please pay for formal lessons for me, which he could have easily afforded.

And Dad, because he was Dad, said no. No explanation, no apology, no "Let me think about it," just "No."

He wasn't warm.
Well, not to her,
Well, not to us.

That "no" came as no surprise to Mom. She took it as nothing more than an annoying, predictable bump in the road and yet

another opportunity to deny her something that might make her happy. She was a resourceful woman, with the survivor's instinct of a lioness when it came to her children, and she moved right along to plan B without batting an eye. She happened to be a gifted pianist with a particular affinity for classical music, a skill highly valued by ballet schools. So she bartered that talent to pay for my classes, and at the age of eight, I began studying at the American Ballet Theatre in Denver, under the brilliant tutelage of teacher, dancer, ballet master, and regisseur Dimitri Romanoff and his equally brilliant wife, Francesca Ludova Romanoff.

Classes were magical, a fantasy world through the eyes of an eager eight-year-old.

> *Up a steep and very narrow stairway*
> *To the voice like a metronome . . .*
> *It wasn't paradise . . .*
> *But it was home.*

I worked hard, and I loved every minute of it. Of course, the harder I worked, the more Mr. Romanoff was impressed with me, and the more impressed Mr. Romanoff was with me, the harder I worked. He was a stern man who never laughed, or even smiled, and high praise from him was limited to the words "okay," or a very occasional "good." We students were not allowed to talk, or even whisper, *ever*, and there were times when he'd poke us between the shoulders if we weren't standing up perfectly straight. But he was incredible on so many levels, a spectacular dancer who

knew every step of the choreography of every part of every ballet that was ever performed, which made him a very big deal in the prestigious American Ballet Theatre. He'd occasionally be gone for weeks at a time on tour in New York and have his wife take over classes for him, but I thrived on his approval when he was in the studio with us.

I thrived on Mom's approval too, as I had all my life, and nothing nourished my soul more than seeing the pride in her eyes when she watched me dance. I was sure she thought I walked on water, until another one of our "ironing talks" that made me feel a bit doomed.

There was a popular song in the 1950s, sung by Doris Day, called "Que Sera, Sera (Whatever Will Be, Will Be)," that began:

When I was just a little girl
I asked my mother, "What will I be?
"Will I be pretty, will I be rich?"

I'm assuming that was what inspired me to ask that day, "Mom, will I be pretty when I grow up?"

If you didn't want an honest answer about something, my mom was not the person to ask. I was expecting some adoring motherly response like "Of course you will! Don't be silly, you'll be gorgeous!"

Instead, she looked up from her ironing board and studied my face for a moment, almost as if she were seeing it for the first time. Finally after a thoughtful pause, she replied, "You'll be very different. You'll be dramatic. And you'll have a lot of flair."

I remember my heart sinking. I was crushed. If I didn't have "pretty" to look forward to when I was a grown-up, what possible hope was there for me to have a happy future?

"Diff'rent" is nice, but it sure isn't pretty.
"Pretty" is what it's about.
I never met anyone who was "diff'rent"
Who couldn't figure that out.
So beautiful I'd never live to see.

Which made my lessons with the Romanoffs even more important to me, because . . .

Everything was beautiful at the ballet.
Graceful men lift lovely girls in white. . . .
I was happy . . . at the ballet.

I felt pretty there. I belonged there. I excelled there. In many ways, the ballet saved me from a life with no purpose, no sense of direction, and no self-confidence, other than having a lot of whatever the hell "flair" was.

The ballet was also my one constant at a time in my teens when almost everything else that was familiar to me seemed to crumble and fall away.

First came something I never thought I'd see: after eighteen

years of a miserably unhappy marriage, my parents got divorced. There was no precipitating event, no major blowup, no explosion that pushed Mom over the edge. She and I had always talked about everything, all my life, so one night she just sat me down and told me she was finally done with Dad and everything he'd subjected us to. "I just can't do this anymore" was the way she put it, and she'd been trying to build up the courage to put a stop to it for a very long time. His alcoholism. His other women. His almost daily rages out of nowhere, over anything and nothing. His constant verbal abuse, with nasty comments like "You're the scum of the earth" and "I got you out of the gutter, and I'll put you right back." His physical abuse of my brother. His obvious disinterest in me. She knew all three of us deserved much better, and we were never going to get it from him. She regretted that it took her almost two decades to face that, but eighteen years was better than never. Dad didn't care enough to argue about it and moved out, and it was over.

Obviously, on one hand, it was a dream come true. I couldn't have been happier about the idea of having my father out of our lives once and for all. Which made it even more confusing when I found myself depressed and struggling with it. Maybe there had been some comfort in knowing what I could count on from the day I was born, even when what I could count on was less than perfect, and that familiar stability wasn't there anymore. Maybe it was being so close to Mom that I could tell how hard she was trying to protect my brother and me from seeing how scared she was to find herself forty years old and alone. Or maybe I wasn't ready to learn yet that, as the saying goes, "There's nothing permanent except change.

I was still both celebrating and reeling from my parents' divorce when the Romanoffs dealt what felt like a death blow: they were closing their ballet school in Denver and moving to Northern California to direct the San Jose Ballet School.

It decimated me.

Proving that sometimes serendipity shows up in our lives disguised as the worst news you can possibly imagine.

Mom was as invested as I was in my success at ballet and in what it meant to me on so many levels. It was obvious to her that I was struggling, that losing the Romanoffs felt like having part of my oxygen supply cut off, and she empathized, since she was struggling too. On top of all the other repercussions of her divorce, she was feeling completely ostracized. She'd been a favorite for many years among the couples she and Dad socialized with, when she was a sweet, pretty little married woman. But the women in that group didn't want her anywhere near their husbands when she became a sweet, pretty little available divorcée. The phone stopped ringing, the lunch and dinner invitations dried up, and there she was, unwanted again, through absolutely no fault of her own.

Self-pity had never been a part of her repertoire, though, and she was an activist who never faced a problem she didn't try her damnedest to solve; so I shouldn't have been surprised, but I was, when one day she simply announced, "I've got to get out of Denver."

So, with a little help from Dad's modest child support payments, Mom; my brother; our rescued English setter, Pat; our res-

cued Siamese cats, Magda and Buttercup; and I piled into our 1957 Volvo and moved. Not to start over in some random destination but to follow the Romanoffs to the apartment above a parking garage they found for us in Northern California, and to pick up where I left off with them at the San Jose Ballet School.

My brother, who was about to start his senior year, didn't appreciate having his stable, successful life pulled out from under him, but he picked up where he left off too. Within a month he became one of the most popular boys in his new high school. While he was thriving all over again, I was seeing a psychologist to sort out my general teenage turbulence and confusion. It helped. Slowly but surely, my mind cleared, my priorities fell into place, and I felt back on track again.

I'd been giving serious thought to not going back to school. I still hated it, and I was sixteen, so I could legally quit. It sounded like a great idea, until I thought about my mom. She'd gone from being a dirt-poor exceptional high school student to a college graduate with no one supporting her or cheering her on. She'd managed to become an accomplished pianist with no one around to encourage her, and a gifted ballet dancer who forfeited a potential performing career to be a devoted wife and mother. In the end, she deserved a whole lot better than a daughter with plenty of advantages, intelligence, and potential, who thought getting a high school diploma was too much to ask.

So when I started my sophomore year, I gave up my timeworn tradition of heading straight to a desk in the back of the classroom on the first day of school, where I could mindlessly stare out the

window unnoticed until it was time to go home. Instead, I made myself take a seat front-row center, paid attention, and got amazing grades once I discovered that school was actually much easier when I stopped fighting it. I still hated it. I still resented the intrusion on my time and energy, and my added challenge of a mild case of dyslexia (although I didn't realize then that's what it was; I didn't learn that word until I was in my twenties, and it helped explain one of the many reasons why school had always been such a chore for me). I remember having trouble telling the difference between the words "dairy" and "diary," for example, and trying to imagine what a "diary farm" could possibly look like. I was also completely mystified by a newspaper headline that I thought read "Mother Kills Man, First Time in Ten Years" until I forced myself to look beyond the "m" and the "t" in that first word and finally figured out that it actually read "*Meteor* Kills Man . . ." It was so relatively minor as dyslexia can go that I didn't mention it to Mom or my teachers; I just assumed it was a natural thing that everyone found as confusing as I did. But once I had the Romanoffs and the ballet to inspire me and propel me forward again, I graduated right on schedule two years later.

By then, Mom was commuting to the secretarial job she'd found in San Francisco. She was able to support us, but continuing to pay for my ballet lessons by being the school's pianist was impossible. The Romanoffs, God bless them, let me keep studying with them free of charge, in exchange for my helping out with their Saturday morning children's classes. They couldn't have been more generous to me, which motivated me to work harder and harder, and get better and better, with one single, very precise goal in mind: I wanted

to thank them by following in Dimitri Romanoff's footsteps and become a star in the American Ballet Theatre, which was revered as a national treasure and one of the greatest dance companies in the world.

One day Mr. Romanoff announced that somehow the planets had aligned perfectly enough that, even though it was based in New York, the American Ballet Theatre was touring in San Francisco, just a one-hour drive from San Jose. As if the possibility of getting to see them perform wasn't thrilling enough, Mr. Romanoff sat me down and informed me that I was being given the huge honor, on two occasions, of taking classes with the company. He even arranged a photo session for the two of us to send to the cofounder, principal dancer, and prime financial backer of the American Ballet Theatre, the esteemed Lucia Chase. I was Mr. Romanoff's little protégé coming into those San Francisco classes, and the plan was that Ms. Chase would see the photos, stop by to watch me dance, and be so overwhelmed by my artistry that she'd insist on making me *her* little protégé.

Mom and I went to a performance of the American Ballet Theatre before I took my classes, and I was mesmerized by two of the dancers in particular—prima ballerina Maria Tallchief, who later became the first American dancer to perform at the world-renowned Bolshoi Theatre in Moscow, and an exquisite performer named Lupe Serrano, who went on to dance with the legendary Rudolf Nureyev at his invitation.

I was in awe of both of them, so finding myself dancing just a few feet away from them in class was both intimidating and such

an honor. I still remember putting on our "class uniform" of a black leotard and pink tights—and walking onto the stage where the classes were held. The black floor, the dark wings, the black curtains that opened to a vast, empty theater, all that shadow making us dancers sparkle like jewels in a jewelry box. . . .

It was scary. It was magical. It had "fairy tale" written all over it.

Or it would have, if Lucia Chase had ever shown up.

But she didn't. Not once.

I was disappointed. I was also much too determined to quit. I knew I was good enough to be accepted into the American Ballet Theatre, I just needed a chance to prove it. I thought that would happen in San Francisco. But if Lucia Chase wouldn't come to me, I'd go to her, and I knew exactly where to find her.

At the age of eighteen, I packed my bags, and, with the blessings of Mom and the Romanoffs, I moved to New York City.

Chapter
Three

Family friends from Denver had moved to the Bronx a few years earlier, and they were kind enough to let me stay with them when I arrived in New York. The impact of finding myself in that tall, vast, electrifying city barely registered. I was there for the sole purpose of proving myself to Lucia Chase. Nothing more, nothing less.

I almost literally went directly from the airport to the New York Theatre Ballet School, where I studied and worked as if my life depended on it. Other than that, all I paid attention to was how to get from the Bronx to the Theatre Ballet School on 57th Street, which, of course, meant taking the subway. Board at 242nd Street, get off at the 59th Street stop, and walk two blocks. Got it. The only thing that distressed me about the subway was the fact that, possibly because I was an eighteen-year-old girl with an open, innocent, new-in-town face, men kept exposing themselves to me. If what they were after was shock value, it worked. They shocked me. But I got some satisfaction out of refusing to let it show, even pretending

not to notice. In fact, I spoke up only once. I was on a crowded subway one morning when I suddenly felt a very deliberate hand on my ass. I looked down at the hand and followed it up the arm to a man in a suit, wearing horn-rimmed glasses and carrying a briefcase. He refused to look at me, as if he had no idea whose hand that was, which pissed me off even more. So I said, really loudly, "Is this it? Is this your sex life? If this is what you have to do to get horny, I think maybe you need some therapy." He still never looked at me, but his hand instantly came off my ass, he actually pushed people out of the way to get off at the next subway stop, and I smiled to myself and thought, *Okay, now you know how to handle that.* I was almost expecting a round of applause from the other passengers, but they just stared at me as if I'd offended them. Oh well. New city, new people, sooner or later we'd all get used to each other.

Finally, a month after I got to New York, a month that consisted of nothing but the friends' apartment in the Bronx, the subway, and ballet classes, it was time for the first of two auditions at the studio for the American Ballet Theatre corps de ballet, the group of dancers who form the backdrop for the principals and soloists in a performance. I can't begin to guess how many of us girls were at that first audition, but as well prepared as I was, I was also more than a little terrified. None of us had any idea how many judges we'd be facing, or who they might be, and I was pleasantly surprised and a bit more confident when I entered the room in the midst of all those other girls and got the answer—the only two people watching the auditions were my mentor, Dimitri Romanoff, and none other than world-renowned Lucia Chase herself, the imperious, terrifying woman who finally

held my future in her hands. There they sat, their backs facing the ever-present mirrors, with no expressions on their faces whatsoever, giving us no hint whether they were pleased with what they were seeing or if they were wondering how much longer they had to sit there. These auditions were very formal, so there was no little wave or casual chatting with the judges before or after; we dancers simply took our positions and tried to look as expressionless as Mr. Romanoff and Ms. Chase.

There's a reason why wall-to-wall mirrors are a staple in every dance studio, by the way. They have nothing to do with vanity and everything to do with giving dancers a view of the instructors from both the front and the back so you can learn the steps and combinations, and with judging how well you're doing compared to the other dancers. You can see that extra pirouette, or that leg that's raised higher than yours, and adjust accordingly.

Back then, there were two kinds of ballet dancers: the "soft" ones and the "hard" ones. The soft dancers were the lovely, gentle ones whose movements were slow and delicate. The hard dancers were the ones who excelled at jumps and turns. Hard dancers were flashier and more exciting than soft dancers in my opinion, even though we were all performing the same choreography. I was a hard dancer, and a very good jumper and turner. There was only one other hard dancer in that audition I felt really competitive with, a tall, strong brunette whose jumps and turns were impressive enough to inspire me to step up my game. Aside from that, I was feeling pretty self-assured and completely unthreatened.

I noticed on a couple of occasions that while my group and I

were dancing our hearts out, Mr. Romanoff would tap Ms. Chase on the shoulder and whisper something. They'd both stare at me for a moment, and then she'd pat his arm and turn away, almost refusing to look at me. We dancers were required to line up at the end of the audition and be presented to Ms. Chase. She would say, "Thank you," we'd shake hands with her and curtsy, and she'd be on to the next in line. I had every intention of adding a respectful nod and a smile to her, but I ended up not bothering, since she avoided making even a split second of eye contact with me.

Then, while we all stood there nervously, Lucia Chase called out the names of the two dancers who'd especially impressed her. "Carole Bishop" wasn't one of them. The rest of us were excused. I still remember going back to the dressing room in a complete state of shock, almost too stunned to move, while I changed into my street clothes and left.

I lost a lot of sleep trying to interpret Ms. Chase's behavior toward me. She and I had never met, so I couldn't possibly have done something to offend her. Had she taken a dislike to me or my dancing, even though my audition went perfectly? Was this just something she did to intimidate random dancers to remind us and our teachers who was in charge?

In the end, whatever it was, it apparently didn't matter—I was invited back to the second audition. One audition closer to the dream I'd been preparing for since I was eight years old. It was happening. I could see it. I could taste it. I could smell it. I could picture the joy on Mom's face when I told her that the little girl she'd taught, and believed in, and sacrificed so much for had made it into the American Ballet Theatre.

My second audition went even better than my first. Thanks to those mirrors, I knew I was spectacular, if I do say so myself. The second audition was identical to the first, including the fact that there was still exactly zero eye contact from Lucia Chase, even when we lined up again at the end to be presented to her, but obviously I'd read too much into it . . . or maybe I hadn't.

At the end of that audition, Ms. Chase called out the names of the two dancers she was interested in. Again, I wasn't one of them. I was so devastated that I didn't even cry. I kept vacillating between shock and anger—I'd taken classes with the girls who did get accepted, and I *knew* I was a better dancer than they were. The other hard dancer in the group, the tall, strong brunette who'd impressed me so much at the first audition, didn't make it either, but that was no consolation. It was a huge blow that wasn't softened one bit by reminding myself of the old cliché that life isn't fair. No, it isn't, but it damned well should be. Being one of the top performers at an American Ballet Theatre audition should mean that your talent and years of hard work paid off, you've finally made it—break out the confetti. Apparently, though, there were other agendas at work.

Mrs. Romanoff called to console me. She and Dimitri were as shocked as I was, and so sorry. She told me that Mr. Romanoff had even thought of calling Lucia Chase to force her hand and demand that she take me into the company. But he was sure that if he did that, Ms. Chase would think of me as the dancer who was shoved down her throat and make my life so miserable that I might quit dancing altogether, so he opted to stay out of it.

I thought about it endlessly. I obsessed about it. And I kept coming back to the same bottom line: no matter who'd been pulling for me from the sidelines, no matter how much it hurt, or how right or wrong it was, I'd been turned down by the American Ballet Theatre. By then I'd moved out of the Bronx and into a room in an apartment with rent to pay. I was an unemployed dancer in serious need of a paycheck. I had to do something about it, and fast.

There was very little work for ballet dancers in New York City in 1962, but it was common knowledge that a lot of dancers' lives were being saved by one of New York's most treasured entertainment venues, an art deco masterpiece called Radio City Music Hall. Home of perhaps the world's largest and most famous chorus line, the Rockettes, and the far lesser-known dance troupe, its own corps de ballet. There was no doubt about it, it was the Rockettes and their kick line that audiences flocked to see. I was definitely not an aspiring Rockette—it was hard to picture superstar ballerinas like Anna Pavlova or Dame Margot Fonteyn putting on their tap shoes and high-kicking and jump-splitting their nights away on the vast stage of Radio City Music Hall. I was, however, hungry enough to start yearning to become part of that corps de ballet so I could finally dance for a living.

They held auditions every two weeks, and I couldn't line up fast enough. I was a little incredulous to discover that their corps de ballet audition was actually much harder than the auditions for the American Ballet Theatre. The audition itself was much longer. The

floor was slippery, while ballet dancers need an almost sticky floor. The combinations we were asked to do were more complicated—we were required to do sixteen fouettés, for example, while the American Ballet Theatre auditions asked for none. (You may have seen fouettés but not known what to call them. They're a showstopping step in which the dancer turns to start a double pirouette, does a plié with the standing leg, extends the "working" leg out to the side, brings the working leg in again so that the toe touches the knee of the standing leg, and then does another pirouette. Sixteen times in a row, all without moving from our spot.)

In sharp contrast to the American Ballet Theatre, Radio City Music Hall called a day or two after the audition to welcome me to *their* corps de ballet, and just like that, I was a real, live, professional dancer.

From the very beginning, it was impossible to ignore the clearly defined hierarchy between the Rockettes and the corps de ballet dancers. They were the main attraction, the tap-dancing sensations, while we were the "art," the "quiet elegance" of the evening's entertainment.

We corps de ballet dancers even had a separate stage door from the Rockettes—ours was on Fiftieth Street, while theirs was a block away on Fifty-First Street. We'd step through the stage door and take the elevator up to a vast dressing room filled with long rows of mirrors surrounded by globe lights, with fabric curtains in the aisles that served as closets for our costumes and clothes. It was always friendly, high-energy, organized chaos, with twenty-seven women changing from our street clothes into our costumes—everything

from brightly colored calypso outfits to black-and-orange Halloween cats to heavily modified nun habits with lilies, depending on the theme of the show—after first sitting down at those mirrors to put on our makeup. Eyelashes were a top priority when it came to Radio City dancer makeup; so instead of mascara, we were required to bring the tools and supplies for a popular process called "beading": black wax, a little pan and chafing-dish-style candle to melt the wax, and an eyelash brush to apply the melted wax to our lashes. Then, eventually, right on cue, we corps de ballet dancers, our beaded lashes, our blistered feet, our costumes, and our pointe shoes would hit that gigantic stage and perform beautifully, never doubting for a moment that everyone in the audience was really just waiting for us to finish so they could see the world-famous Rockettes.

I didn't care. It felt great to be able to support myself by dancing, "support myself" being a relative term. My first year at Radio City I made $90 per week and cleared $79. The second year I was given a raise to $100 per week and cleared $83. We did eight shows a week, seven days a week, with a paid week off every two or three weeks. Between rehearsals and performances, it was relentless, exhausting work. The choreography was frankly pretty cheesy, and the pay was terrible. Looking back, I have no idea how any of us managed to survive in New York in those days on those salaries, I just know that we had to, so we did.

Make no mistake about it, though, I'll always be grateful. Radio City Music Hall gave me my first job, and my first serious boyfriend.

<p style="text-align:center">*　　*　　*</p>

Dating had been of little or no interest to me since I'd arrived in New York. I was there to earn a living as a dancer, fill my "time off" with ballet classes—which I never stopped taking—and sleep when I could. There was a guy I'd met at Radio City, a trumpet player I went out with a few times for a beer and a make-out session here and there, but he was so inconsequential that, meaning no disrespect, I'm not sure I even remember his name. I was too busy with life to even think about investing my energy, my focus, and my heart in anything resembling a relationship . . . I thought.

The Rockettes and the corps de ballet occasionally did specialty shows that involved eight or ten male dancers. Back then, adult female dancers were referred to as "girls," and the male dancers were referred to as "men," which irritated me no end. One of the *men* in one of those specialty shows was a guy named Roy Volkmann.

The schedule for corps de ballet dancers at Radio City Music Hall left virtually no time to meet anyone outside the theater. Our performances were at 12:00 p.m., 3:00 p.m., 6:00 p.m., and 9:00 p.m., and between performances we'd all warm up in the vast wing space and hang out at the portable barres that were set up for us there. I'd noticed Roy during rehearsals—he was a good dancer, cute, probably about five foot ten, and one of the only heterosexual men in the troupe—and he and I got acquainted at those portable barres. He was fun, with a wonderful sense of humor, and unlike a lot of stage performers, both male and female, he was refreshingly un-self-involved, just a good guy and a good listener who seemed genuinely interested in anything I had to say. We had a lot in common besides

being dancers. He was from St. Louis, so we were both transplants to New York City, and we were both too focused on our careers to be worried about our social lives and/or the fashionable places to "see and be seen." He got an immediate "yes!" from me when, after a couple of weeks, he asked if I'd like to venture across the street to the coffee shop in Rockefeller Center to get something to eat.

I hadn't realized how attracted I was to Roy until we were standing on the curb, waiting for traffic to clear, and he put his hand on the small of my back. He wasn't making a pass at me; he was simply being a gentleman, but the instant he touched me, I felt this full-body electric shock go through me, something I'd never experienced before. While I had no idea where this was going, if anywhere, there wasn't a doubt in my mind that I wanted to really get to know this man. I don't remember any specifics of our conversation at the coffee shop that day, except that it was lovely and stimulating, just trading stories about our lives and our careers, from my ordeal with the American Ballet Theatre to his confession that while he was grateful to be working as a dancer, his real passion was photography, which he hoped to be able to afford to pursue full-time someday.

That coffee shop lunch evolved into casual dating, which evolved into more serious dating, which eventually evolved into our first romantic encounter in his East Village apartment. It still makes me smile to look back on that night and to remember saying to him when we got into bed, "Teach me how to make love." I'd never made love before, so I wasn't being coy, just honest and curious, and I couldn't have asked for a gentler, sweeter, more wonderful teacher.

Two or three months later I moved from the room I was rent-
ing into Roy's tiny, run-down apartment, and it went so well that
before long we decided to pool our limited resources and find a
more suitable place where we could officially live together. Next
thing we knew, we were moving into a small one-bedroom walk-
up apartment on West Sixteenth Street. It was the mid-1960s,
and landlords wouldn't rent to unmarried couples, so I wore a
wedding ring.

While I danced to afford my passion for dancing, Roy danced
to afford his passion for photography. He was making money on the
side taking 8x10 headshots of dancers and actors for their portfo-
lios, and we converted our living room into a photography studio.
He loved trying new cameras, new lenses, new film, new lighting
equipment, new techniques, whatever he'd read about and could
afford. I became his go-to model whenever he wanted to experiment
with something. I'd come home from work, still in my corps de bal-
let hair and makeup, and pose for him for hours. It was flattering, it
was fun, it was yet another thing we enjoyed doing together, and I
was blown away by how talented he was.

While I was friendly and easy to get along with among my fellow
dancers at Radio City, I didn't have what I would consider "friends"
there. I'm a fairly private person, and I'm not nosy or interested in
gossip; so while we were all vaguely aware of who had boyfriends
or girlfriends and who didn't, it never occurred to me to share the
news that my boyfriend and I had moved in together, or to ask any-
one else about their living situation. I had no idea, nor did I care,
whether or not they would have approved, or been shocked.

The only shock I encountered came from my mom, who was deeply offended to learn that her daughter was "living in sin." She and I had been writing letters a couple of times a week for years rather than calling each other—a five-cent postage stamp was far more affordable than long-distance phone calls, after all, and emails and texts were decades away. Mom and I kept no secrets from each other, and she was *horrified* when I told her that Roy and I were sharing an apartment together. She didn't hold back on her disapproval either. "'Common law' means exactly what it says—*common*," she wrote. I didn't answer that letter from her—I wasn't about to break up with Roy and move out. It wasn't until a month later, the longest she and I had ever gone without being in touch, that she finally wrote me again, just several typical handwritten pages about some new curtains she'd found and how she was thinking about redoing the bathroom. Not another word about this supposedly disastrous life choice I'd made that would doom me to an eternity in hell.

Not only did she never mention our living arrangement again, but she completely got over it once it became apparent that Roy was a really wonderful man. He was supportive, upbeat, multitalented. He was good for me. He even helped me feel brave and confident and "pretty" enough to see that unless I loved it—which I didn't—I had no business settling for the mundane security of being a Radio City corps de ballet dancer until I was too old to dance anymore.

It was thanks to his encouragement that, after a year and a half, I quit my job at Radio City Music Hall, started auditioning for other work, and ended up being hired for a job at the 1964 World's Fair. It was a huge extravaganza, or maybe a series of extravaganzas,

one after another, called *Wonder World*. Thirty-two of us dancers, choreographed by the legendary Michael Kidd. Thirty-two singers. Sixteen synchronized swimmers who performed in a pool between the stage and the audience. Even a fleet of motorcycle riders, one of whom wore a jet pack on his back that, once activated, would emit flames and fly him across the stage. The show was produced by one of the Radio City Music Hall producers—in some ways it was a bit like being a Radio City dancer again, but with different choreography that definitely got my attention. There was one member of the dance troupe I especially liked—a very nice, very talented Black performer in his thirties named Morgan Freeman. I've loved watching his star rise ever since and thinking, *My God, I worked with him when he was a dancer!*

To my surprise, *Wonder World* had a major impact on me and my dreams. It introduced me to show dancing. Unlike ballet, which is very structured and regimented, the show dancing of *Wonder World* included character dancing, stylized representations of folk and native dances, and jazz dancing, i.e., upbeat music and fast-paced movement, both of which involve a lot more freedom, a lot more flair, and some improvisation. Still no Rockette dancing—no tap shoes and spectacularly synchronized kick lines—just a whole other style of dance, as exciting to perform as it was to watch. I was hooked, and I wanted more.

Then the World's Fair ended, and work for dancers in New York became hard to find again. Roy and I both needed jobs and

paychecks, so we started brainstorming, and he came up with a possible temporary solution to tide us over until New York auditions reactivated: he had connections with an agency that supplied dancers for shows in Las Vegas and Lake Tahoe in Nevada. With so many shows in perpetual production, they always seemed to need dancers, and they notoriously paid more for chorus dancers than New York theater did. It sounded like a potentially exciting adventure and change of scenery. Besides, we'd been living together for a year, and our lease was up, so the timing seemed perfect. We packed up our West Sixteenth Street apartment, loaded up Roy's Mustang, and drove across the country to find work, income, and new territories to explore until it made sense to head home again. We auditioned for a few of his agency contacts in Los Angeles, landed chorus work at Harrah's hotel and casino, rented a small furnished apartment in Lake Tahoe, and started rehearsals.

That's when I got a call, out of nowhere, that my father had died.

Dad and I had seen each other only a couple of times in the years since he and Mom divorced. I think he called a total of twice, when he was coming to New York on business anyway, and I met him for lunch. Predictably, those lunches didn't turn out to be poignant father-daughter reunions; they were more like two distant relatives awkwardly going through the motions. I knew I should have felt something when I heard the news that he was gone, but I didn't. I felt nothing.

Mom and Dad had both been victims of a rheumatic fever epidemic in Colorado Springs in the 1920s, which resulted in a

heart murmur for her and an enlarged heart for him. He went on to become a heavy smoker and a heavy drinker who was overweight and had a lifelong aversion to any form of exercise. His condition had finally become severe enough that they elected to do a fairly new surgical procedure on him in which they were replacing his heart valve with a pig valve, and he died on the table.

Dad's sister, Aunt May, made the funeral arrangements, and Mom, my brother, and I met in San Francisco and flew to Colorado Springs for the service. Aunt May had insisted on an open casket and urged my brother and me to go into the sanctuary and spend some time with our father before the funeral started. I'd never seen a dead body before, let alone the dead body of someone I'd known, and I remember having a small epiphany as I watched him just lying there perfectly still, an almost childlike realization of *Wow, that's Dad, that's his body, but he's not in there. So, I see, there's life, and then there isn't.* I kept waiting to feel something, but it kept not happening.

My brother and I hadn't been in touch very often since my move to New York, probably like most siblings who find themselves living across the country from each other. I was off in my world, and he was off in his, getting a degree in agronomy at the University of California, Davis, and working a side job or two or three to be able to afford it. We called each other occasionally, on birthdays and holidays, but mostly, we kept in touch through Mom, and we never stopped loving each other and feeling connected when we were together.

He and I took a walk around the funeral home grounds after we viewed our father's body. We didn't say much. There wasn't

much to say. He was really struggling with his grief, his whole body aching almost as if he were getting sick, and he didn't want to talk about it. I understood. Dad had been much harder on him than he'd been on me, so I recognized that he didn't know how to process the loss of a man he'd hated but kept wishing he could love. He'd calmed down by the time we got back to the sanctuary and slid into a front-row pew beside Mom, who was doing fine and was just there to show respect for Dad's family and to be supportive of my brother and me.

I've never been much of a crier. In fact, sadness rarely moves me to tears. When I do cry, it's occasionally out of frustration, but it's most likely over something beautiful, like a spectacular sunset, or anything animal-related, or a profound act of kindness. Which is why what came next was one of the most bizarre and visceral experiences of my life.

A few minutes into the funeral service, I didn't just begin to cry—I began to keen, to wail uncontrollably at the top of my lungs, from some part of me so deep I'm not sure I knew it existed. I was vaguely aware that people were staring at me, but this was too involuntary for me to stop it. Maybe it was every grievance, every fear, every hurt that had been building up in me since the day I was born, finally exploding. Maybe I was grieving for the father and the love I never had. I didn't know. I still don't. I just know that it shocked me and that I couldn't wait for that funeral to be over.

There was a dinner I barely remember after the funeral, and then it was off to the airport to fly back to San Francisco. I hopped into the little red Volkswagen Roy and I had bought in Las Vegas

for my round trips from Tahoe to Vegas, drove to my hotel in Lake Tahoe, and collapsed.

It had never occurred to me that Dad's funeral would have any real impact on me, let alone that it would leave me so deeply shaken, so I hadn't made arrangements to give myself a night or two off from the show. Instead, there I was onstage, less than twenty-four hours after I got back, and my mind suddenly shut down completely. I had no idea what the next step was, or what was supposed to happen after it, which taught me a great lesson in the miracle of muscle memory—while my head was nowhere to be found, my body went right on dancing without missing a beat.

And thanks to Roy, and the corps de ballet, and work in general, in a few short weeks I was able to put the funeral and any connection to my dad behind me and move on.

Before long Roy got a job at the Dunes in Las Vegas, and I was hired to dance in a pitiful lounge show at the Flamingo. The Dunes choreographer Roy was working with was an absolute genius named Ron Lewis. One night Roy and I went to see a revue of Ron's with some of his favorite dancers in downtown Vegas, and I was enthralled. That was a man I wanted to work for.

Ron had a very popular lounge show called *Vive Les Girls*, consisting of maybe eight dancers and six showgirls. I auditioned for it at North Lake Tahoe and got the job for the summer. I'd never worked with a choreographer before who was so inventive, and imaginative, and stimulating. There were five numbers in each

lounge performance. One would be a straight-out jazz number. Then we'd dash offstage and come back out for an East Indian character dance in sari-inspired costumes with finger cymbals and bells on our ankles, followed by another change into a sequined ruffled dress to perform a traditional cancan, followed by a couple more costume changes and numbers I can't even recall . . . all in a matter of about a forty-five-minute show. It was such an exhilarating challenge, to say the least, that in just a few weeks I sat down with Ron Lewis and told him, "If you're happy with my work, I want you to promise me a job with the new *Vive Les Girls* in Las Vegas."

And that's how I ended up in the incredibly *not* pitiful *Vive Les Girls* in Vegas while Roy was still dancing away in the big show at the Dunes. We were doing three hard, intricate, skillfully choreographed shows a night and rehearsing during the day, and a couple of weeks into rehearsals, I broke. I'd always been so quick to pick things up, but one day I couldn't get the steps Ron had devised to register in my brain, no matter how hard I tried. I finally felt so defeated that I sat down and burst into tears. Ron walked over and sat down with me.

"I'm sorry," I told him. "I know I'm tired, between working at night and rehearsals all day. I should be able to get this, but I'm so tired my brain's just not getting it."

He compassionately let me get it out of my system and then, with his arm around my shoulder, he said, "Here. This should help." And he handed me a little white pill.

Amphetamine. Speed. But in Las Vegas in the 1960s, we called them "pep pills."

He was right. It helped.

It helped so much, in fact, that when I injured a tendon doing a jump split during a cancan number, I discovered that if I took two aspirin and a pep pill, the pain went away completely for two or three hours, and I started taking those pep pills every day.

Such became life in Las Vegas. A name that conjures up so many images. The world-famous Strip. The fairy-tale sea of neon lights. The nonstop, noisy whirlwind of excitement. The glamour. The celebrities. The ecstatic casino winners. The bankrupted losers who keep coming back for more.

And then there's the view from backstage. Rehearsals, followed by hair, makeup, and wardrobe, followed by a pep pill, followed by showtime, followed by collapsing, exhausted, in our little cookie-cutter apartment, to rest up for exactly the same thing the next day.

While I was busy enjoying *Vive Les Girls* and making good money, Roy was still plugging away onstage in the main showroom of the Dunes hotel, one of the twelve male dancers in the show, and talented as he was at it, he was slowly but surely burning out. He'd never lost his passion for photography, so in a way, dancing for a living was not much different to him than if he'd been going off to work in a garage every night.

So I can't say I was really shocked when one night, after yet another big show at the Dunes, Roy was taking off his costume, a beige-colored satin tuxedo with sparkly lapels, a sparkly stripe down the pant legs, and a sparkly beige top hat, when he suddenly stopped, slumped down onto a chair, and announced, "I feel like a dancing bear. I can't do this anymore. I'm done. I'm going back east."

My heart went out to him. There he sat, exhausted, in a costume that would have compromised almost anyone's dignity, a man who'd been working so hard for so long, not because he was in love with dance but because he was determined to eventually save up enough to pursue the full-time photography career he'd been yearning for since before I'd met him. I didn't have any words of encouragement to offer him, or any argument against his being ready to give it up, so I said nothing. I just disappeared into another room with a lot to think about.

Our relationship had been slowly, quietly disintegrating while we were in Nevada. It was such a shame. I remember wishing I could have met him several years later, instead of when I was nineteen and too young to be looking for something permanent, because he really was the perfect guy and would have made such a good husband. But our three-month summer separation while I was in Tahoe and he was in Las Vegas kind of sealed the deal. I missed Roy terribly while we were apart, but I'd also started making my own plans, my own routine, and my own life, so that by the time we were together again, adjusting to having him around almost felt like an intrusion. It made no sense to me—he was still the same dear, remarkable man I'd fallen in love with, and it was so unfair to him, I just couldn't seem to get past it.

So when he told me he was leaving, my first instinct was to help him pack, wave goodbye, and keep on working. Before long, though, I realized that I wasn't enchanted enough with Las Vegas to stay there without him. I'd already worked with the best chore-ographer in the city, and at least back then, the only way to move

up as a dancer in Vegas was to become a lead topless dancer in a sequined G-string, and that wasn't an option as far as I was concerned. Besides, when that gig ended, then what? And no doubt about it, I was getting as homesick for New York as he was.

And so it was that after about a year and a half in Nevada, I sold my red Volkswagen, Roy and I handed in our resignations and glitter-wear and packed our bags, and we drove home together.

As we climbed into Roy's Mustang, I remember saying, regarding my new and only drug of choice, "By the time we get back to New York, I'm going to be off those things." And I consider myself lucky—I was right. The only effect those pep pills had ever had on me was the energy they gave me to get me through a brutal schedule of rehearsals and performances. I never got high from them, or edgy, or unable to sleep, or any of the other "speed" reactions I'd heard about. Our four-day drive from Las Vegas to New York required no energy at all, and I was pleased to discover that when I didn't need extra energy, I didn't need pep pills. I never took another one.

Roy and I amicably ended things when we got back to New York. I'd been only nineteen when I moved in with him, and he was in his early twenties, and I don't think he was any more ready than I was to settle into a permanent relationship. Freedom was still as important to me as ever, not to mention the fact that my parents hadn't exactly made marriage look like a pathway to heaven on earth. So we lovingly wished each other well and went our separate ways.

Roy's "separate way" was that successful full-time career in fine art photography he'd dreamed of for so long. Probably because he

was a dancer who understood movement and musculature and the exact moment to take a shot, he went on to create some of the most exquisite dance photographs I've ever seen, featured in galleries throughout the United States and Europe.

My "separate way" when I was back in New York and on my own took me to a nightclub dancing job at the Latin Quarter in Times Square. It was tacky and awful, and I was relieved to be able to move on to a couple of other jobs and industrial films, until finally, in the summer of 1967, I got my first Broadway show, *Golden Rainbow*, starring the popular husband-and-wife singing team Steve Lawrence and Eydie Gormé.

I hadn't lost my dream of being a show dancer, and I'd been auditioning for Broadway work for months, with the same pattern repeating itself over and over again: First audition, they couldn't get enough of me. Called back for the second audition, same thing. When the time came after the second audition for them to start eliminating dancers, I'd invariably be eliminated, even though I knew I was at least as good as some of the dancers who got hired, if not better. It kept becoming more and more apparent that my American Ballet Theatre experience wasn't an anomaly after all—if I didn't have the right connections, I was likely to lose out to the dancers who did. Right or wrong, it really does turn out to be not what you know but who you know.

I'm nothing if not persistent, so there I was, at the second audition for *Golden Rainbow*'s incredible choreographer Ron Field, braced for the same old elimination process, when Ron scanned the group of contenders and asked, "Is one of you named Carole Bishop?"

Without a clue what was going on, I raised my hand. Ron looked at me, nodded, and simply said, "Oh, okay, that's good."

What? If I hadn't known better, and I didn't, it almost sounded as if someone had talked to Ron about me, he was honoring a favor by paying special attention to a dancer named Carole Bishop, and he was pleased to discover that I was the subject of that favor.

I found out later that a New York choreographer I'd worked for had mentioned me to his ex-wife for some reason, the ex-wife happened to be Ron Field's assistant, and she mentioned me to him. Convoluted, right? All without my knowing a thing about it. But it worked. I ended up being one of the finalists.

There was one only more hurdle standing between me and my first Broadway show: the producers wanted to know if any of us finalists would be willing to dye our hair red or blond. It seems the dancers they'd already hired were all brunettes, and they wanted to sprinkle in a few redheads and blondes.

I had dark hair and dark eyes, and I thought I'd look ridiculous as a blonde. But as a redhead? Sure, why not? That might be interesting.

I volunteered to go red, and I guess that sealed the deal. I was officially a twenty-four-year-old redheaded Broadway show dancer. I was excited. I was on my way.

And against my better judgment, I was also in love.

I'll always think of him as the quintessential New York Jew. He was fabulous—always impeccably dressed, very classy, fun, and funny. He was a highly successful publicity agent with several clients in the

cast of *Golden Rainbow*, and he hung out a lot backstage on that show, which is where I met him. We were immediately attracted to each other, and almost from the beginning we had a good time engaging in some mildly flirtatious chats.

Nothing happened between us until one afternoon after a rehearsal, we casually passed each other when I was on my way to my dressing room. He slipped me a small, gift-wrapped box as he walked by. I opened it the minute I was alone behind my closed dressing room door and discovered that he'd given me a small, pretty piece of jewelry with some wit—and a not particularly subtle invitation behind it. I played the character of Cat-Girl in *Golden Rainbow*, and the gift was a brooch that had the image of a cartoon cat with a green onyx face. The message that came with it was a well-known Hollywood quote that was originally directed at the legendary Cecil B. DeMille but also happened to apply perfectly to "Cat-Girl" Carole Bishop: "Ready when you are, C.B."

I was ready. We went out after the show that night to a table for two in an elegant, wood-paneled lounge at the Plaza Hotel. There was no need to hide—he had a lot of male and female clients in the theater, so there was nothing unusual about seeing him sharing late-night drinks with a woman performer. We spent a couple of hours getting to know each other, and before I knew what hit me, I was crazy about him, and we had an exquisite, romantic affair.

Unfortunately, I didn't get to see him as often as I wanted, because he also happened to be married.

I know. I should have said no before it ever started, and it was wrong all over the place. Frankly, and selfishly, I didn't really care at

first. He was married, I wasn't, and it was easy to look at his marriage as his problem, not mine. I'd never met or even seen his wife, which made it easy to ignore her existence. I just enjoyed and cherished every minute we spent together, and nothing else mattered to me.

Between my innate privacy and the obvious need for discretion in that situation, I didn't discuss him, or our relationship, with the gay pals I danced and hung out with in the *Golden Rainbow* chorus. In fact, I confided in only two people about it, ever.

One was the only female friend I had in the show, a terrific Broadway singer and actress named Marilyn Cooper, who was understudying Eydie Gormé. Coopie, as I called her, was the first person to take me to Joe Allen's, a popular Theater District hangout on West Forty-Sixth Street that had opened just a couple of years earlier, and I was so flattered when, for some reason, she singled me out and took me under her wing. In musical theater in those days, the principals in shows, which certainly included Coopie in *Golden Rainbow*, didn't socialize with the chorus, not out of snobbery but simply because they were two different groups of people. Coopie was about ten years older than I was, definitely more experienced and more sophisticated, and somehow she picked up on the energy between me and the married man at the theater, even though we were careful, we thought, to behave like nothing more than nonchalant backstage acquaintances. Late one night, after a show, over a glass of wine at Joe Allen's, Coopie came right out and asked me if the married man and I were having an affair. I trusted her enough to confess that yes, we were, and to my surprise, she did not disapprove and give me a morality lecture, she was thrilled about it. She

thought it was just wonderful and romantic, and she couldn't blame either of us one bit for acting on "such an obvious mutual attraction." It was a relief to confide that secret in someone I was sure would keep it to herself, and to not be judged for it. As so often happens in the world of show business, Coopie and I went on with our lives and our work when *Golden Rainbow* ended, but we stayed in touch occasionally, and I'll always be grateful to her for being such a good, discreet friend.

The only other person I ever told about the affair was my mother. She came to New York to visit me for a couple of weeks; and while she didn't exactly turn handsprings over the fact that I was involved with a married man, she also met him one night when he came to pick me up at my apartment. She found him as attractive and charming as I did, especially when he presented her with a beautiful bouquet of flowers. We didn't have any long conversations about that relationship, and I got the feeling she just accepted it as kind of a romantic show business thing or something.

Ironically, in a way, it was eventually the fact that I loved him so deeply that ended our affair. Right around the time I left *Golden Rainbow*, the reality finally sank in that if this man's wife loved him nearly as much as I did, I was doing her a huge, incredibly unkind disservice. I had to say goodbye to him, and I did. It was painful for both of us—I think he was genuinely in love with me too, and it broke my heart to hurt him. But I guess no one ever said that doing the right thing would always feel good.

Luckily, I couldn't indulge in curling up under the covers and feeling sorry for myself. I had a new job to focus on, as a chorus

dancer in an extraordinary production of a Broadway show called *Promises, Promises*.

Promises, Promises was star-studded from the top down. Book by Neil Simon. Music by Burt Bacharach, lyrics by Hal David. Jerry Orbach and Jill O'Hara in the two principal roles. Choreography by none other than my future hero, nemesis, friend, and headbutting opponent Michael Bennett.

I was excited and very grateful to be a part of it . . . but it also led me to make a choice I wouldn't recover from for years.

Chapter
Four

His name was Peter Miller. He was a stagehand, an electrician on *Promises, Promises*. He was a couple of years younger than I was. He was cute, sexy, charming, employed, and *single*, and I was rebounding from my doomed love affair with the married man. I'd forgotten how nice it was to have a man in my life I could spend evenings and nights and holidays with, openly talk about with my gay male chorus dancer pals without having to carefully edit his name from conversations, call whenever I wanted—even hang out at his place instead of out-of-the-way five-star hotels.

Looking back, I also realize that I was falling into the same cultural trap that had lured my mom into marrying my dad. In the 1940s, the curse of spinsterhood hit in a woman's early twenties. By the 1960s, that age had extended to thirty at the latest. I was twenty-six when I got involved with Peter. Did I really have the spare time, the energy, or the inclination anymore to dump him and find myself another potential husband?

If I sound as if I'm trying to justify the fact that I married this man, it's because that's exactly what I'm trying to do.

On the flip side of his better qualities, Peter was also a compulsive gambler, a thief, and a pathological liar. You name it, he bet on it, from poker and blackjack to sports and the ponies. It always amazed me that our friendly neighborhood loan sharks didn't beat him up, but he was so charming, and such a good liar, that they let him get away with his empty promises to pay them back. After ten months or so together, we kind of mutually decided to get married. I don't remember anything about the conversation except that there was no formal proposal, and there was certainly no point in bothering to shop for an engagement ring—he would have just pawned it or cashed it back in at the jewelry store.

I knew all that before I married him, so what was I thinking? Well, stop me if you've heard this one, but I guess I thought I could fix him. I forgot to ask if he wanted to be fixed. And why would he? He was engaged to a dancer in a hit Broadway show, a woman who was making good money and had some cool possessions he could steal to help pay off his gambling debts.

As if that wasn't enough to make Peter think he'd hit the jackpot when I agreed to marry him, even his mom liked me. In fact, she glommed on to me and seemed to love showing me off. She took me to matinees with her theater group. She was over the moon one day when I mentioned to her that I wouldn't mind converting to Judaism. (I'm sure that was a lingering attachment to the married man.) She promptly booked an appointment for me with a rabbi in a reform synagogue, whom I think I came to care more about than

I cared about Peter. I still remember our last session, when I opened up about the downsides of the relationship and my reason for staying. The rabbi's exact words were "Well, if anyone can fix him, it's you." That bolstered my resolve all over again. Me, walk away from a challenging unfinished project? I don't think so.

And so, one fateful day in 1970, a group of friends gathered at a reform synagogue on Seventy-Ninth Street on the west side to watch Rabbi "If Anyone Can Fix Him, It's You" unite Peter and me in holy matrimony. I wasn't about to wear white, so I stopped by Saks Fifth Avenue one day and bought a pale green gown that probably looked like a bridesmaid dress I might actually wear again.

Peter's mom was giddy.

My mom wasn't. She'd met Peter when she was on another trip to visit me in New York, and while she was too polite to show it, or even say it out loud to me, I knew her well enough to see very clearly by her relative stiffness around him that she was completely underwhelmed. When I called to tell her I was marrying Peter, she simply asked, "Are you sure you want to do this?" I said, "Yes, I've decided to do it," to which she replied, "Fine." End of conversation. I was actually touched that she took the time and the effort to fly in from out west for the wedding, not to endorse the marriage but to be supportive of me, and she was a perfect lady to me, to Peter, and to his family through the whole thing. Her wedding gift to me was a framed charcoal sketch she'd done of a sailboat, which I still have, and the emphatic, rhetorical reminder before she headed home, "Don't ever worry about giving me grandchildren."

It was exactly as festive as it sounds. We didn't even have an after-wedding dinner. But hollow as it was, I'd officially dodged the "old maid" bullet. Peter and I moved into an apartment on West Ninety-Third Street just off Central Park West a few weeks later, and now I could sharpen my focus on a new career goal that had started taking shape.

In those days, it was routine in Broadway musicals for there to be a few very small singing or speaking parts. Rather than go through the effort and expense of hiring "outsiders" for those parts, it was cheaper and more efficient for the producers to give them to chorus dancers who were already there, already knew the show, and only had to be paid an extra $5.00 a week.

I always seemed to be doing one of those five- or six-line speaking roles when I was chorus dancing, just some little scene playing someone or other doing something or other, and *Promises, Promises* was no exception. It piqued my interest in acting, in maybe breaking out of the chorus someday and playing a character with an actual name and purpose. I thought I might enjoy it and be good at it, and I was also a realist—at a certain age, even though I would always dance for the sheer love of it, it was going to be time to move on and stop trying to compete with twenty-year-olds for dancing jobs, while actors can keep going for as long as their health and their interest hold out.

In an ideal world, I would have been chosen for one of those little singing parts and ended up becoming the star of a Broadway

musical. God knows I tried. I took voice lessons like a good girl, I have a good ear, I became good at vocal technique, and I have a good sense of rhythm. All that was missing, unfortunately, was a good natural singing voice. There was no way around it; it just wasn't lovely to listen to, and it never would be. *So much for being a principal in a major musical,* I thought.

Then, one Sunday night—Broadway's night off—I went to an Actors Fund benefit. The Actors Fund (now the Entertainment Community Fund) is a great charitable organization that supports performers and other workers in the arts-and-entertainment business, and we were all more than happy to contribute to it. That particular night we were being treated to a special performance of a hit show called *Company*, which I'd never seen.

I still remember sitting there in the mezzanine, enjoying the show, when who should make her entrance and come walking downstage to sing Stephen Sondheim's classic "The Ladies Who Lunch" but a force of nature named Elaine Stritch. *Oh. My. God.* It was as if a bolt of lightning went through me. I jerked to attention in my seat and fixated on her like a puppy waiting for a treat. Hers was *not* a good natural singing voice. At all. Not a voice that would ever be mistaken for Barbra Streisand or Barbara Cook. It was on-key but kind of low and gravelly, an acting performance that happened to have a melody attached to it. There she was, this not-a-singer phenomenon, with this huge principal role in a hit Sondheim musical, and she brought down the house.

It was an epiphany for me, the moment when I realized, *I can do that after all!* And thanks to that night, and Elaine Stritch, I started

turning down chorus jobs. It was a hard thing to do, and it took a lot of courage and determination. Peter hadn't started financially decimating me yet, though, so while I wasn't wealthy, I was secure enough that I even said "No, thanks" to the latest edition of the world-renowned *Milliken Breakfast Show.*

I'd still been doing the *Milliken Breakfast Show* every year, and loving it, and it was a real moment of truth when the stage manager called and invited me to come in for an informal audition. I was already a "Milliken girl," so he said, "You won't have to sing or dance, come dressed in your street clothes if you want and just be there."

There was a long pause on my end. Did I really have the courage to go through with this? And if not now, when? I finally took a deep breath and said, firmly but respectfully, "Thank you for calling me, but I'm not doing chorus work anymore."

I heard a quiet gasp, and, "Wow. Okay," followed by a few pleasantries, and we hung up.

The silence was deafening in the wake of that call. I was proud of myself and scared at the same time. Passing up a guaranteed, enjoyable, well-paying job felt like either a brave step toward my future or the dumbest decision in theater history. I wasn't quite sure which until about a week later, when the stage manager called again and asked if I'd like to come in and audition for a principal role.

Needless to say, I told him I'd love to, and for the first time in my life, I auditioned for a singing role, doing my best to channel my inner Elaine Stritch.

I didn't get the part, but it honestly felt like more of a win than a disappointment. I'd had the guts to try, they'd taken me seriously, and it meant the world to me and my confidence.

Then along came a perfectly timed call from one of my earliest career champions, a choreographer named Bob Herget. He'd hired me for a lot of summer jobs, most of them industrial films, and kept me from ever defaulting on my rent. There were times when he believed in me more than I believed in myself. He was always positive and supportive and had never doubted that I had more to offer onstage than chorus dancing.

Hearing from Bob was always a nice surprise, even if he was just checking in to catch up. This call, though, took my breath away. He was directing a production of *West Side Story* for a few little dinner theaters on the East Coast and wondered if I'd like to come in and audition—not for the chorus, but for the role of Anita. The role brilliantly originated by Chita Rivera on Broadway. The role for which Rita Moreno won an Oscar in the original film version. A singing role with lots of backup singers. Exactly what I'd been praying for. Dinner theater or not, that would be a definite "Yes!" and "Thank you, Bob!"

I auditioned.

I got the callback.

Then life intervened.

Peter got a stagehand job, going on tour for two months. Our marriage was hanging by a thread, and I knew if I didn't go with

him, it would be completely over. Peter's gambling addiction was getting progressively worse, and when I'd point out what financial trouble he was getting us in and ask how he could possibly let this happen, his answer was always, "It's not about the money, it's about the action!" He'd also started cheating, and not even hiding it well, which by then didn't even hurt me, it just insulted me. On one particularly memorable occasion, I was staying overnight in the hospital after minor surgery, and I specifically said to him, "Please don't bring anyone here." Imagine my chagrin when I got home the next day to discover that all my belongings, and every trace of my living there, had been thrown into my closet.

But I don't do failure well, so I had to make the effort and go on that tour with Peter, or I'd spend the rest of my life with that "What if?" hanging over my head. I was still stubbornly clinging to the idea that gambling was a compulsion, not the addiction it is, and to my belief that, by treating him with enough kindness and respect and loyalty, I could inspire him to become the man I wanted him to be. Besides, to be brutally honest, our sex life was great. And then there was an underlying sympathy factor: like me, Peter had grown up with an awful father, a chronic philanderer who was as cruel and demeaning as my father was. Blaming his father was easier than blaming him . . . but then again, it wasn't his father I was struggling to live with.

I went in early on the day of the final *West Side Story* audition, found the stage manager, and asked him to please tell Mr. Herget I was sorry but there was no point in my auditioning again. I wouldn't be able to take the part, even if they offered it to me. Thank him so much for calling me back; I just can't do this.

Then, like a dutiful wife, I went on tour with Peter. It was a disaster. What a surprise. I did try, though, if spending two months with someone you don't love or even like anymore without killing them counts as "trying."

As if our marriage weren't already fatally flawed enough, Peter was becoming more and more insistent that I go off my birth control pills so that we could start having children. First of all, yeah, right. Second of all, he'd already been married and divorced by the time I met him, and he had a little girl he rarely saw. I got so tired of arguing about the having-children issue that I admit it, I lied.

Peter and I had a sweet female dog I adored. I'm a big believer in having dogs spayed and neutered. Peter was stubbornly opposed to having her spayed, so I told him I wasn't going to stop taking birth control pills until that happened. He relented, as I knew he would, and our dog was successfully spayed. Then months went by, and Peter couldn't figure out why I still wasn't getting pregnant. He finally demanded an explanation, and I finally told him—"Oh, I never stopped taking my pills."

He didn't take it well, and I didn't care.

Which made going on tour with Peter even more of a disaster than I was expecting, and getting home to New York even more of a relief.

A few days after we got back, I was sitting in our apartment, idly wondering whatever happened with that *West Side Story* company and wishing to God I hadn't given it up for what turned out to be such a worthless reason.

In my hazy, romanticized memory, within an hour, which might really have been the next day or two, I was on my eight thousandth "Gee, I wish . . ." when the phone rang. It was the producer of the *West Side Story* dinner-theater production, calling to say that the woman who was playing Anita had to leave, and would I by any chance consider taking over the role?

I couldn't believe it. Why, yes, as a matter of fact, I would.

"Glad to hear it," he said, sounding as genuinely excited as I was. "Do I negotiate with you, or do you have an agent?"

Funny he should ask. I'd been trying to get an agent, one in particular named Beverly Anderson, who mainly handled singers. Someone in her office was a cheerleader of mine and had been talking me up to Beverly, but she wasn't even interested enough to meet me.

On sheer impulse, though, I told him, "Call Beverly Anderson. She'll be happy to negotiate the contract," and I gave him her phone number and hung up.

In my defense, I didn't lie. I didn't actually say she was my agent, I simply said she'd be happy to negotiate the contract. I was sure that was true—I've never met an agent who'd turn down a commission that falls in their lap like that. Two hours later, sure enough, Beverly Anderson was on the phone, letting me know that she'd negotiated my contract and I was officially hired to play my first principal singing role in a dinner-theater tour of *West Side Story.*

And it was a joy, every minute of it. The actors were good, I was good in it, and with the original score, book, and choreography, and Bob Herget directing, we couldn't miss.

That man was such a hero to me.

If only I could have turned him loose on my personal life.

By then, my marriage was on full-blown life support. Peter had pretty much cleaned me out, emotionally and financially. My one remaining asset was the beautiful apartment we were living in, in a sixteen-story building on Eighty-Third Street and West End Avenue, mortgage-free—since I hate owing money, I'd been able to afford to buy it outright for $13,000 when the building went from rentals to a co-op. God, I loved that place, especially its huge terrace with a view to the south and east that included the Empire State Building, until the Gulf and Western Building went up and got in the way. Peter had brought home a German shepherd puppy I named Venus, from a litter another stagehand's German shepherd had given birth to. Venus became my constant companion and travel buddy, and she and my two rescued cats, my long-haired gray Caesar and my black-and-white short-haired Duke, were every bit as happy living there as I was.

Peter was in serious debt, so I borrowed against that dream-come-true penthouse through my union, Actors' Equity, to pay off one of his many loans. He was working fairly regularly, and our deal was that he would make the loan payments and I would cover all the other bills.

It was while I was on the *West Side Story* dinner-theater circuit, with Venus in tow and a neighbor taking care of Caesar and Duke, that Actors' Equity called to say that the loan was in default and they were foreclosing on my penthouse.

Finally. That long-overdue last straw. I was done. And I learned a lesson I'm sure I should have learned from my mother many years earlier: Anyone who's married to an addict who shows no interest in doing anything about it needs to be prepared for the probability that sooner or later, the only hope of surviving intact is to get out. I felt like a failure in my mission to "fix" him, but I knew staying was not an option.

The divorce was as big a mess as the marriage. It shouldn't have been. I was willing to pay half the divorce cost. I didn't want alimony. I didn't want anything other than out of there. But somehow it took two years, including a trip to the Dominican Republic, to end a five-year marriage.

And then, thank you, God, in the middle of all that darkness, shortly after the *West Side Story* tour wrapped, my old friend Tony Stevens called to invite me to the workshop that would someday become *A Chorus Line*.

Chapter
Five

I wasn't locked into the role of Sheila in *A Chorus Line* quite yet. I still had one more major challenge to overcome: I had to do a singing audition for the show's brilliant composer, Marvin Hamlisch.

I would have preferred a root canal, not because of him but, obviously, because of my voice. Yes, I'd had a principal singing role in a successful tour, with lots of backup singers helping me sound pretty damned good. But this was Marvin Hamlisch. *The* Marvin Hamlisch. Who'd been accepted into the Juilliard School Pre-College Division shortly before he turned seven years old. Who'd started his incredible music career as the rehearsal pianist for Barbra Streisand in *Funny Girl* and written a song for Liza Minnelli's debut album when he was a teenager. Who'd written the score for *A Chorus Line* and had every right to want no one but the best of the best to perform it. With all the incredibly talented singers in New York to choose from, how could I possibly convince him it should be me? There was no getting around it, though, so I trekked downtown to meet him and get it over with.

I passed a couple of other Sheila contenders outside, reviewing the sheet music they brought with them, as I walked into a little black box theater where Marvin and Michael Bennett were waiting for me, along with a pianist. The three of us engaged in less than thirty seconds of small talk before I cut to the chase and laid out my reservations about this audition.

"I don't want to waste your time, Marvin," I announced, "but as much as I want this role—and I want it *very much*—I don't even have a song prepared."

God bless Michael. He jumped right in and told Marvin about my just having played Anita on the *West Side Story* dinner-theater circuit. Then he turned to me and said, "Don't worry about not having a song prepared, why not just sing a few bars of Anita's song 'America'?"

"America" was hardly written to be an a cappella solo, but Marvin was fine with it, so, surprised and a little self-conscious, I took a deep breath, and gave it all I had.

I like to be in America
Okay by me in America

That's about as far as I got before Marvin held up his hand and stopped me.

"Okay, I've heard enough," he said, and my heart sank.

"That's fine. We're good," Michael added.

I think I said, "Thank you." I'm not sure. I just remember leaving the room in a state of devastated shock and getting to the door leading into the lobby, where Michael came up behind me.

"Don't tell anyone," he whispered, "but you've got the job."

I was so relieved and so ecstatic that I couldn't even be bothered to watch my mouth. "Oh, good, I get to play myself!" I blurted out. Michael apparently expected nothing less—he just smiled, shook his head, and disappeared back into the audition room.

And with that, I officially became a member of the cast of *A Chorus Line*, the role and the show that changed my life.

Very early on in rehearsals, to put the whole singing thing behind me once and for all, I stopped thinking of the show as a musical and started embracing it as a play that happened to be set to music, a fantastic opportunity not to sing but to act, to *perform* the gorgeously personal "At the Ballet."

In fact, because the book for *A Chorus Line* was more a transcript of those preliminary tape sessions than it was a fictional script, I also started picturing each of us onstage holding up mirrors, aimed not at ourselves but at the audience. The people in those theater seats could see themselves in us, and the fact that we happened to perform for a living was beside the point. The private issues we'd opened up about in those sessions were so honest, and so relatable, that they closed the gap between the stage and the audience and brought us all together as human beings. Even during rehearsals, when those seats were empty, I could feel the power of what we were doing, more power than I'd felt from any other show I'd ever worked on.

That relatability might have been part of why, all things considered, Michael Bennett and I played nicely together, most of the

time. He even fell into the habit of calling me to debrief every night, like actual friends, when we'd collapsed in our respective apartments after another long day of work.

I only remember one incident when I couldn't stop myself from taking him on.

Our costume designer was a lovely, gifted Greek woman named Theoni Aldredge, who'd been creating Broadway theater wardrobes for more than fifteen years. We all loved and respected her and felt lucky to be working with her. Michael came up with the interesting idea of having her sit with him in the rehearsal hall to discuss what each of us actors/dancers wore to rehearse, and then Theoni would design our costumes based on our own personal styles. There was certainly enough variety among us to give Michael and Theoni plenty of inspiration—every possible combination of T-shirts, sweats, yoga pants, sneakers, you name it. I always dressed like a showgirl at rehearsals, in leotards and tights, which inadvertently created the problem.

For as long as I could remember, it had been my routine to come home from a day of classes or rehearsals, handwash the leotard and tights I'd worn, wring them out with a towel, and hang them over the shower rod so they'd be clean and ready for the next day. But when we were in the full swing of rehearsals for *A Chorus Line*, I'd be so exhausted when I got home that I'd just throw the damned things in a bag to be dealt with some other time. Day by day I was depleting my leotard wardrobe until I finally got down to one I'd bought years earlier and hadn't worn in ages, because I hated it. For one thing, it was flesh-colored, the exact color of my skin. For

another thing, like most dancers at the time, I'd cut it up a bit as I did with all my other leotards, lowering the neckline and the back a little, and making the leg line a little higher. Unfortunately, I'd cut this one farther than I meant to, almost but not quite cleavage-low. It was the only clean leotard I had left one morning, though, and I had no choice but to put it on, with a promise to myself that if I still hated it as much as I had the last time I'd worn it, I'd throw it in the trash where it belonged the minute I got home.

That leotard was in the trash that night before my head hit the pillow.

Wouldn't you know, a couple of weeks later, Michael called me in for a meeting with him and Theoni to discuss my costume. They seemed excited and very pleased with themselves, and Michael broke the news as if he couldn't wait to see the look on my face.

"Okay," he announced, "you know your kind of low-cut, flesh-colored leotard?"

"Uh-huh," I mumbled hesitantly.

"That's what I want Sheila to wear."

The glare he got back from me was definitely not what he was expecting. I climbed right up on my high horse and blasted him.

"Well, first of all, Michael, *no*. Second of all, I hate that thing so much that I tossed it down the garbage chute. Why on earth would you want me to wear that old rag?" As I took a breath, a thought suddenly hit me, and I added, in my most withering, mocking tone, "Because it's so blatantly sexy?"

"Sure, that's part of it—"

I cut him off. "And what's the other part of it? Because I'm onstage a lot next to Donna McKechnie, and she's wearing red, and a flesh-colored leotard will make me pretty much disappear when I'm beside her?"

He remained remarkably calm and replied with strained patience. "No, because when you go into 'At the Ballet' and drop your hands the way you do, and the lighting changes, that leotard makes you look like a naked, vulnerable little girl."

Oh.

I thought about it for a few seconds before I sheepishly climbed down off my high horse. "Okay," was all I said, but it was a stroke of genius on his part, and Theoni's, something I would never have come up with in a million years. They were right; I was wrong.

And that's how Sheila's costume was born.

Broadway had been in an almost unprecedented slump for years in the early 1970s, but word was spreading that a show called *A Chorus Line* was getting ready to premiere at the Public Theater, an arts organization in Lower Manhattan that showcased new productions. This was obviously decades before cell phones and the Internet came along and made it possible to publicize anything and everything to millions of people in less than a second.

But we didn't need any high-tech help to fill every seat in the Public Theater on April 15, 1975. The inevitable New York City grapevine that can make or break a show before it even opens came through for us that night beyond our wildest dreams, fol-

lowed by *New York Times* critic Clive Barnes, who kicked off an avalanche of thrilling reviews with such comments as "the conservative word for *A Chorus Line* is tremendous, or perhaps terrific" and "the reception was so shattering that it is surprising if by the time you read this, the New York Shakespeare Festival has got a Newman Theater still standing in its Public Theater complex on Lafayette Street."

One night after a performance, about three weeks after we'd opened, we were all summoned to the big common room backstage at the Public Theater, where Michael Bennett made the announcement: *A Chorus Line* was moving to the Shubert Theatre on Broadway!

We took a two-week break while the crew transported the show from Lafayette Street to West Forty-Fourth Street. Then, to the surprise of no one after that amazing launch, *A Chorus Line* sold out for opening night at Broadway's Shubert Theatre on July 25, 1975. What did surprise us was the unbelievable news that we weren't just sold out for opening night—we were sold out for months in advance. We instantly became one of New York City's most popular tourist attractions, and we were credited with being "the show that saved Broadway."

Night after night, our packed audiences were scattered with celebrities who hopped out of limos that lined up for blocks in front of the theater. Most of those celebrities came backstage after performances, and there they'd be, major stars, from the stage to television to the silver screen, waiting to congratulate us and thank us for a wonderful evening.

I've never been particularly starstruck, but I have to say, there was one celebrity encounter that truly blew me away. There we all were, milling around among our famous fans one night after the show, when I looked through the crowd and spotted her just a few feet away—none other than my heroine, Elaine Stritch. I was shy about approaching her, but I couldn't pass up the opportunity to thank her for the difference she'd made in my career, and my life, for that matter.

I stepped up and introduced myself, and the words almost came spilling out of me in one breath. "I'm not a singer, Ms. Stritch, and I'd all but given up on becoming a principal in a musical, until I saw you in *Company*. You were such an inspiration, and I'm so grateful. I watched you bring down the house with your performance of 'The Ladies Who Lunch,' and I finally realized, *I can do this!*"

"Well, you're doing it" was all she said, and she smiled and walked away.

I stood there for a minute, unable to move, taking it all in—I'd just met one of my idols when she came backstage after my performance in the biggest, most successful show on Broadway. I would have pinched myself, but I was too afraid I'd wake up.

Without a doubt, though, the audience member who made me more nervous than any of the countless celebrities we entertained was my mother, who flew in from her home in Northern California to see me in the show. Her life had done a complete turnaround, and I was so happy for her. She had a good job working as a secretary at a bank, and she'd met and married a terrific guy who absolutely adored her. And now, in large part because of her, her daughter had

a principal role in a massively successful Broadway show. I knew she'd love it, and I knew she'd be proud of me. What made me nervous was her hearing the intensely personal "At the Ballet," which contained a line I almost couldn't bear to have her hear.

Mother always said I'd be very attractive
When I grew up, when I grew up . . .
"Diff'rent," she said, "with a special something
"And a very, very personal flair."
And though I was eight or nine,
Though I was eight or nine,
I hated her.

That verse of the song was performed by Nancy Lane as Bebe, so I was distanced from it a little. But Mom knew all about the soul-baring tape sessions that had inspired the show, and I knew she'd recognize our long-ago "ironing talk" when it was quoted almost word for word onstage. If it entered her mind for one second that I'd ever hated her, or even just said I did, I'd be devastated, and so would she, unless I prepared her for it. So before she was led to her seat in the audience, I warned her that she was going to hear some things in "At the Ballet" that were very theatricalized, and I made her promise not to take it literally, because I adored her. Always had, always would.

She promised, and she kept her word. As I've said before, one of the many qualities I cherished in Mom was her honesty. I knew I could count on it that if that line in the song hurt her one bit, she'd tell me immediately, and we could talk it out.

Instead, I'd never seen her more ecstatic than she was after the show that night. She was the closest she'd ever come to being speechless—she managed to stammer a couple of words like "wonderful" and "thrilling," but she couldn't even seem to put a complete sentence together. There was such joy, and pride, and love in her eyes when she looked at me that I felt as if I'd just given her the most beautiful thank-you gift a child could possibly give her mother. It was one of those rare freeze-frame moments I'll never forget.

During Mom's trip to New York, I got to introduce her, my lifelong best friend, to Priscilla Lopez, who'd become, and still is, my best friend from *A Chorus Line*. Priscilla played Diana Morales in the show, the streetwise, Latina, starry-eyed dancer who gorgeously, unforgettably sang, among other songs, the iconic "What I Did for Love."

Kiss today goodbye,
The sweetness and the sorrow . . .

Priscilla and I were so close that when Michael Bennett initially gave us our dressing room assignments at the Shubert Theatre, instead of having us be roommates, he placed us next door to each other, with a stupid wall between us. Close, but not close enough, as far as we were concerned. So we put our heads together and did a little plotting, and it worked. Priscilla convinced our dear producer Jerry Schoenfeld to knock down that wall, et voilà,

we ended up sharing a nice, large dressing room on the first floor above the stage.

In the early spring of 1976, nominations for the Tony Awards were starting to arrive, and one day after a matinee, Priscilla found her Tony nomination for Best Performance by a Featured Actress in a Musical waiting in her mailbox. Her reaction spoke volumes about the kind of person she is—rather than screaming with joy when she read the announcement, she casually asked me if I'd gotten anything interesting in *my* mailbox. Nope. Nothing. Which made her almost apologetic when she told me why she was asking. I stopped just short of scolding her for worrying about my feelings instead of being as thrilled for herself as she deserved to be, and by the way, I was thrilled for her too, so let's celebrate, for God's sake!

I'd been taking Venus to the theater with me since we'd started rehearsals on *A Chorus Line*, to the point where she'd essentially become our backstage mascot, so she and I went home to the apartment that afternoon to feed the cats and clean their litter box, and then headed back to the theater for the evening performance. And there, in my mailbox, was my Tony nomination. Best Performance by a Featured Actress in a Musical.

"Disbelief" is not too strong a word. I honestly hadn't given more than a passing thought to whether I'd be nominated, probably trying to protect myself from being disappointed. But holding that nomination announcement was another one of those moments I wasn't about to risk by pinching myself and waking up.

Priscilla and I were and are very much alike in a lot of ways. One of the ways we were very different, though, was that I was always,

always early to the theater, while Priscilla could be counted on to come flying in with only seconds to spare. So there I was at the mirror in our dressing room, halfway through putting on my makeup, when Priscilla raced through the door and started getting dressed and ready to go onstage, in too big a hurry to say much more than hi. I didn't say much either, for a minute or two, but then . . .

"Oh, Priscilla, by the way?"

"Yes?"

"I got a nomination."

She shrieked, "OhmyGod, ohmyGod, ohmyGod!!!" and we hugged and giggled and jumped around in a circle like a couple of giddy little schoolgirls on a playground.

It didn't occur to either one of us, nor did we care, that since we were both nominated in the same category, we were competing against each other for a Tony Award. A few petty people, particularly a couple of understudies who shall remain nameless, kept their eyes on us, eagerly anticipating the drama of our friendship disintegrating into jealous, catty backstage sniping, but no such luck. We were each other's biggest fans, and no one was prouder of her than I was. Being nominated felt like enough of a win to me, and I had too many other things on my mind at the time to obsess over who'd be going home with a trophy a month or so later.

For one thing, in addition to our usual rehearsals and performances of *A Chorus Line*, we were also spending long hours rehearsing for the Tony ceremony, where we were opening and closing the telecast with our own show's opening and closing numbers, "I Hope I Get It" and the seminal "One." Exhausting as it was, it was also

exciting to prepare for Broadway's biggest night, which was being held at our home, the Shubert Theatre.

For another thing, I'd just kicked off my latest harebrained relationship. I'll call him Kevin, because it bears no resemblance to his real name.

And for yet another thing, I was in the complicated process of changing my name.

Chapter Six

My jobs in show business at that point had led me to memberships in a variety of unions, from American Guild of Variety Artists (AGVA) to Equity to American Federation of Television and Radio Artists (AFTRA). The one union I still had my heart set on joining was the Screen Actors Guild (SAG), which would allow me to start doing on-camera television and film work.

Becoming a member of SAG wasn't all that easy. You couldn't just walk into a SAG office with your checkbook and say, "Sign me up." I don't know what the requirements are now, but back then, you had to work two jobs for SAG-signatory companies before becoming eligible for membership on the third one, and I wanted in.

In my case, those first two jobs were commercials. They were a good learning experience—I figured out very quickly that they weren't my thing. I'd scan the waiting room at commercial auditions and find myself surrounded by a crowd of wholesome-looking "moms," while I looked more like the tough, sexy tootsie their husbands were probably cheating with. There was also the problem of doing "cold

readings," i.e., reading lines out loud that you were seeing for the first time at auditions. For one thing, thanks to my dyslexia, I didn't excel at those. For another thing, when I did make it through the lines, I had trouble sounding enthusiastic about a new and improved laundry detergent or the very latest advancement in mouthwash. I finally had to admit to myself that, as I used to say, "This face don't sell soap."

Which probably explains why the only two commercials I ever booked had nothing to do with my face or my line readings. The first one I did was for a carpet company. Or, to be more accurate, my legs did that one. They shot my legs in heels from the knee down, dancing and moving around on whatever carpet they were selling, but the rest of me never appeared on camera. The second one was a deodorant commercial that involved a line of dancers, backlit so you couldn't tell who we were until the camera moved slightly and you could *kind of* make us out. Presumably the message was that if this deodorant was effective enough for professional dancers, it would be effective enough for you. Sure, whatever. Two on-camera jobs down, one to go.

That third job, the one that finally qualified me for membership in the Screen Actors Guild, was a film called *Step Out of Your Mind.* I confess, I had to go online to look that up. It was never released, and frankly, I have absolutely no memory of doing it, or even what it was about. But whatever *Step Out of Your Mind* was, it got the job done and ushered me into SAG, so in the end, the details of how I got there were beside the point.

Now all I had to do was send in my application for a Screen Actors Guild card, just the usual information, with one minor

exception—in addition to "name," it also asked for an "alternate name." Without giving it a thought, because what difference could it possibly make, I shrugged, wrote in my married name, and mailed it in.

Imagine my confusion, and chagrin, when my SAG card arrived, bearing the name "Carole Bishop Miller." All things considered, not just no, but *hell* no. I immediate called the SAG office to demand a replacement card that simply read "Carole Bishop." The answer? No. That's when I learned that the Screen Actors Guild already had a member named Carole Bishop (with or without an "e," they never told me), and to avoid all sorts of confusion when it came to credits, residuals, health benefits, et cetera, they couldn't have two members with the same name. I could still be Carole Bishop onstage, but for any TV and film work that might come along, I had to become someone else.

There was a hardcover publication at the time called the *Players' Guide*, essentially a phone book of union actors with their current credits, contact information, headshots, and any updates we wanted to add every year. I wasn't expecting a stampede of TV or film producers to come pounding on my door any time soon, so I let myself be listed as "Carole Bishop Miller" in the *Players' Guide* and went on with my stage career. . . .

Until we started *A Chorus Line* rehearsals, and it became apparent that it could lead to all sorts of work, including on-camera SAG jobs. Suddenly, getting rid of that "Miller" appendage felt imperative. Since "Carole Bishop" had already been ruled out as an option, I had to come up with something else.

The solution came thanks to a kind of running backstage joke among me and some of my castmates when I danced in a production of the musical *On the Town* at the Imperial Theatre on Broadway in 1971. A lot of us, just for fun, adopted alter egos with made-up names. Mine was "Kelly Westbrook," a spoiled rich girl. I started being called "Kelly" more often than I was called "Carole," and it seemed to fit me like a glove. It eventually spilled over to the cast of *A Chorus Line* and became so popular that even Michael Bennett started calling me "Kelly." Finally it occurred to me—why not make life really easy for myself, for the Screen Actors Guild, and for everyone else across the board, and just go with "Kelly Bishop" once and for all?

I talked to Michael Bennett about it. He was on board, but by then the Tony Awards were coming up, and he suggested I wait until after the ceremony to make it official. That's exactly what I intended to do, until I realized that the deadline for annual updates to the *Players' Guide* was right around the corner. Did I really want to be Carole Bishop Miller for another year?

Then the Tony committee got wind of it and asked me about it during a rehearsal for the awards telecast.

"When we announce you as a nominee, do you want to be Carole or Kelly?"

Oh, what the hell, if I was going to change my name, why not do it on national TV?

"I'd prefer Kelly, please," I said, and it felt good, like one more step forward, and one more step away from that dedicated, hard-working chorus girl who sometimes had trouble making it past the second audition.

* * *

Finally, along came April 18, 1976. The night of the Tony Awards, Broadway's answer to the Oscars. A thrilling, gorgeous night, as a sea of gowns and tuxedos basked in the electrified air of the Shubert Theatre.

There's nothing quite like performing live for an audience of your peers. Our opening number, "I Hope I Get It," was even more energy-charged than usual, and the applause was deafening. Then all of us onstage raced to our dressing rooms to change into our formal wear for the ceremony and take our seats in the audience. My very fashionable castmate Michel Stuart, who went on to become a costume designer, had taken me to get a flowy, periwinkle blue dress by designer Giorgio di Sant' Angelo that artfully resembled a leotard and wrap skirt, accessorized with a long scarf, and it made me feel—yes, I'll say it—pretty.

I was so excited for Priscilla. It was common knowledge, according to weeks of backstage rumors and speculation, that she was guaranteed to walk away with the Tony Award that night. Her character, Diana Morales, was sweet, lovable, vulnerable, and very popular, and she had two showstopping songs. A few cast members would tell me, "You should win that Tony, but Priscilla's got it," and I'd just reply, with absolutely no resentment, "Yeah, I know." Priscilla's Tony Award was such a given backstage that Michael called a few nights before the awards to make sure I'd be okay with it, and to unnecessarily remind me to react as pleasantly as possible when Priscilla's name was called, because the losing

nominees' reactions would be captured via split screen on national television.

I could tell she was nervous that night, but she was hiding it gracefully. She was seated on the aisle like most anticipated winners, and I was a couple of rows behind her, next to my boyfriend, my plus-one for the evening, Kevin.

It seemed as if hours went by before Jerry Lewis came striding onstage to present the award for Best Performance by a Featured Actress in a Musical. I planted a big, genuine smile on my face for the losing nominees' televised split-screen moment so the world could see how happy I was for my best friend, and how undisappointed I was when her name was called instead of mine.

Jerry Lewis stepped up to the mic at the podium, holding the envelope that contained the winner's name, and read the list of nominees from the teleprompter:

"And the nominees are," he began, "Kelly Bishop, for *A Chorus Line* . . ." (For a split second I imagined viewers in the theater and watching on TV who knew it was *Carole* Bishop, not *Kelly*, in that show and must have thought he got my name wrong.)

"Priscilla Lopez, for *A Chorus Line*," he continued. "Patti LuPone, for *The Robber Bridegroom*, and Virginia Seidel, for *Very Good Eddie*. And the winner is . . ."

Then came that moment we've all seen a million times, when the nominees sit there leaping out of their skin, wondering how it can possibly take anyone that long to open an envelope, followed by . . .

"Kelly Bishop! *A Chorus Line!*"

I know it really happened, because I've seen footage of it. I kept that same frozen smile on my face, gave a slight nod, got a quick kiss from Kevin, and made my way to the stage, stopping to kiss Priscilla as I passed her. It was such a surreal out-of-body experience that I was wondering if maybe I'd just heard some insane mispronunciation of "Priscilla Lopez."

I never did know what this was about, but the nominees in our category had been told that Jerry Lewis would be presenting our award, and under no circumstances were we to touch him. He did *not* want to be touched. I was in such total shock that I was on that stage, and about *why* I was on that stage, that I'm not sure how I remembered not to hug him. He simply gave me my Tony statuette, I thanked him, he surprised me by extending his hand, I shook it, and he was gone, leaving me alone at the mic thinking, *Now what?*

For obvious reasons, I hadn't prepared a single thing to say, so I looked around for a second. There I was, holding a Tony, at the Shubert, the theater that held so many memories for me, from *Golden Rainbow* to *Promises, Promises* to previous Tony Awards where I'd worked in the chorus, and of course to *A Chorus Line*.

Then I stepped up to the microphone and said what came naturally: "Welcome to my theater." I acknowledged that I was accepting the award on behalf of everyone involved in the show, "but I'll keep it at my house," and I walked away, still in total, grateful disbelief.

Priscilla was a champion when we met in our dressing room to get ready for the closing number. I'm sure it was a difficult loss for her after all that buildup, but she never revealed a hint of disappointment. I'm also sure she was genuinely happy for me, since she's

one of the most gracious, generous people I've ever met. She was literally beaming with pride when she hugged me and said, "You *floated* across that stage!" She was right, I did—I wasn't conscious of my feet ever even touching the floor when I walked toward the podium.

We all went back onstage and finished the ceremony with "One," to a standing ovation, and thus ended a glorious night for me, and for *A Chorus Line*—twelve nominations and nine wins, including Donna McKechnie, Michael Bennett, Marvin Hamlisch, and Ed Kleban. Sammy Williams, who played the Nicholas Dante character Paul, won the Tony for Best Featured Actor in a Musical, and James Kirkwood Jr. and Nicholas Dante won the Tony for Best Book of a Musical.

Michael Bennett, James Kirkwood Jr., Marvin Hamlisch, Ed Kleban, and Nicholas Dante went on to win the 1976 Pulitzer Prize in Drama for *A Chorus Line*, making Nicholas Dante the first Latino in history to win a Pulitzer. And in 1980, Priscilla won a well-deserved Tony Award for her performance in Tommy Tune's Broadway musical comedy revue, *A Day in Hollywood/A Night in the Ukraine*, and we've occasionally celebrated our "matching Tonys" ever since.

As an added bit of trivia, I haven't looked this up to see whether it's true, but I think I may be the only Tony winner who was nominated by one name and won by another name. Until someone proves me wrong, I'll keep that on my personal "dubious achievement" list.

* * *

There's nothing quite like an avalanche of awards to create a whole new flood of press and ticket sales, so I was shocked to hear Michael's announcement shortly after that night that he was going to tour the original cast of *A Chorus Line*, first in San Francisco and then in Los Angeles.

On one hand, I could see how it made sense to him. A West Coast tour would sell out before the cast and crew could even start packing, and Michael had been yearning for a while to break into the movie business as a director.

On the other hand, I personally wasn't having it. I couldn't stop thinking of all those people in New York who'd been holding tickets for months, only to arrive at the Shubert and find themselves watching a second cast, because the original cast they'd heard and read so much about, and paid to see, was entertaining audiences thousands of miles away. As far as I was concerned, it wasn't right, and of course that's exactly what I told Michael when it was my turn to meet with him in his office about the tour.

His spiel about the infinite show business doors this West Coast tour could throw open for all of us, and himself, of course, went nowhere with me, nor did the money offer.

"Michael, most of my castmates haven't been on the road as recently as I have," I pointed out. "It's a lot more expensive than it used to be, and thanks to my ex-husband, I've learned that being destitute is not a good look for me. I have rent to pay. I have bills to pay. I have pets to take care of, and I'm determined to put two hundred dollars a week into a savings account."

He chimed right in with, "I'll put two hundred dollars a week into a savings account for you, Kelly."

I shook my head. "You know me better than that. If I don't earn it, I don't want it."

Seeing that he wasn't getting anywhere with that approach, he tried coming at me from a different angle, leaning forward and looking into my eyes with a subtle smirk. He mentioned the name of the actress he was considering to take over my role if I passed on this tour and said, "If I were you, I wouldn't let her play Sheila in LA."

His subtext, based on some of our previous conversations, was that everyone in the cast of a hit show as huge as *A Chorus Line*, once they were seen by Los Angeles producers, directors, and casting and talent agents, would be "discovered" and go on to become television and movie stars. So by forfeiting the opportunity to play Sheila in LA, I'd be handing over all those future TV and movie roles to the actress who'd be playing Sheila instead of me.

It was a typical thinly veiled Michael Bennett attempt at manipulation, and I wasn't about to engage, let alone change my mind about touring with the show. So I simply met his eyes and replied, "You shouldn't."

That was it.

After we'd silently stared at each other for several seconds, he ended the meeting with a terse "I think we're done here."

I came back with an equally terse "Yes, we are," walked out the door, and stayed with the show on Broadway.

Four of us from the original cast passed on the tour and stayed in New York—me as Sheila, Clive Clerk as Larry, Wayne Cilento

as Mike, and my great pal Thommie Walsh as Bobby. No second thoughts, no regrets, and we kept right on playing to sold-out houses. The only thing I didn't like about it was that "Tony-winner Kelly Bishop" kind of became the star of the show, which was never my intention, or the intention of *A Chorus Line*.

Several months later, it was time to renew my contract. I asked for a raise and a two-week out, i.e., an agreement that I could leave the show, provided I gave two weeks' notice. Michael and I were still in our not-speaking-to-each-other phase that had started that day in his office, so he responded through our stage manager that I could have the two-week out, but no on the raise.

Well, right is right, and fair is fair. There wasn't a doubt in my mind that I'd more than earned a raise. I was every bit as sure that Michael's only reason for refusing to give it to me was to punish me, and I wasn't about to settle for less than I knew I deserved.

I kept working until my contract was up and my replacement was ready to go.

And then, after about a year and a half with *A Chorus Line*, I walked away.

I can still reach back and access the waves of emotions I was feeling in the wake of that decision. There was sadness, of course—no second thoughts about the choice I'd made, just sadness over saying goodbye to a show, and the extraordinary people involved, that had transformed my life in so many ways.

But there was also the exhilaration of being free again.

I kept picturing a massive oak door at the end of a dark hallway, a door that opened not toward me but away from me. There was

this almost blinding glare of sunshine-yellow light beyond it, and as I crossed the threshold and stepped into that brilliant light, I was transformed from chorus dancer Carole Bishop to actor Kelly Bishop, with endless possibilities ahead of me.

There's a line from the song "New York, New York" that goes:

If I can make it there,
I'll make it anywhere.

I'd apparently made it "there."

And with an acting career as my new target, "anywhere" sounded like Hollywood.

Chapter
Seven

For the most part, Hollywood doesn't seem to care very much about what's happening on Broadway, but it does pay attention to Tony Award winners with the word "actor" or "actress" in the category. So thanks to my Tony for Best Performance by a Featured Actress in a Musical, and help from my New York agent Beverly Anderson's connections, I was quickly signed by a successful LA agency, introduced to all the agents in the firm, and trotted around to the studios for meet-and-greets with producers and casting directors. Believe me, I was well aware of how lucky I was—I knew from friends in the business that a lot of perfectly talented "newcomers" in Hollywood spend years just trying to get an agent, who may or may not lift a finger to do anything for them, and they end up waiting tables or driving cabs to keep their rent paid every month.

Thanks to that same luck, it took me almost no time at all to book my first TV acting job, an episode of *Hawaii Five-0*. The episode was called "Oldest Profession," and I was cast as the former owner of a brothel who'd moved on to running a massage parlor.

Hookers in Honolulu were being extorted by a sleazy thug named Caldwell, played by the terrific character actor Ned Beatty, but one of my former employees, Cory (Elaine Joyce), was refusing to pay. I don't remember a single scene in the episode, but I do remember my first TV credit in the on-screen guest-star list, which read, "Introducing Kelly Bishop as Charlene."

I also remember waking up early that first morning in Hawaii, looking out the window of my room in a lovely high-rise hotel, gaping at the breathtaking view of Diamond Head, and thinking, *I'm getting paid for this?!* The weather was exquisite, the air was clear and fresh, there were orchids everywhere, and in the few short days I was there, I was introduced to and fell in love with papayas. Everyone on the *Hawaii Five-0* set was polite and professional, and I was too proud to let anyone know that I had no idea what I was doing. I just learned my lines as written, did what I was told, and got through my scenes in one or two takes. The whole thing seemed fairly impersonal, but to be fair, *Hawaii Five-0* was cranking out twenty-two one-hour episodes per season, eight days per episode, so if "impersonal" was what to expect on TV guest-star gigs, okay, good to know.

It so happened that *A Chorus Line* was on the Los Angeles leg of its tour when I got back from Hawaii, and I couldn't resist going to see it. I sat in the orchestra pit and wept through the whole thing. It was beautiful. The actress playing Sheila did a great job, and I was happy for her, the audience, and my former castmates. At the same time, I also felt an overwhelming pang of separation anxiety. It hit me all over again that night how much I missed the exhilaration, and the brilliance, and the familiarity of it. I socialized a little with

the cast afterward, and it was wonderful to reunite with all of them, except Michael Bennett, who was still emphatically not speaking to me, which worked out perfectly, since I wasn't speaking to him either. I went to my hotel room that night idly thinking how much fun it would be to play Sheila again. Not for one minute did I regret my decision to pass on the tour and to ultimately leave the Broadway show. But a chance to slip into that flesh-colored leotard and join my old friends onstage, not forever, just for a week or two? I'd jump at that in a heartbeat.

I was back in New York when the phone rang.

This was the first time I started picking up on an intriguing pattern in my life—thinking, "Gee, I wish . . . ," and then receiving a transformative phone call at exactly the right moment.

Here, now, was the stage manager, calling to tell me that the actress playing Sheila in LA had to leave the show briefly for a minor surgery, and would I consider temporarily filling in for her, just for a couple of weeks?

Unbelievable. Somehow someone must have been reading my mind the night I saw the show. Oh, and by the way, yes! And thank you!

I had the best time. Reuniting onstage with my dear pals and castmates was like rejoining my old buddies on a championship team for a few games we knew we couldn't lose. When the time came to step aside again, I wasn't sad anymore. It was as if I'd been given one last group hug I hadn't even known I needed.

Besides, I didn't have time to be sad. I had another plane to catch, home to New York to shoot my first movie.

It was called *An Unmarried Woman*, directed by Paul Mazursky, the story of Erica, played by Jill Clayburgh, whose successful businessman husband informs her that he's leaving her for his younger mistress. I was hired for the minor role of Elaine, one of Erica's friends.

It was also the story of Kelly Bishop getting her first on-the-job training in being a film actress, and I had a lot to learn. No complaints—I actually found the whole process really interesting, just a new set of challenges my years in the theater definitely hadn't prepared me for.

The biggest, most obvious one was discovering that every scene, even though I wasn't in that many of them, had to be shot over and over and over again, to accommodate a variety of camera angles. Repeating the same scenes several times in a row was, of course, not a skill that came up during live theater performances, and the trickiest part for me was making sure that I had the same energy on take number 10 that I'd had on take number 1. It wasn't always easy to stay freshly engaged and keep saying the same lines without ending up sounding like a parrot, but it was either that or run the risk of coming off like the world's most boring actor and/or being cut from the scene altogether.

But I was pleasantly surprised to discover that another aspect of being shot repeatedly from a variety of angles—the "matching" aspect—came naturally to me. If I were starting to eat a salad in the first take, for example, I didn't need to be told not to be sitting there with a half-empty salad plate a couple of takes later in the same scene. I've worked with a few actors over the years who don't

appreciate this matching thing and prefer to do something a little different from one take to the next, thinking they're being innovative, which must be a nightmare for the poor editors. I'm a dancer at heart, though, and dancers know about discipline. Matching was a filmmaking discipline I especially enjoyed practicing.

I also discovered while making that movie that I was able to cry real tears on cue. That was a nice surprise. Out of my enormous respect for writers, I've always been very literal when it comes to scripts, so when I read that my character, Elaine, cried, I took it as something I had to do. I'd never taken an acting class (and still haven't) and didn't have a clue if there was a specific technique to make that happen. So when the time came in that scene for me/ Elaine to cry, I just made my mind go to the saddest place I could possibly think of (probably something to do with animals), and what do you know, the tears that don't come naturally to me in real life started flowing down my/Elaine's cheeks exactly when they were supposed to.

My job on *An Unmarried Woman* lasted only a few days, but it was enough to intrigue the hell out of me about my potential future. I liked acting. A lot. I liked developing a character, even a relatively minor one. I liked camera work. I was thirty-four years old and aging out of being a sought-after dancer, and it was so encouraging to feel that, sure enough, just as I'd hoped, thanks to TV and film, my career as a performer might not be slipping away after all.

I was already looking forward to my next chance to do it again.

But for reasons I couldn't begin to understand, my phone wasn't ringing. I'd check in with my agent from time to time, only to be

told that there was "nothing out there for you right now, Kelly," so I couldn't even blame it on bad auditions. There weren't any.

Every actor goes through dry spells, but this one went on for so long that I went back to the stage and kept myself busy doing various regional theater productions. In the meantime, a woman I liked at the agency decided to change agencies and asked me to come with her. I did, thank God.

Not only did I start working again, but I found out about a year later, almost by accident, that my previous agent had been turning down auditions and job offers on my behalf without bothering to mention them to me. I happened to be working a little out-of-town job, chatting with the producer, when he mentioned a film he'd done several months earlier, in the middle of my seemingly endless dry spell.

"I wanted you for the role of [whoever it was], but when I called your agent, he said you weren't available."

I was furious. I wasted a lot of time and mental energy wondering how many other potential employers had been told I was "unavailable" while I sat at home by my silent phone, praying my TV and movie career wasn't over with forever. I've since learned that "they're not available" thing isn't as rare a "show biz tradition" as it should be. Let's face it, agents are paid by commissions, and those who represent some big stars, as mine did, are likely to pour the majority of their energy into them. Ten percent of their "smaller" clients' paychecks hardly seem to be worth reading breakdowns (lists of available parts in upcoming projects), submitting actors, negotiating contracts, and dealing with the requisite paperwork. I

actually heard an agent at a table next to mine say to his lunch companion one day, "I'm doing too well to have to work that hard anymore." So it can become a quick, easy "no, thanks," whether or not that "smaller" client happens to need groceries and rent money. I was livid when I found out what had been behind that dry spell I'd thought might never end; but at least that agency was no longer in charge of my career, and my new agent turned out to be ethical, responsible, and a hard worker who never accepted or passed on a project I might be right for without discussing it with me first.

Looking back, I guess there was a certain symmetry to the fact that I'd wasted almost as much time at the wrong agency as I'd wasted on yet another relationship that seemed like a good idea at the moment. They were both out of my life by then, but those were some damned painful, expensive lessons.

Yes, I'm talking about Kevin. Another ex-boyfriend on my dubious roster, and my date at the Tony Awards. I'd be tempted not to mention him at all, but let's face it, some experiences in life leave wounds that heal, and some leave scars that never quite go away.

I first became aware of Kevin when I was still married to Peter. He was one of the guys who hung out at some of the same places we did, especially the Broadway Show League softball games in Central Park and a popular bar on Lexington Avenue called Bachelors Three, owned by singer Bobby Van and NFL stars Joe Namath and Ray Abbruzzese.

I paid very little attention to Kevin back then, but it was impossible not to notice that one of his most enthusiastic hobbies was latching on to celebrities, as if basking in their spotlights made him

a celebrity too. He usually had a successful actress or singer on his arm, he knew who every star and every up-and-coming actor was in any given room, and he made a point of becoming their charming, solicitous new best friend.

He also loved maintaining a mystique about what he did for a living. He had a carry permit, which wasn't easy to get in New York City in those days, and he'd walk into a club, unbutton his jacket, and lean back against the bar so that everyone could see the butt of his gun under his arm. We all used to idly speculate that he was either a cop or a gangster, but he was always evasive about it when anyone asked.

Then Peter and I got divorced, work and life went on, and Kevin faded from my memory until he showed up backstage at *A Chorus Line* with a beautiful blond celebrity singer/actress I'll call "Linda." It was no surprise to see him with a rising star, schmoozing backstage at the hottest show on Broadway. Of course that's where he'd be. He tracked me down in that crowd like a heat-seeking missile; he and his date and I had a brief, typical post-performance chat, then went our separate ways again, and that was that. Until about a month later, when he called out of nowhere and asked me to dinner.

"Wait, what about Linda?"

"Oh, we broke up."

I'd never given a moment's thought to dating him. He was about eight years older than I was, neither attractive nor unattractive, and I still didn't have the slightest idea what he did for a living. On the other hand, he was single and unattached, I was single and unattached, so sure, why not?

It was kind of fun for a while, very busy, very social, not to mention that unforgettable night at the Tony Awards. I even got to the bottom of his professional-life mystery—not because he told me but because, while this is not my usual style, I looked in his wallet one night after he fell asleep. His ID confirmed that he wasn't a cop, but he was kind of cop-adjacent and definitely not with the Mob. Good to know. One possible red flag eliminated.

But another red flag cropped up shortly after that, when he announced that he was changing careers. "I'm going to be an actor," he said, and I groaned. Loudly. I'd always avoided getting romantically involved with actors. Granted, there were and are some acting couples who make it work. It just always struck me as way too much potential ego drama and competition to me, and I wanted no part of it. On the other hand, there was a huge difference between "going to be an actor" and "becoming an actor." Kevin had no discernible talent that I knew of, and he didn't have an agent. Maybe he was counting on the successful actors he glommed on to to throw him some bones in their movies. Whatever. I saw no point in overreacting to what might amount to nothing but a pipe dream, so I let it go.

The biggest red flag that became harder and harder for me to overlook was the fact that when he and I were alone together, he bored me. He never wanted to have a conversation about anything intellectual, or philosophical, or spiritual. The weather, and what we were going to do over the weekend—that was pretty much it. I'm not good at hiding it when I'm bored, and at around the two-year mark, there was very little left between us.

It probably would have been easy for me to just end it and move on if it hadn't been for a discovery that crushed me:

I was pregnant.

The shock hit me so hard I went numb for a few minutes. The first thing I remember saying, after breaking the news to Kevin, was "Oh God, now I'm going to have to have an abortion."

It was a nonnegotiable statement of fact. I wasn't going to have this child, or any other child, ever. Even if I'd been slightly on the fence about that, he was not the man I would have chosen to be the child's father, nor was this a healthy relationship in which a child could have thrived. Besides, a child would have kept Kevin and me connected to each other for the rest of our lives, and the thought of that was out of the question. Or, "for the sake of the child," I could have married a man I didn't want to be married to, but been there, done that.

I never asked him what he thought, or how he felt about it, and that was very insensitive of me. He didn't try to talk me out of getting an abortion, though, so I let myself assume that he was relieved not to be blindsided by the possibility of fatherhood and child support looming over his future.

I was painfully aware that I'd never been faced with a more important decision in my life. I tried making a list of pros and cons about carrying the child to term, and I can honestly say I couldn't come up with a single pro. I felt, as I still do, that no one knows better than the woman who's pregnant whether she's suitable to be a committed, nurturing, engaged mother, and I have nothing but admiration for women who give birth knowing that they'll be giv-

ing the child up for adoption to someone who'll take better care of it than they're capable of. I couldn't begin to imagine that.

I'd never felt any religious or spiritual guilt about abortions, and I never did understand the justification behind legislating them. I was very grateful that abortions were legal when my need for one came along in 1978, but to be perfectly honest, I'm sure I would have found an illegal way to terminate this pregnancy if it had come to that, since as far as I was concerned, it was my only responsible option.

In the end, I felt only two things about proceeding with the abortion: profound sadness, and an enormous amount of anger at myself—sadness because I'd be ending a potential life, and anger because I let this happen in the first place. My body, my responsibility. Being angry at Kevin never entered my mind. I'd finally gotten off birth control pills after years of taking them, and from then on I embraced a strict policy of "no condom, no sex." But one night Kevin was out of condoms, and I'm the genius who did the math and decided it would be okay, just this once. Famous last words, and incredibly stupid ones.

I was already booked to be in LA for some auditions (that went nowhere), and the timing was right to have the abortion there. I went to a Planned Parenthood health facility and was very impressed with how seriously and responsibly they handled it. Instead of handing me a paper gown and telling me to lie down in an examining room for the procedure, they had me sit down for a two-hour interview with an intelligent, sensitive young woman to discuss my decision—how I felt about it and why, how I thought

I would feel about it later, just every possible repercussion that might come up. Then, at their insistence, I had to wait forty-eight hours before I could come back and have the abortion if that was still what I chose to do.

It was, of course. Medically, it was simple. Emotionally, it took its toll, but I've never regretted it or doubted that I did the right thing.

Thankfully, I was handed an unexpected opportunity to decompress and regroup before I flew home—I was offered a job in Chicago to replace Elizabeth Ashley in a production of the three-woman play *Vanities* at the Westside Theatre. It was while I was in Chicago that I got a call from Kevin I'll always wish I'd handled differently.

His lease was up, he said, and he wanted to know whether he should renew it. Translation: "How about if I give up my apartment and move in with you?"

I knew our relationship was nearing the finish line. It had been a long time since either of us had been happy, and I'd come to feel that it was never really me Kevin loved in the first place, it was the Tony winner from *A Chorus Line*, the fuss people in New York tended to make over me because of it, and the social life that prestige brought with it. And the distance that had already been growing between us had only widened from the stress of the abortion.

I should have said, "Renew your lease." Instead, I took the coward's way out and told him not to, and when I got home, he moved into my apartment with me. Immediately after losing the penthouse, I'd moved into an affordable but awful, roach-infested, one-room apartment on West Fifty-Fifth Street. But by the time

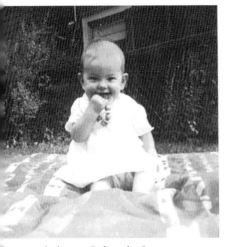

Me as a baby in Colorado Springs, Colorado, 1944

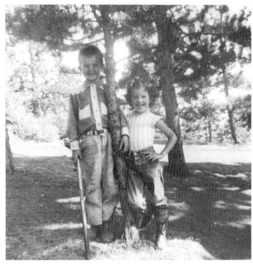

Rocky Mountains with my brother Tony, 1949 or 1950

The Mexican Hat Dance, 1954. We performed this at senior centers, country clubs, et cetera. Always the tallest, I'm dressed as the boy.

My senior picture, 1962

Performance at Ballet Theatre School, Denver, Colorado, age thirteen, 1957

Corps de ballet in a dressing room at Radio City Music Hall

My wedding to Peter
Miller, 1970

Love this picture

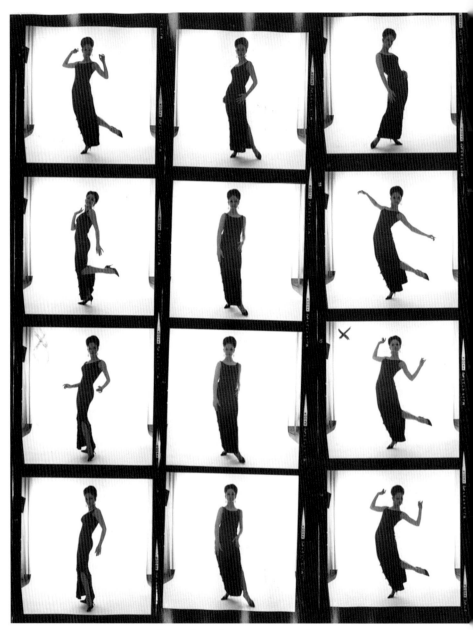

One of my favorite contact sheets

In Los Angeles with
Archie and Mayou

In Los Angeles
with Venus

In South Orange, New
Jersey, with Annie

Mame with Christine
Ebersole at Paper Mill
Playhouse, Millburn,
New Jersey, 1999

Pal Joey tour,
1983

With Joel Grey on
the *Pal Joey* tour,
1983

Pal Joey summer tour. Ron Perlman, me, Randy Graff, and another actor from the show.

Vive Les Girls at Nevada Lodge, Lake Tahoe, 1965

Vive Les Girls at Nevada Lodge, Lake Tahoe

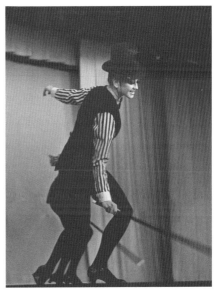

Me; Venus; Thommie Walsh; and Priscilla with her Yorkie, Chelsea, and her German shepherd, Gretel, on my front stoop, West Seventy-Sixth Street, New York City

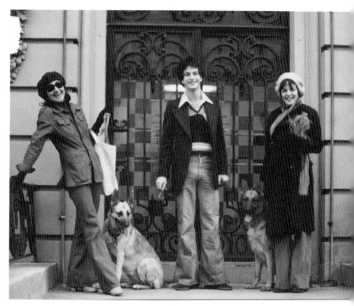

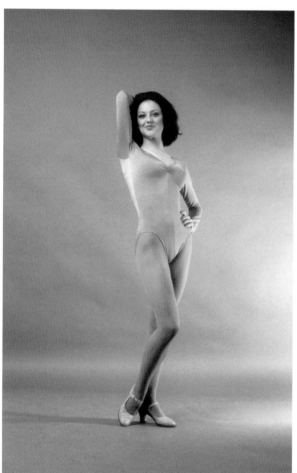

A Chorus Line, 1975

A Chorus Line

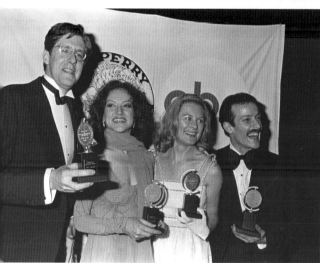

Ed Herrmann, me, Shirley Knight, and Sammy Williams on the night of the Tony Awards, 1976

With Jerry Orbach in *Dirty Dancing*, 1986

NEW YORK SHAKESPEARE FESTIVAL

Joseph Papp Producer

Invitation from Joseph Papp
to the final performance of *A
Chorus Line*, 1990

JOSEPH PAPP

CORDIALLY INVITES YOU TO
THE FINAL PERFORMANCE OF

A CHORUS LINE

SATURDAY, MARCH 31
AT 8:00 PM

AT THE SHUBERT THEATRE
225 WEST 44 STREET

YOU ARE ALSO INVITED TO THE CLOSING NIGHT PARTY
FOLLOWING THE PERFORMANCE

RSVP: (212) 598-7120
BY TUESDAY, MARCH 27

THE PUBLIC THEATER
425 LAFAYETTE STREET, NEW YORK
NEW YORK 10003 • (212) 598-7100

HIT SHOW CLUB™
DISCOUNT COUPON
FREE MEMBERSHIP: (212) 581-4211

EXCHANGE THIS COUPON at Box Office for 1
or 2 reserved seats at least one hour before
performance or mail to Theatre giving alternate
date with payment and stamped self-addressed
envelope
Make checks payable & mail to
VIVIAN BEAUMONT THEATRE
B'way & 64th St , New York, NY 10023

Not Good 1st 10 Rows Orchestra
or 1st 2 Rows Mezzanine

TUESDAY thru FRIDAY EVES at 8 PM
WED & SAT MATS at 2 PM
SUNDAY MATS at 3 PM

Reg. Price		YOU PAY
$45.00	ORCH	$30.00
37.50	LOGE	25.00

This coupon will be honored only if shown at
box office BEFORE ordering seats No Refunds
or Exchanges

BUY TICKETS IN ADVANCE
SUBJECT TO PRIOR SALE

The end of the

LINE

Celebration
April 28, 1990

Above the Line (Grand Staircase)
Cocktails and Buffet Dinner

On the Line (Main Level)
Cocktails and Buffet Dinner

Below the Line (Rear Staircase)
Cocktails, Seating and Dancing
(follow signs)

A CHORUS LINE

An invitation to a party honoring the closing of
A Chorus Line, 1990

A discount coupon for
tickets to *Six Degrees of
Separation*, featuring me,
Courtney B. Vance, and
John Cunningham

John Cunningham, Courtney B. Vance, and me in *Six Degrees of Separation* at Lincoln Center, 1990

Perfectly Frank, Los Angeles, 1980

With Sarah Jessica Parker and Priscilla Lopez at the opening of *A Chorus Line* at the Gerald Schoenfeld Theatre, New York City, 2006

With Priscilla Lopez at the opening night of the off-Broadway musical *Little Miss Sunshine* at Second Stage Theater, New York City, 2013

With Lee on our wedding day, April 14, 1981

Me and Lee

Lee in our kitchen in New York City

My mother, Jane; Lee holding Mom's dog, Tina; me with blond hair; and the wonderful Venus

With Lauren Graham, Ed Herrmann, Alexis Bledel, and David Sutcliffe in season one of *Gilmore Girls*, 2001

Having fun in season four of *Gilmore Girls*, 2004

With the cast of *Gilmore Girls*, season three, 2002

Cake cutting on set at Warner Bros. Studios for the one hundredth episode of *Gilmore Girls*, 2005

With Ed Herrmann in a scene from the one hundredth episode of *Gilmore Girls*, season 5, episode 13, "Wedding Bell Blues"

Me and Sutton Foster in *Bunheads*, 2012

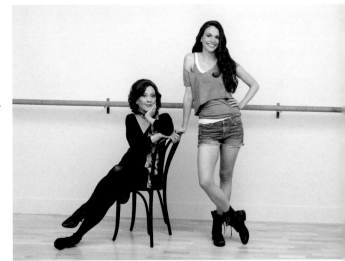

At Richard's gravesite with Lorelai (Lauren Graham) and Rory (Alexis Bledel) in *Gilmore Girls: A Year in the Life*, 2016

Kevin asked to move in, thanks to *A Chorus Line*, I was in a garden apartment I loved, a bright, sunny place with French doors and a walk-in closet. It was on Seventy-Sixth Street between Columbus Avenue and Central Park West, a beautiful neighborhood of brownstones and townhomes, less than a block from Central Park. It was a stretch for me to afford at $400 a month, but I was determined to make it work because it was worth it.

Maybe I was content enough in that apartment to trick myself into thinking that letting Kevin come to live with me wouldn't make that big a difference. It did, of course. It was exactly as strained and awkward as any fool could have predicted. I'd essentially thrown open my door, invited him in, and then resented him for being there. I'd completely lost interest in him, and I'm sure he was well aware of it. I owed it to him, and to myself, to tell him I didn't love him anymore, if I ever really did, and end it as cleanly, honestly, and painlessly as possible. But because I couldn't summon up the courage to do it, we went on living together for another year like two former lovers going through the motions, pretending not to have noticed that the party had ended a long time ago, even before the word "pregnancy" showed up uninvited.

As always, God bless work, especially when it comes along just when your head and heart need it. In this case, it was an off-Broadway show called *Piano Bar*, a musical that was all singing, all the time. I double-checked before I accepted the offer to make sure they'd heard me sing. They had, and they wanted me anyway. So I was out of the apartment and away from Kevin for hours and hours at a time, rehearsing and performing and blissfully distracted.

I made a new lifelong friend in the process, the show's choreographer Nora Peterson.

And, probably predictably, I had an affair.

He was a theatrical director, and we met while I was doing *Piano Bar*. I'll call him Philip. (Yes, another pseudonym. Sorry. I'm not trying to be mysterious, I just have no interest in embarrassing people who don't deserve it.)

What attracted me to Philip from the moment I met him was that he was a genius, one of the smartest people I've ever met, and I loved how he stimulated me. He was also bisexual. That was apparently common knowledge, but I never saw any evidence of it, and it honestly didn't bother me. I followed my typical pattern and rushed right in anyway. This wasn't about finding a man who'd sweep me off my feet and ride me off into the sunset on his white horse. It was about finding a man I looked forward to spending time with, and probably about just spending time with a man who wasn't Kevin.

It didn't take long for Kevin to find out about the affair, and not because I had the integrity to step up and tell him. He actually caught Philip and me together, not in bed, but simply walking down the street, and he could sense that something was going on. Uncomfortable as it was, there was no angry confrontation, but it compelled me to finally do the right thing. That it took my falling for someone else to compel me to break up with Kevin once and for all will always be on my list of times when I really disappointed myself.

As inevitable as the breakup was, Kevin kind of lost his mind. He moved out, obviously. I never did know where he went, but I

had to have my locks changed when he kept coming in and out of my apartment whenever he felt like it. He even started stalking me when I refused to keep seeing him "just as friends." People would drop me off at my place after we'd been out for an evening and see him hiding behind a tree across the street, and it happened so often that I finally confronted him.

"You've been stalking me, so let me make this clear," I told him. "If I end up dead, you're the first person the cops are going to call."

He was furious and yelled back, "I would never do that to my parents!"

I replied, "Good. Don't."

And that was the last conversation Kevin and I ever had.

I never saw him again, but he did go on to piece together a minor acting career, playing bit parts in movies starring those big-name actors he'd worked so hard to latch on to. He finally got what he wanted, and so did I—him in my rearview mirror, and a tubal ligation to make sure I never, ever got pregnant again.

As for Philip, that turned out to be the temporary, low-drama, low-impact affair it was destined to be from the beginning. We kept seeing each other for a while, he moved to San Francisco, I flew out to spend a week with him there, and then he kind of wandered off and I stopped hearing from him.

It was okay, barely a bump in the road, and I had work and plenty of other things to attend to, including an upcoming talk show interview. You'd think that as strongly as I believe in the importance of instincts, I would have seen it coming that that interview a year later would kick off a whole new chapter of my life.

Chapter Eight

The talk show was called *Midday Live*, one of the first televised talk shows in New York with a live audience. It featured everyone from celebrities to authors to chefs to athletes, and the premise for the interview I'd been invited to do involved pairing a current actor in a long-running Broadway hit with the actor who originated the role—in this case, the current Sheila in *A Chorus Line* and me.

It sounded perfectly pleasant. The one aspect of it that made me just a tiny bit uncomfortable was that *Midday Live* was hosted by a classy, erudite man named Lee Leonard. In one of life's small-world quirks, it so happened that before Kevin moved in with me, he'd lived in the same high-rise apartment building as Lee Leonard on the Upper East Side, and we'd run into each other from time to time over the years. I'd actually met him once, in a coffee shop called the Green Kitchen, where all the local bachelors used to hang out. Kevin and I were sitting there having breakfast when Lee bounded in. He'd just come from his publisher's office, and he was carrying a hardcover copy of his new novel, *I Miss You When You're Here*. He

was excited about it, and he made a beeline for us to show it off. The three of us chatted away for a minute or two before Lee took off for the kitchen to share his first published book with his pals on the cook staff. As soon as he was out of earshot, Kevin turned to me, dropped the smile he'd been wearing like a cheap mask, and said, "I hate that guy."

I didn't bother to ask why. For one thing, I'd lost interest in what Kevin thought about pretty much anything. For another thing, it would have been a rhetorical question. Lee Leonard was a tall, handsome, popular, successful television celebrity, none of which ever seemed to go to his head. In other words, everything Kevin thought *he* should be but wasn't. And now, on top of everything else, Lee Leonard was a published novelist, which seemed to annoy him even more.

So I admit it, it made me cringe a little to go striding onto the set of *Midday Live* and shake hands with a man who'd naturally think of me as "Kevin's girlfriend." I knew better than to hope he'd block that out of his mind, but I also knew that *Midday Live* wasn't a cheesy gossip show, and there was no reason Kevin's name would even come up. My fellow "Sheila" and I were there to talk about *A Chorus Line*, nothing more, nothing less.

One of Lee's many gifts as an interviewer was that he brought out the best in his guests and let them be the stars of the segment. He made me feel brilliant, respected, and honored to be there, and the longer the interview went on, the more secure I was that we wouldn't be getting into anything personal . . . until the commercial breaks came along, and he caught me completely off guard:

Break #1

LEE: Are you still seeing Kevin?

ME: No, we broke up.

Break #2

LEE: So you're not seeing him anymore?

ME: I haven't been with him for over a year.

Between the interview and the commercial breaks, I was having such a good time that I was disappointed when our time was up and he moved along to his next guests.

And I definitely wasn't expecting the call I got from him a couple of days later, asking if I'd seen the show. I hadn't. He told me it came out really well and I would have been very happy with it. Then he abruptly changed the subject.

"Would you like to have dinner?"

I hesitated for a beat. Why? Because Lee Leonard had a reputation for being a bit of a ladies' man. But, hey, if he could overlook the whole "Kevin's girlfriend" thing . . . That hesitation was immediately followed by, *Oh, for God's sake, it's been a while, get yourself back out there and keep yourself on the market.* Besides, it was just dinner, and a girl's gotta eat.

It was one of the loveliest evenings I'd had in a long, long time. Lee was a bright, funny, knowledgeable conversationalist. He could talk articulately on almost any subject without pontificating or trying to impress me, and in sharp contrast to what I'd grown accustomed to, he was genuinely interested in what

I had to say. Like my mom, if you asked him a question, you'd better be prepared to hear an honest answer, even if it wasn't the answer you were hoping to hear. He was every bit as honest about himself—no games, no posturing, an open book. Before we'd finished our entrées, he told me about a couple of women in his past he'd cared deeply about, but those relationships had ended pretty abruptly.

Uh-oh. "Why was that?" I managed to sound casually curious, but I was thinking, *Here we go*, and bracing for a response that included something like "compulsive gambler," or "had this bad habit of cleaning out their bank accounts, or "too busy pursuing an acting career," or God knows what.

Instead, he scored more points with me than he could possibly have anticipated.

"My first wife and I had a daughter together," he said. "Don't get me wrong, I love my daughter with all my heart, and I always will. But I'm sorry to say, having a child made me realize that I'm not cut out to be a family man. So when these women told me they wanted children someday, I had to make it clear that if that's what they were hoping for, and if that was important to them, they were definitely getting involved with the wrong guy. And . . . well . . . the end."

Now, there was a conversation I'd never had on a first date before. I didn't go into detail, I just told him that I could definitely relate, because I felt exactly the same way he did about having children. I'm not sure if I literally moved my chair a couple of inches closer to his, but it felt like it.

And for the first time in my life, probably because I sensed he was worth it, I broke my timeworn pattern of leaping into a relationship with eyes closed, feet first, consequences be damned. Instead, I let things progress slowly, easily, and naturally. My therapist and I had had many sessions about my apparent inability to sustain a relationship for more than three years or so. It eventually became clear to me that when longevity isn't one of your priorities when you first get involved, you don't look for things like compatibility, stability, substance, financial responsibility, mutual respect, and admiration from your potential partner, and you're more likely to look for, as the Garth Brooks song goes, "Mr. Right for Mr. Right Now."

Then along came Lee Leonard. He challenged me. He respected me. There was real depth to him. He was thoughtful and attentive. He was honest, and fun, and wicked smart, and hardworking, and solid as a rock. I still remember a moment when he was doing some utterly ordinary thing, maybe just walking across the living room, and I looked at him and the thought washed over me out of nowhere: *This man will never bore me.*

That was the moment when I gave myself permission to break my tired, self-protective, dead-end habit of falling in lust with Mr. Right Now and genuinely fell in love for the first time in my life.

For the next nine months that we dated, it kept getting better and better. Then, one night in 1981 we were at dinner with friends when I mentioned that I was considering an opportunity to join the cast of *A Chorus Line* in Russia. Lee pointed out that due to all sorts of passport and visa regulations, he obviously wouldn't be able to

come with me if I went to Russia. I countered by blurting out, "You could, if we were married."

Yes, it was a hint, and no, he didn't get it. I insinuated the marriage thing a couple more times, but he still wasn't catching on.

The next morning, though, he called and said, "I was thinking about our conversation last night. Do you want to get married?"

I answered with an immediate, resounding, yes.

Not exactly the kind of proposal they write songs about, but it was all I wanted, and our wedding kind of carried out that same theme.

It would be Lee's third marriage and, of course, my second, and we all know how my first one turned out. I couldn't have cared less about spending time, energy, and money making a big fuss over the wedding. In fact, it felt so superfluous that I encouraged my mom not to bother flying out from the West Coast for it, and I was relieved when she agreed to stay home and spare herself and her husband the cost of what would have been a very brief, expensive, last-minute trip. My best friend, Priscilla, was working out of town, so I recruited my *Piano Bar* friend, choreographer Nora Peterson, to be my matron of honor, and Lee's best friend happily stepped up to be his best man. I wore a champagne-colored silk dress with short flowing sleeves and a sash with a pair of copper-colored ankle-strapped pumps; Nora brought me a lovely bouquet of day lilies, we gathered a small group of hand-picked guests, and off we went to the venue Lee suggested, the courthouse in the Bronx, to be married by a justice of the peace.

Unfortunately, thanks to a lack of due diligence on our part, we arrived to discover that the Bronx courthouse was closed for reno-

vations. Instead, a series of signs directed us to a little side build-ing that amounted to a crummy, thrown-together shed they'd put up to conduct courthouse business. But we weren't there for the glamour, hoping to make the cover of *Vogue*, so we soldiered on. We breezed through a lame excuse for a lobby, passed a few young hippie-looking couples waiting for their wedding appointments who stared at us as if we were a clump of ridiculously overdressed fogeys, and within what seemed like minutes, we "made it legal." Then, to carry out the lack-of-glamour theme, it was off to lunch at the Green Kitchen, where I'd first technically "met" Lee when he was celebrating his published book, and Kevin had so memorably announced, "I hate that guy."

Lee and I didn't just become husband and wife that day. We also became partners, lovers, companions, and best buddies who were always supportive of each other, even when work forced us to be apart for a while.

And then, before we knew it, we were busy packing and mak-ing arrangements for our animals—not for our honeymoon; not for Russia, since that production of *A Chorus Line* turned out to be just another one of those show business rumors with no basis in fact—but for a huge step forward in Lee's career.

In 1979, a little over a year before I met him, Lee had been hired to coanchor *SportsCenter*, the inaugural news-and-highlights show on a fledgling cable TV network called ESPN. ESPN, he was told, was going to be exclusively dedicated to entertainment and sports,

two worlds that Lee loved, and loved covering. It sounded like a perfect fit.

But within about six months, ESPN lost interest in show business and evolved into an all-sports-all-the-time venue, and Lee was lured away to another brand-new cable TV network, CNN, to host the entertainment news show *People Tonight*, based in Los Angeles.

So, not long after we got married, we were off across the country to LA, where Lee was an immediate success. He interviewed such up-and-coming stars as Pee-wee Herman, Tom Hanks, and Tom Cruise, all of whom made their national talk show debuts on *People Tonight*. He covered the breaking-news deaths of Natalie Wood and John Lennon, and he was in his element, a world-class conversationalist who had the rare gift of letting his guests be the center of attention and feel so comfortable that they were free to talk about whatever they wanted.

I quickly found work too, and enjoyed every minute of it. I got to go back onstage in *Perfectly Frank*, a revue of the music of the brilliant Frank Loesser, who wrote the score for such Broadway classics as *Guys and Dolls* and *How to Succeed in Business Without Really Trying*. I waded back into some on-camera work, including a TV movie called *Advice to the Lovelorn* with Cloris Leachman and guest spots on the Robert Wagner series *Hart to Hart* and Garry Marshall's *The New Odd Couple*.

We were so happy, and getting as comfortable in Los Angeles as a couple of New Yorkers can. We even took a lovely drive up the coast to meet Mom and her husband, Nathan. Mom and Lee immediately and permanently adored each other, as I knew they

would, and between that and the sheer joy of seeing her finally get to bask in the adoration of the man she married, it was a glorious little side trip.

And then, with no warning and no real explanation, CNN fired Lee and replaced him with Mike Douglas, whose long-running syndicated talk show had recently been canceled. It was a shock, and it made no sense. Lee had always regretted leaving ESPN so quickly, but he'd never regretted it more than he did when CNN suddenly yanked the rug out from under him. It broke my heart to watch my positive, confident, upbeat husband sink into the first and only depression I'd ever seen him go through. At that point I wasn't working, and now neither was he, so we packed up and moved back to the Seventy-Sixth Street apartment I'd kept in New York.

It was a dark time. I got a summer stock job doing the Rodgers and Hart musical *Pal Joey* with Ron Perlman, Alexis Smith, and Joel Grey, who was still enormously popular thanks to his performance as the master of ceremonies in the film *Cabaret* with Liza Minnelli. It took me away from Lee for almost two months as the tour traveled from Dallas to Atlanta to St. Louis to Akron, but it paid well enough that I was able to live on my per diem and send my paychecks home to keep our bills current. Lee found occasional off-air work, and when I got back from the road I said yes to pretty much any jobs that came my way—even some work on soap operas.

I was reluctant to accept a guest spot on a soap opera when one was first offered to me. There was a certain amount of snootiness

among theater people when it came to soaps. I'd heard it a million times—"Theater is art; soaps are commerce." But Lee and I needed money, and if commerce was offering a paycheck, who the hell was I to be a snob, especially when the soaps were being filmed right there in New York? For added incentive, I remembered a word of caution Michael Bennett had given me once: "Don't do a soap, it will ruin your acting." What better way to thumb my nose at Michael yet again than by doing a soap opera and *not* letting it ruin my acting?

I hadn't seen a soap opera since I was a kid growing up in Denver without enough of an attention span to understand the stories, let alone get caught up in them. Acting in a soap was kind of a shock to the system—one episode per day, five days a week, with a lot of dialogue to memorize and almost no time to prepare. Between the actors, the crew, and the writers, those are hardworking people, that's for sure. Not that I was on any of the soaps long enough to get to know anybody, but I came away with an enormous amount of respect for all of them.

Another challenge was the fact that, since I didn't know the shows, I had no idea what the storylines were, whom I was talking to in any given scene, or what we were talking about. On rare occasions, scenes were self-explanatory. I remember one in particular on *One Life to Live* in which I was running an illegal adoption ring. I had scenes with a young character named Tina and apparently suspected her of trying to seduce my husband, or business partner, or something. I got in her face and assured her that she did *not* want to mess with me. Context or no context, I could easily handle that,

and have a good time doing it. Several years later, on that same show, I played a completely different role, a doctor, for a day or two; and it was so interesting to me that it was perfectly acceptable to everyone involved, including the audience, that not one character, even in passing, came up to me and said, "Excuse me, but didn't you used to run an illegal adoption ring?" But, hey, if it worked for them, who was I to criticize?

I ended up doing brief appearances on four soaps—*Ryan's Hope*, *As the World Turns*, *One Life to Live*, and *All My Children*. And I confess, I couldn't have passed a simple quiz on a single one of them about the show, my character, or her point in being there.

In the end, what I did come away with from doing soap operas is that I appreciated getting those jobs when I needed them, especially since they were local jobs, and that, to the best of my knowledge, doing them didn't ruin my acting one bit. Come to think of it, I played Christian Slater's alcoholic mother on a couple of episodes of *Ryan's Hope*, and he managed to eke out an acting career in spite of it, so thanks very much for the great advice, Michael Bennett.

And then, two years later, just when we were convinced that show business couldn't get any wackier, Lee got a generous job offer to co-host a weekly entertainment news program called *Showbiz Today*. The offer came from, of all places, CNN. Yes, they came crawling back. And as if we weren't ecstatic enough over that news, they added that we didn't even have to relocate to LA again, we could stay home in New York.

With that one phone call to Lee, the momentum suddenly shifted from negative back to positive for both of us. We were still

celebrating CNN coming to its senses when I was offered the role of Tutor Nover in a movie called *Solarbabies*.

I was mystified by *Solarbabies*. It was a futuristic science fiction film, not especially my genre, about a parched earth, run by the military, that might be saved by an orb discovered in a cave by a group of dissident teenage orphans on roller skates. I was their tutor. It doesn't really have "me" written all over it, does it? So why did I take the job?

Actually, there were two reasons.

One of them was the director, Alan Johnson. Before becoming a director, he was a spectacular choreographer and performer in, among many other credits, the original *West Side Story* on Broadway. I liked and respected him very much, and it always made me happy to see dancers spread their wings and thrive in other professions. Alan had also worked with Mel Brooks many times over the years. Mel Brooks was executive-producing the movie even though it wasn't a comedy, and Mel Brooks was . . . well, *Mel Brooks*.

The other reason was completely self-serving—*Solarbabies* was being shot in Spain, and I'd never been to Europe before. Any lack of enthusiasm I was feeling toward the script and my role in it was more than made up for by my excitement about spending a few days exploring Madrid. Oh, and of course, working.

Madrid was gorgeous. I was transfixed by the hours I spent in the magnificent Prado Museum. It was great to see Alan Johnson and watch him flourish in charge of a busy, complicated movie set. I imagine the cast and crew I worked with were perfectly lovely, but as usual, I was there for such a short time that I didn't get to know

any of them. I remember telling Lee when I got home, probably for the hundredth time, that just once, I'd love to work on a film where I'd stay until the end and maybe even come away with some new friends, or at least some people I'd recognize later if I ran into them on the street.

But it didn't look as if that would be happening any time soon. A few months after I came back from my few days in Madrid, I signed on for another movie in which I'd just be passing through—a film called *Dirty Dancing*.

Chapter
Nine

*D*irty Dancing is the story of the Houseman family's trip to the Kellerman's Mountain House in the Catskills. One of the daughters, Frances "Baby" Houseman, played by Jennifer Grey, meets and becomes involved with one of the resort's dance instructors, Johnny Castle, played by Patrick Swayze, over her father's objections.

I was cast in the very small role of Vivian Pressman, another guest at the resort who's taking dance lessons from Johnny, hoping to seduce him into, uh, "keeping her company" until her husband arrives. It wasn't much of a part, yet another quick in-and-out that would give me a chance to get to know absolutely no one and envy everyone who got to stay around for the full run of the shoot.

But as I'd started doing before I made a decision on every job I was offered, I made lists of the pros and cons of saying yes to *Dirty Dancing*.

On the "pro" side was getting to do more on-camera work, which I'd fallen in love with; the sexy vintage wardrobe they'd put

together for my character; and the chance to spend a few days in what sounded like lovely locations—the "Kellerman's Mountain House in the Catskills" was actually the Mountain Lake Lodge in Pembroke, Virginia, and a former boys' camp at Lake Lure, North Carolina.

The "cons" included spending time away from Lee for a really minor role that could end up on the cutting room floor for all I knew, and running the risk of becoming the movie version of an anonymous corps de ballet dancer at Radio City Music Hall. Please, not that again.

But when the pros and cons kind of evened themselves out, I always let my instincts have the final vote, and in this case, my instincts gave *Dirty Dancing* an emphatic yes.

It had taken me about a minute and a half to learn Vivian's lines, so I wasn't even bothering to pack my script as I threw a few days' worth of clothes and toiletries in a bag for the trip to Virginia.

Then the phone rang. It was the film's producer, calling to say that they actually wanted me there for a two-week rehearsal.

Huh? A two-week rehearsal for what might amount to maybe five minutes on-screen? It was like being told to plan for twelve hours' worth of travel time for a two-mile road trip. That made absolutely no sense to me, until I really thought about it.

Then it hit me. Of course! Maybe they hired me to play Vivian because I'm a dancer, and since Vivian was taking dance lessons from Johnny, they were probably planning to shoot some lovely scenes of Patrick Swayze and me dancing in the studio together. Great idea, and it made perfect sense! That would be a whole lot

more fun than the script indicated! Besides, I'd been around show business for a while, certainly long enough to figure these things out, so what else could it possibly be?

And thus began another adventure down the hilariously useless rabbit hole of second-guessing.

I tossed another two weeks of clothes and toiletries into my bag, kissed Lee goodbye, and flew off to Virginia, looking forward to rehearsing and filming those long, lovely dance scenes with Patrick Swayze, who I'd been told was the son of a dancer/choreographer and had studied classical ballet. A production assistant picked me up at the airport for the spectacular one-hour drive through the Blue Ridge Mountains to the "Kellerman's resort." We were checking me in to the hotel when a voice crackled through the production assistant's walkie-talkie: "Would you please bring Kelly down to the set?"

I'd just gotten off the flight from LaGuardia to Roanoke, and I looked like hell, but I was there to cooperate. Rather than pause to freshen up, I climbed into a little car with the PA, and we headed to a gazebo where some of the film was being shot. A lot of people were standing around, but they seemed to kind of spring into action when the PA and I got there, as if they'd been waiting for us.

The director, Emile Ardolino, immediately walked over, introduced himself, and pointed to the gazebo. "Kelly, would you go stand over there, please?"

Sure. Whatever he wanted, although this was getting a little confusing.

Then he asked Jennifer Grey, "Baby," the film's costar, to go stand beside me. She did. "Hi, nice to meet you, you know, I worked with your dad [Joel Grey] not that long ago," blah, blah. I was sure Vivian and Baby didn't have a single scene together, but okay.

Next came Jerry Orbach, who wandered over to say hello. I knew he was playing Jake Houseman, Baby's father, and I was happy to see a familiar face—not only had we worked together in *Promises, Promises* on Broadway, but he'd also been a gambling buddy of my first husband all those years ago.

It was right around then that I started noticing what was going on behind us, which only added to my confusion: a lot of those people who were milling around by the gazebo were in costume, and there were lights and cameras already in place.

After what seemed like forever, the producer, Linda Gottlieb, stepped up and solved the mystery.

"Kelly, this morning we released the woman who was playing Marjorie Houseman. Jake's wife. Baby's mother. We were wondering if you'd like to step in as her replacement, and we'll recast Vivian."

I'd read the whole script, and frankly, the role of Marjorie Houseman hadn't really leaped off the page at me.

"Same money," she went on, "you'd start today. . . ."

Today?! What?! With no time to prepare, and I'm *very* big on preparation?! I took a breath, getting ready to suggest they let me stick with playing Vivian and recast Baby's mother instead, when she added, "And you'd work on the entire film until the end."

Suddenly, as Yogi Berra once put it so eloquently, it was like déjà vu all over again, another gift dropping into my lap out of nowhere.

Work on the entire film until the end? Was I dreaming this?! Say no more! Sure, the role of Marjorie wasn't much. Sure, playing a "nice mom" would be kind of boring. Sure, they were offering me a more substantial part for the same money. But so what? When a dream comes true, you're a fool not to grab on to it and just say, "Thank you!"

I was promptly whisked off to wardrobe, where they managed to find some "mom" clothes in my size, since the Vivian/seductress wardrobe they'd prepared for me would have made it look as if Marjorie Houseman was, in reality, a recently reformed hooker. Then it was on to hair and makeup and back to the gazebo to start playing Jennifer Grey's mother all within hours of arriving in Virginia. Actor/choreographer Miranda Garrison was brought in to play the role of Vivian.

So much for my uncanny second-guessing skills and "What else could it possibly be?" Although, in my defense, how could I have ever seen this coming?

While I'm sure there are exceptions, working on a film until the end was every bit as gratifying as I'd imagined it would be. The cast and crew were all kind of isolated together on our mountaintops in Virginia and North Carolina, hanging out together for dinner and drinks like a big misfit family, reviewing that day's work, laughing, getting to know one another and making friends. Jennifer Grey was delightful, easy to talk to, and very focused on proving herself in that role, while Patrick Swayze stayed to himself, other than interacting with a small coterie of other male dancers in the film, so I don't recall that he ever hung out with the rest of us during "misfit family" time.

He was as intensely focused on his work as Jennifer was on hers, as if he knew exactly what that movie was going to do for him and his career and he wasn't about to blow a single moment of it.

The last number in the movie, "(I've Had) The Time of My Life," which took a joyful four or five days to shoot, summed up the whole experience as far as I was concerned. It was less like work and more like four or five days of one of the best parties I'd ever been to. Surrounded by fun, wonderful, talented people. Exquisite music and dancing. Beautiful clothes. (I got to wear a gorgeous strapless cocktail dress from Vivian Pressman's original wardrobe, by the way.) And, as an added, unexpected bonus, when late afternoons rolled around, our prop crew would replace the nonalcoholic beverages we'd been drinking all day with real liquor, so that we were all a bit buzzed for our last few hours of filming. I still get chills of happy, unforgettable memories when I hear that song.

Adding to the embarrassment of riches was getting to work with the sublime Jerry Orbach, my husband in the film. Jerry would occasionally have a week off and go home to New York. Since I was never in scenes he wasn't in, we went together. He'd drop me off at Lee's and my apartment on West Seventy-Sixth Street when we got to the city and then head on to his and his wife's apartment not far away. Then, a week later, we'd share a cab to the airport and fly back to Virginia or North Carolina again. It became a running joke between us that everyone probably thought we were having an affair because of our synchronized disappearances and reappearances. I walked into the production office after one of those weeks off and casually shared that running joke with the people who were

sitting at their desks, and was greeted with sheepish stares and dead silence—in other words, apparently that's exactly what they thought. And if Jerry and I hadn't both been happily married, and he hadn't been saddled with the baggage of acting for a living, who knows?

Jerry and his wife, Elaine, and Lee and I had dinner together in New York every week or two for years after *Dirty Dancing* wrapped. Jerry also loved meeting Lee and me for a round of golf every chance we got.

Lee loved golf. He loved watching it almost as much as he loved playing it, and I think it speaks volumes about what great pals he and I were that he asked me to learn to play so that we could play together. I did, and I loved it too. I know a lot of men who love the fact that their wives have less than zero interest in golf. The men enjoy those hours out of the house with their buddies, and I'm sure the wives enjoy those hours when they're gone every bit as much. But not us. Some of our happiest times were spent on golf courses and inviting friends like Jerry Orbach to join us.

In the end, *Dirty Dancing* wasn't much of a hit with critics, but it was a big hit with the general public. It's a classic now. I've even heard younger people refer to it as "the *West Side Story* of my generation"; and to this day, from what I'm told, there are annual *Dirty Dancing* festivals at our original locations in Virginia and North Carolina. My performance and I had absolutely nothing to do with that success, and I don't take credit for anything but loving the experience, getting to ride that wave, and coming away with a great new pal for both me and Lee. In fact, Jerry Orbach became one of Lee's favorite occasional guests on his CNN talk show.

And speaking of *Showbiz Today*, it was thrilling to see Lee in his element, thriving at CNN, interviewing everyone from Mel Brooks to Steve Martin to Carrie Fisher to Lorne Michaels to Tim Curry. In the meantime, I was back to work in front of the camera, doing everything from series TV like *The Thorns* with fellow Broadway veteran Tony Roberts to a few episodes of the soap opera *As the World Turns*, until I got an offer I couldn't refuse, to go back to the stage.

The play was a fascinating work by playwright John Guare called *Six Degrees of Separation*. I was cast in the minor role of Adele, and we were scheduled for an off-Broadway run at the Mitzi E. Newhouse Theater in Lincoln Center, opening November 8, 1990.

The driving force of the play is the character of Ouisa. She and her art dealer husband, Flan, are wealthy, high-society New Yorkers who fall for the duplicity of a slick, skillful young con man named Paul. Ouisa is an incredible, very difficult role, emotionally multilayered and a whole lot to learn. Blythe Danner was originally signed to play her but left the production very early for reasons none of us ever really understood, and when we all gathered for the first of five weeks of rehearsals instead of the usual four, I was surprised and, I admit it, skeptical when director Jerry Zaks announced a stage direction I'd never seen or heard of before.

"The cast is going to sit in the front row of the audience," he said. "When you have a scene, you simply stand, walk up to the stage, do your scene, and then return to your seat in the audience. The only cast members who will stay onstage and never sit in the audience are the three leads—Ouisa, Flan, and Paul."

Seriously? Sit and watch the whole play from beginning to end for every performance, and make our entrances from the theater seats? We older members in the cast (actually, I prefer "seasoned veterans") gaped at him as if he'd lost his mind, while the younger ones nodded enthusiastically, thinking it was a great idea. In Jerry's defense, it wasn't just an arbitrary device to put his stamp on the production with some unheard-of direction that critics and audiences could buzz about—he went on to explain that he wanted the play to move along. "I hate the pauses" was the way he put it. I couldn't imagine it, but I wasn't there to direct, so okay, whatever, I kept my mouth shut . . .

Until Blythe Danner left, and I couldn't resist speaking up.

The truth is, from the moment I read *Six Degrees of Separation* and started watching rehearsals, the idea of playing Ouisa wasn't just another "Gee, I wish" thing. I was lusting after that role. So when they had to recast it, I offered myself up as an understudy, thinking that way I could work on it and even perform it for rehearsals while they looked for Blythe Danner's replacement.

They said yes, and I was Ouisa's understudy when Stockard Channing was hired. I got to sit in the audience and kind of learn Ouisa along with her. There's usually some tension between principal actors and their understudies, since principals know that most understudies are secretly wishing them some kind of debilitating illness or injury so that they can take over. Stockard and I didn't have that problem. She was too fantastic, and I admired her too much to not be rooting for her every step of the way.

Then came word that Stockard would be leaving the show about two months before it closed, to do a movie she'd already committed to. She'd be back for the last two weeks, but in the interim, they needed another Ouisa onstage. The answer is always no unless you ask, so I went straight to the producer and announced, "For the record, I really want to do that role."

Rather than heave a sigh of relief and throw confetti around his office, he replied, "Oh, really? Well, we're working on a list of possibilities, and we have an offer out to Glenn Close."

Glenn Close. Great choice, obviously extremely talented, but— "Okay, just remember, I want that role," I told him. As I headed for the door, I added, not for effect but because I really meant it, "By the way, if I don't end up playing Ouisa, I won't be understudying her anymore."

It took a while, and I never did find out what happened to the Glenn Close offer, but I ended up getting the role of Ouisa. Conditionally. I asked for the same salary the two male leads were making. The producer found that to be an outrageous request, until I offered to accept the lower pay, in exchange for a run-of-the-show contract—i.e., as long as this production kept going, I'd be playing Ouisa. Of course, I knew they couldn't do that, since Stockard was coming back for the last two weeks, and they ended up giving me the money I'd asked for in the first place.

And that's how I ended up playing Ouisa during our run of *Six Degrees of Separation* that opened at the Vivian Beaumont Theater on Broadway on November 8, 1990. It was the hardest and one of the most rewarding roles of my career. I stayed until Stockard came

back, at which point, at my request, the producers agreed that I didn't have to come in as an understudy for every performance anymore, they'd simply call me when they needed me.

Stockard Channing was nominated for a Best Actress Academy Award and won a Best Actress Golden Globe Award for her portrayal of Ouisa Kittredge in the film version of *Six Degrees of Separation*. It couldn't have been more well deserved. I played a tiny, blink-and-you'll-miss-me role in that movie. Good enough for me. I was happy just to be part of it.

Challenges like *Six Degrees of Separation* were a godsend in so many ways. They helped me grow as an actor. They helped me along in my never-ending pursuit to learn, to find out what I'm good at and what I'm not, and to explore what I really love and what I don't. They introduced me to some amazing people. They were great for my résumé and my bank account. And they were very timely and very therapeutic—for the most part, they kept me focused on life rather than death.

The world in general, and show business in particular, had been decimated in the 1980s by the heartbreaking HIV/AIDS epidemic. We were all mourning the loss of so many friends and colleagues after watching them cruelly waste away.

None of those losses hit me harder than Michael Bennett's death on July 2, 1987. His memorial service was appropriately held at the Shubert Theatre, home of *A Chorus Line* and a wealth of Michael's other brilliant triumphs and, in so many ways, the longevity of my

career. Michael and I went through a lot of highs, lows, and drama over the years, on- and offstage. In the end, though, trying to imagine how my life might have gone if it hadn't been for the genius of Michael Bennett is an impossibility. Thank you always, Michael, for every minute of it.

By then, Mom's dear husband had passed away as well, and she'd moved back east to be closer to me and Lee. Lee and I bought a town house with her in Wilmington, Delaware, not far from the Brandywine Country Club, where we'd enjoyed playing many rounds of golf. It was a luxury to have her living just a train ride away in a nice, quiet residential neighborhood, and to know that she was safe and content with her beloved pets after many years of happiness in the sweet, peaceful marriage she deserved.

Toward the end of 1993, just as winter was making its entrance in New England, I leaped at an opportunity to escape to the warmth of Florida for a small part in a movie called *Miami Rhapsody*. Starring Sarah Jessica Parker, Mia Farrow, and Antonio Banderas, with David Frankel making his directorial debut, I was cast in the role of a travel agent named Zelda, who was having an affair with Vic Marcus, played by none other than the writer/director of my first released film, *An Unmarried Woman*, Paul Mazursky.

It was good to see Paul again, particularly when it was time to shoot the first and only nude scene of my career, if wearing a thong qualifies as "nude." Vic and Zelda were in a hot tub, and when we started out, I was sporting pasties. For those of you who've been wondering about this kind of thing, I'm here to share the lesson I learned that day: the adhesive used to apply pasties and the warm

water of a hot tub are completely incompatible. Who knew? I ended up shooting the scene without them. God bless Paul Mazursky for being more of a gentleman through the whole thing than a lot of other actors would have been under the same circumstances.

Brief as it was for me, *Miami Rhapsody* was another one of those lovely experiences that felt more like a paid vacation than it felt like work. I was home in time to do an off-Broadway production of a very funny play called *Pterodactyls* at the Vineyard Theatre.

According to playwright Nicky Silver, the "broad comedy and utter despair" in *Pterodactyls* was "intentionally polarizing, often extreme, occasionally revulsive, and ultimately a stark picture of futile mortality," which is to say I thoroughly enjoyed it. I played Grace Duncan, a married, alcoholic, wealthy, socially elite mother of two—a dysfunctional, hypochondriac daughter named Emma, and a son named Todd, who comes home to his parents to announce that he's gay and has AIDS, all while he's building a dinosaur skeleton from bones he's dug up in the yard.

Mom was planning to come see it, but I warned her against it, because I died in that play. It still makes me laugh that she gave me one of those dismissive *Don't be ridiculous* hand waves and reminded me, "Oh, I've seen you die before." She was right, of course—she'd been in Cleveland to see me murdered onstage when I played Pirate Jenny in a production of *The Threepenny Opera*, so watching me die was on her "been there, done that" list.

She came from Delaware to see *Pterodactyls* in New York. As usual, she enjoyed it, and as usual, I treasured looking out into the audience and seeing her there, beaming up at me with her singular

brand of pride and love that had been nourishing me since the day I was born.

It was in January of 1994, less than two months later, that a brutal ice storm slammed into the northeast, and Mom, because she was Mom, went out one day as dusk set in to shovel the snow and ice from her driveway. She was in her seventies. She had a pacemaker and rheumatic heart disease. But when snow and ice are blocking your driveway, you do what you have to do, right?

Wrong. One of her neighbors called early that evening to tell me that my mother had had a heart attack and was rushed to the hospital.

I immediately shifted into autopilot, threw some things in a bag, and raced out the door to catch the next train to Wilmington. I told Lee as I ran past him, "I'm not ready for this," and I wasn't, but ready or not, I had to get to my mom.

The neighbors who'd called picked me up at the train station and drove me to the emergency room at the hospital, where Mom was still being worked on. I did my best to hide how frightened I was when I got there—knowing she'd had anything to do with causing me to be afraid would have been harder on her than a heart attack. I made sure she knew I was there and that I loved her; and then, after a quick stop to beg her doctor to give her something for the pain she was in, the neighbors drove me to her town house to take care of her animals and pick up her Cadillac for trips back and forth to the hospital.

Before I went inside, I looked around at the snow-and-ice-covered neighborhood. Mom's was the only driveway that had been shoveled. It made me smile and broke my heart at the same time. She hated being widowed, and I'm sure she assumed that everyone around her had husbands who did all the shoveling. But no. I asked around and found out that the neighbors, most of whom were well into their sixties, hired boys from the foster home up the hill, who were happy to make some extra money doing chores for the older nearby residents who needed help. Mom had just never thought to look into it.

She'd been moved to the ICU by the time I got back to the hospital. She seemed marginally more comfortable, but she looked so tiny, and so helpless and frail. I'll never forget her guilty little nod when she opened her eyes just long enough for me to ask, "Mom, did you shovel that snow?"

She held on long enough for my brother and his wife to get there from Washington State.

Then, the next morning, less than forty-eight hours after she'd collapsed, she passed away, with both her children there beside her.

Lee and Mom adored each other, and he'd arrived by the time we all gathered at the funeral home to arrange for a small, peaceful memorial service. My brother and I opted to have Mom cremated, and fortunately I mentioned ahead of time that she had a pacemaker—it turns out pacemakers explode during cremation. My brother's wife found several photos of Mom in the town house, had them enlarged, and displayed them on easels on one side of the large room, and the funeral home arranged for a table of tea and coffee

to be placed among them. I was so touched at how many people braved the horrible weather and showed up to honor her and say goodbye.

Losing my mom was the worst, most devastating thing that had ever happened to me. When I lost her, I didn't just lose my mom. I lost my hero. My biggest fan. My fiercest protector and my wisest, most patient teacher, who taught me everything from my first ballet lessons to honesty, to not being defined by my circumstances, to always, always loving myself, because if I was special enough to be loved by her, I must be worth loving.

Not long after Mom left us, Lee and I moved with our pets to join her animals in the town house in Wilmington, and I almost manically scurried back to the therapy of work as soon as possible—guest spots on TV series here, another film or two there, some regional theater—anything to stay productive and not let my mother's legacy be solely a marathon of grief and self-pity. She never indulged in those things in her life, and I wasn't about to disappoint her now. I even flew back and forth to LA to do a pilot and four episodes of a series called *My Wildest Dreams* with Lisa Ann Walter that ended up going nowhere, but it felt like a victory to me that I was able to summon up the energy and the discipline to make those cross-country trips, knowing Mom wouldn't have had it any other way.

Almost a year passed, and I was getting my emotional strength back when an odd, seemingly minor development changed everything, again.

Lee started noticing a bruise under the nail on his index finger. He'd always been really good about going to doctors, so when it didn't go away, he went to his dermatologist in New York to see what was going on. His dermatologist couldn't figure it out and sent him to a specialist at Columbia, who diagnosed it as a melanoma, and Lee had to have half his finger removed. When the specialist recommended precautionary X-rays and CT scans every few months, we sold the town house in Wilmington and moved ourselves and our menagerie to our apartment in New York.

As I told Lee, "When I do a play, I want to be able to come home at night."

He replied, "Oh, come on, how often have you done a play in the last few years?"

It was a rhetorical question—it had been at least a year or two since I'd been onstage, with everything else that was going on, and as much as I missed it, it was anyone's guess when I'd be there again. But he then watched in amazement, with a smile on his face, when, almost from the minute we landed back in that apartment, I started auditioning for one theater opportunity after another, starting with a fascinating off-Broadway production of *Death Defying Acts* at the Variety Arts Theatre.

Death Defying Acts featured three one-act plays by three extraordinary playwrights—*An Interview* by David Mamet; *Hotline* by Elaine May; and the one I got to do, and loved, *Central Park West*, by the brilliantly hilarious Woody Allen.

My audition for *Central Park West* was one of my more memorable ones. It took place at an old residential hotel on the East Side,

in a huge room. I was directed to sit at a table that must have been at least thirty feet from the doorway, and way down at the end of the room sat Woody Allen, flanked by two women who looked like female bodyguards. There was a throw pillow on Woody's lap, and he had his arms wrapped around it. It was pulled up over his face so that all I could see for the whole audition were his glasses and the top of his head. I never did and never will have a clue if he typically hid like that when people read for him at auditions; but being unable to see a single facial expression made it impossible for me to know if he was pleased or if he couldn't wait for me to get it over with and leave the room.

A few days later my agent called to say I got the job, and I was delighted—I loved *Central Park West* and my role in it. I played Phyllis, a wealthy psychiatrist who discovered that her best friend, Carol, played so wonderfully by Valerie Harper, a.k.a. TV's beloved Rhoda Morgenstern, was having an affair with her husband. One of my favorite moments: Phyllis's husband asks Carol to go jewelry shopping with him to buy a gift for Phyllis. Carol begins describing the jewelry pieces they bought for Phyllis, to which Phyllis replies, "I know. I've seen them on you."

One of the reasons I loved Phyllis's line in that scene was because it provided me with one of those unexpected moments of vindication that put a little spring in my step for an hour or two. It was trivial, but I've obviously never forgotten it.

It was our first rehearsal, and I delivered the line exactly the way I thought Woody Allen intended: "I know. I've *seen* them on you."

Our director, a lovely Australian man named Michael Blake-more, immediately spoke up and corrected me. "No, no, no," he said, "That should be, 'I've seen them on *you*.'" I silently thought, *I doubt it, that's not funny.* But I did it his way because he was the director, after all. . . .

Until several days later, when Woody Allen came to a rehearsal, heard, "I've seen them on *you*," and stopped me with his one and only note to me: "That's supposed to be, 'I've *seen* them on you.'" I managed not to yell, "See? I was right in the first place!" I wasn't about to rat out Michael Blakemore and explain that I'd been given that correction, but it made me feel so good that my initial instinct was exactly what the playwright had in mind to begin with.

In the end, I thoroughly enjoyed doing *Central Park West,* and word got back to me a few weeks after we closed that Woody Allen had referred to me as "the quintessential Phyllis"—a compliment I'll always appreciate.

In the meantime, the move from Delaware worked out perfectly for Lee as well. It brought us closer to Lee's medical team and his new job in the anchor position on the twenty-four-hour show *News 12 New Jersey.* Between Mom's animals and ours, Lee and I looked as if we were planning to open our own petting zoo—we had her two cats, Sophie and Harry; her little poodle-terrier mix, Lily; our hand-some Waldo, probably a Lab and elkhound mix who had been living on the streets of New York when we adopted him; and our two cats, Mickie and Lola. We adored them all, but they were crowding us out of our apartment, so we started house hunting. My new routine became driving around New Jersey with our Realtor in the morning,

looking at homes for sale, and being back in New York in time for noon rehearsals. We eventually fell in love with and bought a house in South Orange, and life started wading back to our version of normal.

I ended up leaving *Central Park West* a day or two early to play Grace, the bitter, divorced owner of a diner, in the William Inge play *Bus Stop* at the Circle in the Square Theatre. I was getting mentally and emotionally healthier from the grief of losing Mom with every passing rehearsal and performance, and Lee was getting physically healthier with the help of his doctors, his relentless optimism, and the *News 12 New Jersey* anchor job he loved. Our menagerie was thrilled to be out of our apartment in New York and into a house with a yard in New Jersey. Eventually I felt settled enough about things in general that I took off across the country to take on the role of Annie in Neil Simon's *Proposals*.

We rehearsed in Los Angeles before heading on to Phoenix, which is where I was thrown by an unexpected call from Lee, telling me that one of his regular X-ray/CT scan appointments had revealed a spot on his lung. He needed aggressive surgery to remove his lower lobe, surgery he postponed until *Proposals* ended and I was back in New York. The spot on his lung hadn't metastasized, thank God, and his recovery went so well that his doctors cautiously predicted that the worst was probably behind him. Just when I thought I couldn't admire him more, Lee never complained or felt sorry for himself, not once, even though I'm sure he was worried. He returned to work the minute he was well enough; and he insisted that I keep working too, if it was something I wanted to do, even if it took me away from home and him for a while.

So, in the summer of 1999, when I got an offer to play Vera in a regional theater production of *Mame* with Christine Ebersole, right there in New Jersey at the Paper Mill Playhouse, it was too perfect to turn down. I loved the show, I loved the Paper Mill Playhouse, I'd be gone for only hours at a time rather than days or weeks, and vocally it was right up my alley. Bea Arthur had played Vera in *Mame* opposite Angela Lansbury on Broadway, and she and I had what I'll politely call "not dissimilar singing voices." Besides, how could I pass up a chance to sing the line from "Bosom Buddies":

If I kept my hair natural like yours, I'd be bald.

As if "someone" was watching over us, I went from *Mame* in New Jersey to an incredibly funny play called *Inspecting Carol* at the George Street Playhouse in, you guessed it, New Jersey. We closed on December 27, 1999, and as much as I loved doing that show, I also felt myself starting to yearn to be back in front of the camera again.

"Gee, I wish . . ."

And just a few weeks later, I got another one of those phone calls that should have been accompanied by a choir of angels.

Chapter
Ten

The call came from my agent, a man named Robert Attermann. I'd finally found an agent I could trust, respect, and even socialize with and welcome into the family. Robert and I had been talking several times a day, as we always did at that time of year because of a Hollywood tradition called pilot season.

Pilot season was an early-spring ritual in which TV networks would order pilots from the dozens of scripts they received, cast them, shoot them, test them among focus groups, and then either greenlight them to extend into series, or unceremoniously dump them and move on. It was an annual flurry of activity—writers submitting pilot scripts; scripts that are given the go-ahead being passed along to talent agents; talent agents sending those scripts to clients who might be appropriate and available; and we clients getting a pile of scripts to read and audition for if we were remotely interested, or just needed the paycheck whether we were interested or not.

Pilot season of 2000 was the usual flurry. The series *The Sopranos* had debuted in 1999 and became a huge hit, so it was predictable that

almost every half-hour script I read was an effort to cash in on that success in comedy form, one live-audience sitcom after another about, what a surprise, an Italian family. A lot of us theater people enjoyed doing sitcoms for that familiar experience of performing for a live audience, but not one of those scripts appealed to me, even a little.

This particular call from Robert was to alert me to another script he'd just sent that he thought I might want to pay particular attention to. He described it as "an interesting one-hour comedy-drama." Okay, I hadn't read one of those yet. But what intrigued me even more was the fact that, refreshingly, the title didn't sound Italian at all.

It was called *Gilmore Girls*, and Robert wanted to submit me for the role of Emily, the matriarch of the Gilmore family.

I told him I'd look it over and let him know if I'd like to pursue it. Then I sat down to read the script, and it was love at first sight. I'd never read anything like it. Its writer, Amy Sherman-Palladino, was obviously brilliant. The dialogue was smart, razor-sharp, and unpredictable. The humor was a delight, and utterly unique.

Maybe most of all, the more I studied it, the more amazed I was at how closely I identified with the relationship dynamics of the Gilmore girls themselves:

Lorelai. Thirty-two years old. Only sixteen when she got pregnant with her daughter, Rory, to the stern, judgmental disapproval of her wealthy high-society parents. Insists on earning everything she has, rather than expecting it to be handed to her. Fiercely loves her daughter and chooses to be her best friend as well as her mother—very much like my mom did with me.

Rory. Sixteen, sweet, well-mannered, and a bit socially awkward. An excellent student with a passion for classic literature, and an aspiring journalist and foreign correspondent. Deeply appreciative of her friendship with her mother and of the challenges she's gone through to raise her with so much love and so little family support—very much like the way I felt about my mother.

Emily, Lorelai's mother. Married for decades to Richard, a conservative, stoic insurance executive. Wealthy and socially prominent. Opinionated, rigid, hard to please, a woman I would never be friends with in real life. And except for the vast differences in their backgrounds, eerily similar to Mom's mother, whom I exclusively called Louise. Somehow, in Louise's eyes, it was apparently my mom's fault that she was conceived when Louise was sixteen, and she openly resented her for it all her life. As far as Louise was concerned, Mom couldn't do anything right, ever, while Mom always tried so hard to please her. I never could figure out what Louise thought she had to gain by deliberately withholding love and approval from such an amazing daughter.

Thanks to this extraordinary script, I might have an opportunity to explore Louise and her strained relationship with my mom through exploring Emily and her strained relationship with Lorelai, and, to add to the perfection, play a cold, condescending, emotionally distant mother, which is infinitely more fun than playing a nice one.

I called Robert back the instant I finished reading with a simple, emphatic "Yes, please."

I was more excited than nervous when I took the train into New York City to tape my *Gilmore Girls* audition. I've always been a big believer that part of my job as an actor is to learn my lines and make them work exactly as written, word for word, no improvising, especially on a script as perfect as this one, so I'd worked very hard on it, and on the character of Emily, to internalize her rather than simply "recite" her or "act" her.

One of the first people I met at the audition was Amy Sherman-Palladino. I already knew from her writing that she was smart, with an edgy, unconventional sense of humor. It was immediately apparent that there was also an eclectic self-confidence about her that was a real breath of fresh air. I'd read that she grew up in North Hollywood, California, which always struck me as kind of a bland, personality-free suburb of Los Angeles. I was intrigued to discover that she actually struck me as someone who could easily have been born and raised in some charming bohemian neighborhood in Greenwich Village. There was no pretense about her, no slickness, no political glad-handing or equivocating, just a woman who knew the value of her work and the quality of her project and was crystal clear on how it should be done.

I eventually learned that once upon a time, she was a talented aspiring dancer who'd turned down a job in the cast of an off-Broadway tour of the stage hit *Cats* to join the writing staff of the *Roseanne* TV series. When she was a child, she'd even studied at Ballet La Jeunesse in Toluca Lake, California, the same ballet school where I studied when Lee and I were in Los Angeles, so

there was probably a strong intuitive connection between us from the moment we met.

I thought my audition went well, and I commuted home to New Jersey feeling cautiously optimistic about getting cast in *Gilmore Girls*. I knew there would be some waiting involved before I heard anything—as always, the executives in LA would have to watch, endlessly debate, and flex their muscles about every audition tape, while I went on about my life in South Orange with my husband and our pets and kept repeating one of my usual mantras: "If it's meant to work out, it will. If it isn't, it will just make me available for what I'm supposed to be doing instead." (Sometimes it was reassuring; sometimes it wasn't.)

But there's waiting, and then there's *waiting*. Robert checked in from time to time with meaningless "news" like: "They're really interested, and, of course, if the interest continues, you'll have to go to LA to audition for the network and studio executives," and the equally unhelpful, "They want to get the roles of Lorelai and Rory locked down before they focus on casting the other regulars."

It seemed their first choice for Lorelai was an actress named Lauren Graham, who was working on something else and not immediately available. As for the role of Rory, they were considering a young newcomer named Alexis Bledel, but she'd given one good audition and one not-so-good audition, and they were having trouble making up their minds about her.

Finally, when the phone kept not ringing to schedule that audition in Los Angeles, I gave up hope. If "the suits" were still on the fence about hiring me, they could have at least given me another

shot at auditioning. But oh well. There was nothing more to do about it than I'd already done. The rest was up to them.

Or, to be more accurate, the rest, as it turned out, was up to Amy Sherman-Palladino.

The deafening silence was broken one afternoon by another call from Robert. He asked if I was sitting down. I lied and said I was.

"It seems you won't be going to the West Coast after all," he told me.

My heart sank, until he continued, "It won't be necessary. They're offering you the role of Emily in *Gilmore Girls*."

I was too speechless to ask the obvious question: What happened to that supposedly mandatory audition for "the suits"?

Years later, Amy explained it to me.

"They kept throwing names at me for months," she said. "But after I saw your first audition, I just kept saying, 'No, I have my Emily.'"

Next thing I knew, with my brave, supportive husband cheering me on, I was boarding a plane to Toronto in early April 2000 to meet my castmates and embark on an adventure that would last longer, mean more to me, and accompany me through more off-screen life changes than I could ever have anticipated.

The first cast get-together on a project is a lot like your first day at a new school. You kind of mill around, getting first impressions of everyone, which may or may not be accurate, and hoping you're making a good first impression on them—not too friendly

or aggressive, not too shy or standoffish, just someone they'll look forward to working with rather than dreading it. Everyone in this newly assembled *Gilmore Girls* group seemed ready to be a part of an ensemble, which doesn't always happen. There are occasional arrogant attention whores we've all run into who make it apparent from day one that, as far as they're concerned, they're the star of the show, and their castmates are simply there to service them and never, ever infringe on their spotlight. None of that existed in this group, and it was remarkable how quickly we relaxed and felt comfortable with each other.

You know those rare people you're introduced to for the first time and instead of saying, "Nice to meet you," you're tempted to say, "Oh, *there* you are!"? It's as if you're not new to each other, you're actually old friends who've just been waiting for a chance to reconnect. That's how I felt with Lauren Graham, who was playing my daughter, Lorelai, and Ed Herrmann, who was playing my husband, Richard. From the moment we started rehearsing, we "got" each other, and we trusted each other. Lauren already had an impressive TV résumé; and between his TV, film, and theater credits, not to mention a Tony Award, Ed had a résumé as long as my arm, so we came in with plenty of experience and ready to play.

Alexis Bledel, a.k.a. my granddaughter and Lorelai's daughter, Rory, on the other hand, was brand-new. I still remember the first moment I saw her, and it instantly occurred to me that Mom would have called her a "China doll"—maybe not politically correct today, but Mom would have meant it as a compliment on how pristinely, delicately beautiful she was. I was so charmed by the fact that even

during our first rehearsals, Lauren/Lorelai was always touching Alexis/Rory in their scenes together. It fit in perfectly with the sweet mother/daughter connection between their two characters, but it was also Lauren's subtle way of reassuring Alexis and gently guiding her to her marks on the set.

Shooting the pilot was an absolute joy. I'd already been blown away by Amy's writing, but one of many things I also came to admire so much was how economical it was in illustrating the relationships between the characters. Emily, for example, answered a knock at the door of her and Richard's mansion to find her daughter, Lorelai, standing there with a smile and a pleasant "Hi, Mom." Emily responded with a tepid "Well, this is a surprise. Is it Easter already?" Enough said, before Lorelai had even stepped inside the house. And when Richard entered and saw Lorelai sitting in the living room with Emily, he answered her "Hi, Dad," with a distant "Is it Christmas already?" compressing what other writers might have stretched out to several pages of awkward exposition into a few short, perfect lines that set the stage beautifully for the Lorelai/Emily/Richard ride ahead.

I'm honestly not sure which was more fun—shooting the pilot, or watching the finished product. We were all proud of it, and really hopeful that the WB network would pick it up for a series. Of course, the fact that it was exceptionally good didn't necessarily mean a thing. This was show business, after all, so logic? Don't be silly.

Fortunately, this time around, we got to skip the usual months of nervous waiting. On May 16, 2000, just a month after we shot

the pilot, *Gilmore Girls* was given the green light for a twenty-one-episode first season. I couldn't have been happier. . . .

Well, actually, I could have, but only because of logistics. The series was to be shot at Warner Bros. Studios in Burbank, just under three thousand miles from Lee and home in New Jersey. It was going to be a long commute. I'd also agreed to pay for my rented, furnished apartment at a complex called Oakwood Gardens, about a quarter mile from the Warner Bros. gate; for my rental car; and for my coach airline tickets back and forth to the East Coast. Granted, I was less than five minutes away from my ballet classes at La Jeunesse, and my castmates and I had countless relaxing dinners at the infinitely charming Smoke House across the street from Warner Bros.

Our "homes" on the lot were the usual trailers. Lauren and Alexis each had their own, and Ed and I shared one, which was great fun. He was smart and funny and a real professional, and we quickly discovered that we had a lot in common. We were both happily married, with homes on the East Coast. Not only did we both come from New York theater backgrounds, but I'd forgotten that we actually won Tony Awards on that same magical night in 1976—mine for Best Performance by a Featured Actress in a Musical in *A Chorus Line*, and his for Best Performance by a Featured Actor in a Play called *Mrs. Warren's Profession*. We were even mutually addicted to the *New York Times* crossword puzzles, which we did together every day we worked.

Ed and I also shared a private running joke that went on throughout the series, whenever there was a scene at the Gilmore

dinner table. We'd all be called to the set, and he and I would promptly take our places at opposite ends of the table. There we'd be, just the two of us, staring at each other and looking around, waiting and waiting, and sooner or later Lauren and Alexis and any of our other "dinner guests" in the scene would come wandering in and take their seats, and we'd start shooting. One day the waiting went on for so long that I finally looked at Ed and said, "Are we assholes, or what?"

He replied, appropriately, "We're theater people."

He was exactly right. In theater work, the words "Places, please" mean "The curtain's about to go up, so get onstage where you're supposed to be, or the show will start without you." In television work, the actors come to the set when they get around to it, because the cameras aren't going to start rolling until everyone's on their mark and ready to go. I can picture Ed and me sitting by ourselves at that table as clearly as if it just happened this morning, and not once did it annoy us or fail to make us laugh, either at our leisurely castmates or at ourselves, we were never sure which.

I loved my job. I loved the brilliant dialogue and multilayered characters we got to play, thanks to Amy's writing. I loved everyone I worked with, and the subtle, innate decency of the storylines. I loved the meticulously detailed sets Amy insisted on. I loved Emily's St. John Knits wardrobe and the earrings I bought at Ross-Simons for her. I was visiting my brother and his family in Seattle when we went window shopping and I spotted a gold Omega necklace, about an inch and a half wide, I decided I had to have, to wear in every episode as Emily's "signature" piece of jewelry.

And I especially loved my husband, who was doing an incredible job of keeping up with his work and his regular X-rays and CT scans and cheering me on while I was busy on the other side of the country. There was so much to be grateful for, and believe me, I never took any of it for granted.

If Emily had been a one-dimensional woman who adored her granddaughter but was never anything but mean and demanding with her daughter, she might have worn thin with me, and with the audience. I was always convinced, though, and I'm sure Amy was too, that Emily loved Lorelai as much as she loved Rory, she just didn't have a clue how to connect with her, and her frustration over that only added to her icy disapproval. Of course, she held a major grudge against her for getting pregnant at the age of sixteen, which was *simply not done* in proper families. But in true "what I fear, I create" form, she relentlessly made it difficult for Lorelai to be around her, and then resented Lorelai for keeping her distance.

One particular exchange between Emily and Lorelai has always stuck with me: Emily called Lorelai out of the blue and impatiently asked, "What day is this?" Lorelai had no idea what she was talking about, so Emily coldly informed her, "We're back from Martha's Vineyard. I told you we'd be back today." Lorelai, thoroughly confused, responded with something noncommittal, like, "Uh-huh...?" To which Emily replied, "No flowers, no welcome-home card, no nothing, as if we never even left?" Part of me couldn't imagine that sense of entitlement, and looking that hard for an excuse to criticize

your daughter for supposedly offending you. But another part of me reacted to it as a show of Emily's weird, deeply hidden insecurity that her daughter didn't care enough about her to even notice she'd been gone, without knowing why or what to do about it.

There was also a scene that took place at a spa that made a lasting impression on me and the subtext of playing Emily. Emily was trying to understand how Lorelai and Rory had such a warm, loving bond between them. As she and Lorelai sat together on the end of the bed, she verbalized her vulnerability, almost grieving the fact that she didn't know how to do that, that she was raised to obey the rules and play by the book, which didn't include being friends with your children. And Lauren and I both loved playing the scene in which Emily and Lorelai were packing to go home from the spa and Lorelai suggested that they steal the spa robes they both liked so much. Emily wouldn't hear of it, until she asked if Lorelai had ever done such a thing with Rory. The instant Lorelai replied that no, she hadn't, Emily was delighted with the idea, and the two of them stole their spa robes—i.e., Emily leapt at the chance to share a silly, harmless prank with her daughter that would always be between just the two of them. (Another reason that scene has stayed with me for all these years, incidentally, is the fact that after we finished shooting it, our wardrobe woman gave me my spa robe, and I still have it.)

No doubt about it, Emily never bored me, or ceased to surprise me, and there wasn't a day when I didn't look forward to getting to the studio and walking onto that set.

* * *

The first episode of *Gilmore Girls* aired on October 5, 2000. By early 2001, our ratings were going up, and our reviews were including compliments like "intelligent, creative, and sophisticated," "warm, cozy, and quirky," "makes you feel good," and "gets under your skin and refuses to let go." In other words, we had every reason to feel optimistic about getting picked up for a second season; but as all of us knew who'd been in the business for more than about five minutes, it never pays to second-guess "the suits."

So I was very happily surprised, but not, when my agent called me at home in New Jersey on the afternoon of March 20, 2001, to tell me that not only had the WB network ordered twenty-two more episodes of *Gilmore Girls*, but they wanted Ed and me back as well. Richard and Emily had been in only fifteen of the original twenty-one episodes; and there had been this nagging possibility in the back of my mind that the WB financial guys, who might not have even seen a single episode of the show for all I knew, could assume we were expendable, not because we were, but because "Think of the savings!" But no, Richard and Emily were being offered fifteen of those twenty-two season two episodes, same contract as season one, and I may have responded with the quickest yes! in show business history.

We started filming again in Burbank in July 2001, and you've never seen a group of people more thrilled to see one another and work together again. Even though it had been about six months since we'd finished shooting season one, it felt as if almost no time had passed at all. We picked right up where we'd left off onstage,

filming Amy's razor-sharp scripts; Ed and I went right back to our crossword puzzles in our shared trailer; Lauren and I went right back to hanging out together during breaks; and I went right back to my round trips from California to New Jersey to spend as much time as possible with my husband. And I'll always be so grateful that my schedule allowed me to be in New Jersey for a day that none of us will ever forget.

It was a couple of months into filming, and they were shooting a second-season episode in Burbank that I wasn't in, so I had the week off to spend with Lee at home in South Orange. On that Tuesday morning we were being lazy, hanging out in our bedroom with Annie, the newest member of our family. She was a sweet mixed-breed dog who clearly had some greyhound relatives, and Lee and I had literally found her hiding under a parked car in New York—no collar, no tags, no way on earth to track down her owners—so she immediately became ours for the rest of her life.

Lee still had a few hours before he needed to leave for his anchor job in Edison at *News 12 New Jersey*, so we were looking forward to taking Annie for her morning walk around the neighborhood on that absolutely perfect early fall day—a clear blue sky, hardly any breeze, and not even a slight chill in the air.

Then Lee turned on the bedroom TV, and we froze in place, staring at the most unimaginable sight we'd ever seen. It had to be special effects from some horror film, except it wasn't.

It was a couple of minutes past 9:00 a.m. on September 11, 2001. A gigantic plume of black smoke was rising from one tower of the World Trade Center in Lower Manhattan, and we watched in

disbelief as a plane crashed into the second tower, while a distraught newscaster tried to describe the incomprehensible nightmare that was going on across the river from us. Except for an occasional "Oh my God" and "What the hell are we looking at?!" we were speechless.

Lee immediately put on a suit and tie and raced out the door, knowing this would be an "all hands on deck" situation at *News 12 New Jersey*. Off he went to Edison, while I kept gaping at the TV, unable to watch and unable to stop watching what we were told was a series of suicide terrorist attacks carried out by al-Qaeda. After an hour or so I called a neighbor who lived on top of what they call "the South Mountain" (I'm from Colorado, so trust me, it's not a mountain, it's just a big hill) and asked if I could come over. I knew she had a big backyard with a view of the city, and I needed to get away from the television and out of the house to see this horrific tragedy with my own eyes. I don't think she wanted to be alone any more than I did, since she almost sounded relieved that I'd asked.

So Annie and I walked to the top of "the South Mountain" and sat there for the rest of the day, just staring at those massive clouds of black smoke where the twin towers used to be, trying unsuccessfully to fathom the chaos that must have been going on in Lower Manhattan. I don't think my neighbor and I said a word to each other—we were so overwhelmed that there was nothing to say. In fact, one of the countless things that got to me that afternoon was the total, eerie silence. None of the usual, mundane traffic noises, none of the usual planes flying overhead from the Newark airport because all air traffic had been halted, just the almost deafening

stillness of a country paralyzed in shock from the sudden loss of our innocent, or maybe arrogant, belief that terrorist attacks only happen in faraway places but certainly never on American soil.

I was in as much of a daze as everyone else for the next week, some combination of depression, difficulty concentrating, and barely sleeping. The airlines were back in action again just in time for me to head back to work. Lee, who was exhausted from endless hours of overtime at *News 12 New Jersey*, hated to see me go, and I hated to leave him, but I wanted and needed to focus on the friends and job that were waiting for me in Burbank. I may never forget walking through the creepy, almost deserted Newark airport, which looked like a ghost town, or taking my assigned coach seat in the back of a plane that was carrying a total of seven other passengers. Before we took off, I asked the flight attendant if I could change seats, and she sadly replied, "You can sit anywhere you want."

Between *Gilmore Girls* getting picked up for a second season, and my landing safely in Burbank from the East Coast a week after 9/11, I got to celebrate two reunions in just two short months with a cast and crew I'd come to cherish. How lucky was I . . . ?

Until the time came to negotiate my contract for season three, when life intervened in that way it has, and I found myself with a sudden dilemma on my hands.

Lee and I had been feeling more and more optimistic about his health for a couple of years when we were blindsided by the news that he now had prostate cancer. It was his third primary cancer,

none of which had metastasized, thank God, but the news still came as a horrible shock.

After a lot of consultations with his oncologist about his options, Lee chose radiation, which meant being zapped with a laser five days a week at St. Barnabas in Livingston, New Jersey, just eight minutes from our house.

One of the many things we'd learned the hard way in the past few years was that the right attitude is essential when you're fighting cancer, and there was no way I was going to make my husband go through those treatments without my being there when I had days off from the series. My agent put up a fierce battle with "the suits," trying everything he could think of to compel them to be compassionate and make adjustments in my schedule to help me help Lee. He got nowhere, again, and again, and again. Finally, having run out of patience and compromise suggestions, he called and said, "I think you're going to have to talk to Amy."

I did. I'll never forget what she did for me—after hearing me out on the phone, she said, "Thank God. I was afraid you were calling to tell me you're leaving the show." And then, thanks to her, my episodes were arranged so that I could be home with Lee for two weeks at a time. The production company even took over paying for my round-trip plane tickets and my apartment rent after I'd been footing those bills for the first two seasons. Believe me, walking into the Gilmore living room again after that new contract was signed, I felt as if the weight of the world had been lifted off my shoulders.

And as usual, back in New Jersey, although I knew he had to be frightened and discouraged, Lee fought that cancer with astonishing

determination and not a word of complaint, even when he kissed me goodbye and watched me leave him for my next flight to Burbank. He knew how much I loved being a "Gilmore girl," everyone I worked with, and working in general, and he wanted no part of having me give all that up so that I could stay home and do nothing but worry about him.

I'd never spent any personal time with Amy away from the studio. That changed not long after we finished shooting season four, when Amy, her friend and *Gilmore Girls* producer Helen Pai, and I went on an adventure I'll always think of as one of the most memorable experiences of my life.

I was on email lists from a few pro-choice organizations like Planned Parenthood and NARAL, the National Abortion Rights Action League, now known as Reproductive Freedom for All; and in late 2003 they started promoting an upcoming pro-choice rally in Washington, DC, to celebrate the anniversary of *Roe v. Wade*. I'm not very political, but the more I thought about it, the more intrigued I got by the idea of participating in a march for a cause I passionately believed in, a cause that had certainly had a major positive impact on my life twenty-six years earlier. Planned Parenthood had been there for me in 1978. Here was my chance to be there for them and say thank you.

I'd never had a conversation with Amy about politics, or anything remotely related to politics, so it was pure impulse that inspired me to forward one of those emails to her with a note from me that read, "Does this interest you?"

Amy's response was a simple "YES!" She promptly booked rooms for us at the Four Seasons in Washington, first class as usual, and she, Helen, and I joined the estimated 1.1 million people who marched down Pennsylvania Avenue to the Mall on April 25, 2004. I read later that marching with us were activists from nearly sixty countries, along with representatives from the Planned Parenthood Federation of America, NARAL, the ACLU, the National Organization for Women, the Feminist Majority, the National Latina Institute for Reproductive Health, and the Black Women's Health Imperative.

So many things about that day beyond the sheer number of people took my breath away. It wasn't the gathering of raging feminists some might have expected. There were lots and lots of men as well, along with countless families and children. A couple who looked to be in their early seventies. A woman pushing a baby in a stroller. A guy in his late teens, who was walking behind us and observed to his friend, loudly enough for us to hear, "You know, if men could get pregnant, abortion clinics would outnumber Starbucks."

This massive crowd was passionate and enthusiastic but amazingly peaceful for a rally over such a controversial cause. The only raised voices I remember walking past came from a few people in a circle around a man who was sitting on the back of a park bench with a large picture of a bloody fetus. No one was threatening him, they were simply chanting, "Choice, choice, choice!" over and over again.

I still shake my head a little over my memory of walking back into the hotel lobby at the end of the day in my protest-wear of

jeans, a T-shirt, and my large sticker that read "Women's rights are human rights," and finding myself passing through a large group of distinguished gentlemen in their suits and ties, who turned out to be members of the International Monetary Fund and were probably wondering what the hell a rumpled hippie activist like me was doing at the Four Seasons.

Amy and Helen flew back to Los Angeles, and I took the Amtrak Acela train from Washington, DC, to Newark, all three of us so gratified that we'd been part of such a historic event and that we'd done it together. I still look at aerial news photos of that gigantic crowd assembled in the Mall and am proud to be able to say, "I was there!"

Then, of course, it was back to *Gilmore Girls*, with an even deeper appreciation of Amy after the experience we'd shared in Washington, DC. I didn't think it was possible, but she continued to outdo herself, episode after episode, season after season, and see to it that our characters kept growing and revealing new layers of themselves. She never backed down from an opportunity to let us be very sweet or very dark, which made our jobs even more of an exhilarating surprise from one script to the next.

Ed and I were especially delighted when we were given the script in which Richard and Emily officially separated. It opened up a front-burner storyline for us, with new levels for us to play, and Amy built to it slowly and beautifully. Emily found out that Richard had been having secret annual lunches with his former fiancée. He skipped the funeral of one of her close friends because it conflicted with a golf meeting. He made a major business decision

without telling her. Finally, Emily felt dismissed and disrespected and moved into a hotel.

It was during the temporary downward spiral of their marriage, by the way, that Emily delivered a line that seems to have become one of her classics—a line I'm a little embarrassed to say I'd completely forgotten until a few years ago, when a friend gave me a Christmas gift of a set of custom-printed dinner tumblers. She set them up in order so that they formed a very funny, very specific sentence that didn't ring a bell with me . . . until she reminded me of an episode in which Emily announced to Richard that she was going to Europe, planning to sleep until ten o'clock, and have two glasses of wine with lunch. Richard observed that "Only prostitutes have two glasses of wine with lunch," and Emily's reply was printed on my new dinner tumblers: "Well then, buy me a boa and drive me to Reno, because I am open for business." (In my defense, it was twenty years ago, and we shot over one hundred episodes in our first seven seasons, so I hope I can be forgiven for an occasional memory lapse.)

As much fun as Ed and I had shooting Emily and Richard's separation, we were both especially touched by the episode Amy had been building to—our one hundredth episode, actually—in which Richard and Emily, after reconciling, held a vow renewal surrounded by family and close friends at a beautiful party. Emily beamed as Richard delivered a speech to her that centered around a favorite song of hers, "Wedding Bell Blues," about a woman who loved a man named Bill, believed he loved her too, and wanted to marry him:

Please marry me, Bill.
I got the wedding bell blues.

He ended the speech by telling her that "tonight, and tonight only, my name is Bill, and this is our song," and then swept her onto the dance floor. It was wonderful to perform, enhanced by what close friends Ed Herrmann and I had become, and so sweet without a hint of sappiness.

In sharp contrast, there was what I'll always think of as "the Tennessee Williams episode," in which Emily got to be completely "out there" and as "un-proper-Emily" as she'd ever been. Richard's mother had passed away, and to put it as politely as possible, she and Emily didn't care much for each other. While going through the woman's belongings, Emily came across a letter Richard's mother had written to him the night before Richard and Emily's wedding, begging him not to marry her. Emily was so offended and outraged by it that she proceeded to drink. A lot. She even lit a few cigarettes. Lorelai, Rory, and Lorelai's best friend Sookie (Melissa McCarthy) bustled around the Gilmore mansion preparing for the funeral reception and reacted to the shock of seeing Emily drunk and wearing a kimono in the middle of the day as she tossed out lines like "Find a box, throw her in, we're done" and "Throw the old harpy's carcass in a ditch. Let a wolverine eat her." That episode was like being turned loose on a playground for me, and I had an absolute ball filming it.

I watched every episode of *Gilmore Girls* from the very beginning, whether I was in them or not, and I can honestly say I was one of the show's biggest fans. Everything about it, from the writing

to the cast to the direction to the production values, made me so proud to be a part of it. And just when I'd think Amy had outdone herself, she'd prove me wrong, especially when it came to some of the guest stars she and the show attracted. There was Senator Barbara Boxer, playing herself at a Junior Leadership Brunch. Secretary of State Madeleine Albright appearing to Rory in a dream sequence. CNN Chief International Correspondent Christiane Amanpour guest starring as Rory's hero. The wonderful British actor Michael York in the recurring role of Asher Fleming, a Yale professor and author who developed a romantic relationship with Rory's friend Paris Geller (Liza Weil). Literally making my jaw drop open, Carole King, composer and performer of the *Gilmore Girls* theme song "Where You Lead," as Sophie Bloom, owner of Stars Hollow's music store. None of whom I got to work with, but that was beside the point. Watching them was enough of a delight to remind me over and over again that I was part of something very, very special.

And speaking of very, very special, an episode that's always stuck with me took place at a DAR (Daughters of the American Revolution) event that Rory organized. It was at that event that Emily confronted Shira Huntzberger. The mother of Rory's boyfriend Logan. A woman Emily once considered a friend. A woman who'd married the wealthy Mitchum Huntzberger. A woman who Emily discovered had told Rory she wasn't "properly bred" for their world and wasn't good enough for their son. In one of my all-time favorite monologues, Emily had the satisfying pleasure of eviscerating Shira Huntzberger at her center table. I kept a smile on Emily's face so that, from a distance, it could have appeared that she was

complimenting Shira on her dress and asking who designed it, while she was actually delivering lines like, "You were a two-bit gold digger fresh off the bus from Hicksville when you met Mitchum at whatever bar you stumbled into," and, referring to Shira's husband, "He's still a playboy, you know. Well, of course you know. That would explain why your weight goes up and down thirty pounds every other month." Finally, after a perfectly pleasant "Now, enjoy the event," Emily walked away to continue socializing. It was an absolute masterpiece by Amy and a joy to deliver, not only because it was Emily at her force-of-nature best but also because it was another display of her fierce love for her granddaughter.

That scene was in an episode from season six called "We've Got Magic to Do." I still remember, after we shot it, marveling at the fact that the show was as strong and fresh as it was in season one, and feeling so gratefully confident that *Gilmore Girls* could go on forever.

I was wrong.

Of course, we all contributed to the monstrous success of *Gilmore Girls*, but that was only because we'd been invited into the world of Stars Hollow that Amy and her husband/cowriter/producer, Dan Palladino, had created and manifested so brilliantly. It was a devastating shock, to say the least, when, after we'd shot the sixth season and I was back in New Jersey with Lee, I got a call from Dan saying that he and Amy were leaving the show, due to a long list of failures in contract negotiations.

A new writing team was brought in for the seventh season, and I know they tried their best, but there's no such thing as "trying to be" Amy Sherman-Palladino. We actors were contractually obligated for that seventh season, and we did the best we could too. It just seemed to get kind of sleepy and tired from one week to the next, as if the air was being slowly let out of a big, sparkly balloon, and we could sense that the party might be ending, even though no one wanted to say it out loud.

And sure enough, after seven seasons, 153 episodes, and more round trips from Burbank to New Jersey than I can begin to count, *Gilmore Girls* was canceled. Fans were understandably disappointed in that seventh season, and to the best of my knowledge, Amy still hasn't watched a single minute of a single episode of it. As for the rest of us, we all knew getting canceled feels like an inevitable possibility in series television, but we weren't ready for it, and it was heartbreaking to say goodbye. It's such a cliché to say it was like seeing your family split apart against their will, and yet that's exactly how it felt. We'd become so close, personally and professionally, and been through so much together over those seven years. Alexis and I rarely hung out during our off-hours, but I thought the world of her; and Lauren and I hung out a lot and had even started referring to each other as "TVM" (TV Mom) and "TVD" (TV Daughter). Of course, we hoped we'd see each other and work together again, but it's not the kind of business that makes that possible very often, with everyone scattering all over the place as they move on to other projects.

Nothing any of us could do about it, though, so like it or not on to the next.

* * *

I was back in New Jersey with Lee, doing some TV guest spots and a couple of films here and there, when I got an offer I couldn't quite believe—I was asked to replace Jessica Walter in a Tony Award–winning revival of the Cole Porter musical *Anything Goes* at the Stephen Sondheim Theatre . . . *on Broadway*. It was 2011. I hadn't appeared in a Broadway musical since *A Chorus Line*, more than thirty-five years earlier, and I was thrilled. It felt like coming home.

Anything Goes was a terrific show in so many ways, and a real breath of fresh air. The classic music of Cole Porter scored a story that was mixed in with a bit of vaudeville and a bit of farce, I got to do a little tap section in the finale, and I didn't even have to sing!

My character was a woman named Evangeline Harcourt, the overbearing mother of a young debutante, Hope Harcourt, played by Laura Osnes. Evangeline was hilarious fun to play because she took herself so seriously and had such overblown confidence in herself that she believed she was *never* wrong, while she fiercely held on to her upper-echelon social status out of a fear that she might end up poor someday. The more foolish I could make her look, the funnier the audience thought she was, and there's nothing more gratifying than hearing a live audience laugh, especially when you make it happen.

I'd gone to see Jessica Walter in the show before I took over the role of Evangeline, and there was only one "note to self" I came away with: Evangeline always carried her little dog, Cheeky, with her wherever she went. In this production, Cheeky was played by a

little stuffed toy dog, and Jessica carried it as if it were a roll of paper towels or something. Not me. I made such a fuss over that toy dog you would have thought it was real the way I petted it, scratched it under its chin, kissed it, cuddled it, basically did everything but take it home with me every night after the final curtain. For a small performance choice that might not have made a difference to anyone else but me, I got such satisfaction out of bringing that toy dog to life onstage.

There was one member of the cast in particular who completely blew me away. Her name was Sutton Foster, in the role of former-evangelist-turned-cabaret-singer Reno Sweeney. Good god, she had it all—a terrific actress, a great singer and dancer, sexy and funny at the same time, and she had a lot to do with the fact that the cast of *Anything Goes* was so happy and had such fun together.

Amy Sherman-Palladino came to see the show one night, and she was as enthralled by Sutton as the rest of us were. It so happened that Amy was writing a pilot for an ABC Family series. I'd already said yes to the role of Fanny in that pilot, possibly without even reading the script, and Amy and I were both ecstatic when Sutton, a die-hard *Gilmore Girls* fan, signed on to play my daughter-in-law, Michelle.

The series was called *Bunheads*, a slang word for ballerinas. The premise of the pilot was that Michelle (Sutton) was a former ballerina who became a Las Vegas showgirl (gee, that rang a bell), but eventually her career came to a grinding halt. On an impulse, Michelle got married and moved to her husband's sleepy little hometown in California. Then he was killed in a car wreck, leaving

Michelle to adapt to this new small-town life that included getting a job teaching at a local ballet school, owned and operated by her deceased husband's mother, Fanny (yours truly).

It was smart, it was fun, it was dimensional, and it was uniquely creative. In other words, it was textbook Amy.

It was also a Los Angeles production that was picked up for eighteen episodes, which meant I'd be back to the tough *Gilmore Girls* coast-to-coast commute. By then it was 2012, and Lee had been diagnosed with his fourth cancer, multiple myeloma. I knew he was really struggling because, for the first time ever, he didn't want me to take the job. But Amy moved heaven and earth to make it work as best she could for Lee, me, and the show.

It was difficult for all of us. Amy's already stressful, exhausting job had the added challenge of juggling my work dates to deal with. Lee was tackling his latest health crisis without me more often than either of us liked. And no matter which coast I was on or how hard I tried not to let it happen, I was always preoccupied, feeling as if I should really be taking care of my responsibilities on the other coast. I remember telling Amy one day when I was feeling especially used up, "I'm trying to serve two masters," and she replied, with her usual compassion, "Yes, you are." To this day, I still haven't completely forgiven myself for not being able to give 100 percent to her and to *Bunheads*.

Sadly, Amy was also getting no support at all from ABC Family, and in July 2013, the show was canceled after just one season. It deserved better, from the studio, and from me.

My one consolation was that I'd had a chance to perform Amy's words again, and I'd missed that so much since *Gilmore Girls* ended. For that matter, even though six years had passed, I still missed *Gilmore Girls* so much.

And apparently, I wasn't the only one.

Chapter
Eleven

I was far too busy focusing on Lee's ongoing health challenges to pay attention to the never-ending chess game of show business, so it was news to me that, in the years since Warner Bros. canceled *Gilmore Girls*, they'd sold the series to Netflix. That figured—as far as I was concerned, Warner Bros. had never fully appreciated its potential, or given it enough press and promotion in the first place, and they deserved to lose it. If they'd really known what they had, they would never have let Dan and Amy Sherman-Palladino slip through their fingers. I'll always believe that if Dan and Amy had been with us for season seven, it wouldn't have been our final season after all.

It reminded me yet again of a delightful book I'd read years earlier. It was called *Adventures in the Screen Trade*; and it was written by a man who knew exactly what he was talking about—William Goldman, screenwriter of such classics as *Butch Cassidy and the Sundance Kid* and *All the President's Men*, among many, many others. On the very first page of that book, he commented that there's one

thing to remember about this industry: "Nobody knows anything." I was also reminded of an apparently true story in the 1980s, that as a result of extensive research and several focus groups indicating that no one would be interested in seeing it, a major studio had turned down a Steven Spielberg movie called *E. T. the Extra-Terrestrial.*

Sure enough, as soon as Netflix bought and started streaming it, *Gilmore Girls* took off like a rocket. Not only did its original viewers jump right in to enjoy it all over again, but whole new generations were introduced to it and fell in love with it too.

In fact, *Gilmore Girls* became such a hit on Netflix that the Paramount Theatre in Austin, Texas, booked a fifteenth-year reunion for us on June 6, 2015, at the ATX TV Festival. All twelve hundred seats were filled, and it was overwhelming to hear all twelve hundred people singing along with our theme song, Carole King's classic "Where You Lead," when the opening credits started to roll.

Seventeen of us, including Amy and Dan Palladino, joyfully gathered onstage.

But there was a deliberately empty chair among us. Our precious, priceless Ed Herrmann, who'd been the first to sign up for the reunion, had passed away from brain cancer six months earlier, on December 31, 2014.

I hadn't even known he was sick until one day a couple of weeks before he died. I happened to be scanning Page Six of the *New York Post*, a page devoted to entertainment and celebrity news, when I noticed a brief article about some trouble between Ed and his business manager. I was just skimming it until I came across the words, "Herrmann, 71, who is battling brain cancer . . ."

I must have stared at those words for ten minutes, hoping I'd misread them, or that maybe it was just a misquote or something. When I ran out of desperate excuses and let that news sink in, it felt like a vicious gut punch. I almost reached for the phone to call Ed's wife, Star, but she and I barely knew each other, and I was afraid I might be intruding, so I called Lauren and Amy instead. They were as terribly shocked as I was, so much so that we struggled to even figure out what to say beyond "Oh my God" and "Please don't let this be true."

The next shock came a couple of weeks later, when Star actually called *me* to ask if I'd like to come to the Sloan Kettering Cancer Center in Manhattan to say goodbye to Ed. It was so thoughtful, and generous, and touching of her; and while saying goodbye to Ed was one of the last things I ever wanted to do, I wasn't about to say no.

I walked into that hospital room expecting to find other cast-mates there, but no, it was just Star, Ed's brother, his stepson, and one of his daughters. Ed was in a coma, on life support. I think I just stood there looking at him for several seconds, trying to process the incomprehensible reality of it. It was during those seconds that Star walked over to me and quietly asked, "Would you like to talk to him?"

I knew I'd regret it for the rest of my life if I didn't summon up the courage to get past all those tubes and beeping monitors and focus on the fact that this was Ed lying there. My great pal, my set buddy, my extraordinary "husband" for seven years. Whether he'd actually be able to hear me or not, of course I wanted to talk to him.

I had to talk to him, even though I didn't have a clue what to say without spending several hours, and I wasn't about to intrude like that on his family's time with that dear man.

In the end, I kept it short and sweet, which I'll bet surprised him. I walked over to stand beside his bed, took his surprisingly hot hand, and told him that Lauren, Amy, and Alexis sent their love.

Then Star said, "You can kiss him goodbye." So I simply kissed him on the forehead, left a lip print, and whispered, "Tell them that's from me."

I left feeling unbearably sad but at peace, and so grateful to Star for letting me share some of the last precious moments of Ed Herrmann's life. He used to say, "I've had three wives—the blond Star, the silver star [his first wife, Leigh Curran], and Kelly." I'll always be honored to have been one of them.

That empty chair on the stage that night in Austin for Ed was a beautiful way of including him. We'd all adored him so much, and it meant the world to us that Amy had put together a memorial video of some of his most unforgettable scenes as Richard Gilmore, including Richard and Emily's "Wedding Bell Blues" vow renewal reception. Amy, being Amy, concluded that moving tribute to him as only she could, with a loving, heartfelt "Fuck you for dying." There literally wasn't a dry eye in the house, including mine. Just writing about it and remembering him chokes me up all over again.

It was an extraordinary evening, and almost immediately we started hearing rumors about the possibility of a reboot of the series. Those rumors evolved into the reality of four commercial-free, ninety-minute episodes called *Gilmore Girls: A Year in the Life,*

produced by Warner Bros. for Netflix. Another "Gee, I wish . . ." come true, and it far exceeded any expectations I would have had, if I hadn't been too superstitious to let myself have expectations about it in the first place.

Without Ed Herrmann, there was no Richard Gilmore, and without Richard Gilmore, Emily was a widow in those four episodes. Amy had always been very close to her father, Don Sherman, an actor, comedian, and writer she adored. He'd passed away in 2012. We shot *Gilmore Girls: A Year in the Life* between February and May 2016, so not only was Amy's writing inspired by her own loss, but she was also able to add a whole new wealth of emotional depth to my character after watching her mother cope with widowhood. Of course, I'd seen my mom widowed too, and then gone through my own devastation of losing her, which made me manic and aggressive; I felt that if I were to slow down, I might fall completely apart and never be able to put myself back together again. So having Amy's scripts and my fairly recent personal history to draw from deepened the whole experience for me and gave me so many new places to go with Emily and so many new levels to explore.

It meant facing another four months of the New-Jersey-to-Burbank commute, though, and that wasn't going to be easy. Granted, I'd done it for seven years throughout the original *Gilmore Girls* and survived it, but I'd been younger then, and Lee's health hadn't been as fragile as it was getting to be in 2016. It was imperative that I spend as little time away from home as possible.

Saving the day, though, was Sheryl, Lee's daughter from his first marriage.

Sheryl had been part of my life for almost as long as I'd known Lee. She'd attended our wedding, and she came from her home in Virginia to visit us a few times a year, especially to celebrate her birthday on December 23. In spite of Lee's "I'm not a family man, and I don't want children" position, he and Sheryl adored and were incredibly devoted to each other, so she'd made many trips to New Jersey since his illnesses had become critical, and she knew the drill. She and Lee and I had a long talk about it, and Sheryl volunteered to spell me when I was filming on the West Coast—the three of us agreed that *Gilmore Girls: A Year in the Life* wasn't just something I was yearning to do, it was something I *had* to do, because my heart would have broken if that show had gone on without me.

That fact became apparent from the moment we dived in to the first episode of *A Year in the Life* and a reunion of us Gilmore girls. After that disappointing final year of the original series, we had Amy Sherman-Palladino at the helm again, so we were all exactly where we were supposed to be, and we never doubted that while Ed Herrmann was technically "gone," he was hovering around the set watching over us, because he loved that show, and us, and he wouldn't have missed it for anything.

Amy was smart enough not to kick things off with Richard Gilmore's death, the funeral, and all the predictable darkness that goes with losing a loved one. Instead, she picked up with the after-math, and Emily suddenly being a new, devastated widow. Rather than curling up in a fetal position and letting her grief paralyze her,

Emily was a raw nerve, manic and aggressive and trying to blast through her grief like a bulldozer, much like I'd done when I lost my mom. One of her most reliable survival techniques of refusing to be vulnerable started disintegrating, along with her studied elegance, and the St. John Knits frequently gave way to jeans and T-shirts as she started to rid herself of everything that suddenly didn't seem to matter anymore.

This woman who couldn't keep the same maid from one episode to the next in *Gilmore Girls* moved in not only a maid named Berta, who didn't speak a word of English, but also Berta's whole family. While it was never explained in the script, I took it as another sign of Emily's emotional evolution. Berta, after all, was a good cook, and cheerful, and her husband happened to be a very useful handyman, and I think at that point in her grieving process, Emily, who'd always been so insistent on taking charge and running things in the household, didn't have the strength or the ability to focus to turn down the opportunity to let someone else deal with them and take care of her until she was back on solid ground.

Emily's determination to declutter the house, inspired by a recommendation from one of her fellow garden club members to read Marie Kondo's book on how tidying up can be life-changing, really amused me. Her looking at everything she owned, piece by piece, including her dining room chairs, to decide whether they "brought her joy" wasn't just fun to play with Lorelai, it also fit with Emily's evolving ability to recognize what mattered and what didn't. What really touched me in that scene, though, and what I didn't see coming when I first read that script, was Lorelai's deep, open sympathy

for her mom, and the two of them arriving at a rare meeting of the minds the "old Emily" wouldn't have been emotionally available enough to allow.

Leave it to Amy to have Emily circle back to the DAR, site of her confrontation with Logan's mother, Shira Huntzberger, for another artful rant that further illustrated the changes Emily was going through. I especially loved working with the remarkable Carolyn Hennesy, who played a character named Toni. You could tell that Emily and Toni had been in more than one battle over the years about which of them was in charge of their branch of that organization. Through Emily's eyes, the veil of superficial propriety and hypocrisy among the members had obviously lifted, and she'd had all she could take. She didn't even try to hide her boredom, yawning and wandering over to a table of snacks during a conversation among the other "daughters," until she finally hit a wall and announced that she couldn't waste another minute on "artifice and bullshit."

It was the second or third time Emily used the word "bullshit" in that scene, with Toni finally warning her not to say "bullshit" to her one more time. I loved it, but it shocked me that Emily was finally getting to swear, until Amy reminded me that this was Netflix, not network television, so we were pretty much free to say whatever we wanted. She also delighted me with her decision that the only person who'd swear in *A Year in the Life* would be Emily. It made perfect sense.

That DAR scene ended with Toni excusing Emily from the organization (very politely, of course), and I thought Emily's last

two lines as she walked out of that room were indicative of how she was feeling about so much of the shallow pretense she'd been tolerating in her life for years: "This whole thing is dead to me anyway. It died with Richard."

Another reason I took such delight in that scene was that it felt kind of like Kelly Bishop peeking out from behind Emily Gilmore. This is not an indictment against the DAR, since I've never been to a meeting or talked to anyone who has; I avoid elitist, exclusionary groups like the plague. On the very rare occasions when I've found myself surrounded by judgmental snobs, I've been politely tolerant while secretly looking for the exit. The opportunity Amy gave me to act out a fantasy, what I'd love to do in groups like that if I had Emily's chutzpah, was as much fun as being turned loose on a playground.

From one script to the next, Emily's evolution was undoubtedly as much of an interesting surprise to me as it was to the audience. When she began to realize that Richard was really the only person she'd been close to, while the women in her Hartford social circles were just arm's length acquaintances, not friends, she sold her and Richard's mansion, which had become nothing but a big, empty house full of memories to her, and moved to their vacation home in Nantucket. She took a job as a tour guide in a whaling museum and developed a real empathy for animals and the environment. Her loneliness even led her to start dating a man who'd been a good friend of hers and Richard's, although while she appreciated having warmth and affection in her life again, she was actually relieved when he left. So much for that.

But most of all, she finally managed to work her way closer to Lorelai, something she'd yearned for, for as long as we'd known her. She even came full circle and blackmailed Lorelai and her new husband, Luke, into coming to Nantucket for two weeks every summer and one week at Christmas, in exchange for giving her a loan to expand the Dragonfly Inn, just as she'd blackmailed her in the *Gilmore Girls* pilot episode—Rory's tuition fee, in exchange for Lorelai joining her and Richard for dinner every Friday night. Now that she'd stopped resenting the distance between her and her daughter that she never did understand, she was able to let herself be vulnerable enough to finally show her admiration for the success Lorelai had created for herself, and the love she'd always felt for her, underneath her misguided belief that she was setting an example of how proper, respectable people live.

A lot of fans were frustrated by the loose ends they felt they were left with when *Gilmore Girls: A Year in the Life* ended. I prefer to think that those "loose ends" were simply left to the fans' imagination to tie up.

Those mysterious "last four words" between Lorelai and Rory, for example—"Mom?" "Yeah?" "I'm pregnant."—struck me as more interesting than infuriating, since it opened debates among viewers to decide who Rory was pregnant by, and what the repercussions would be. I personally think it was Logan, by the way. I was always Team Logan. All the young actors on *Gilmore Girls* were terrific, on- and off-screen, but while several of them seemed

boyish, Logan (Matt Czuchry) took a more manly approach that I thought worked perfectly as a partner for Rory. And as for Lorelai, I was definitely Team Luke (Scott Patterson). It wasn't just that Luke genuinely loved her. He also understood that he was dealing with a very quirky, specific woman, and he "got" her. I loved watching them together.

Where would Emily go from there? Almost anywhere she wanted, as far as I'm concerned. I refuse to believe she'd settle for anything less than happiness for the rest of her life. She had plenty of money, she had her daughter and granddaughter to love and be loved by, she was growing enough not to take advantage of her freedom, and she was too smart not to have learned from everything she's been through.

There's no doubt about it, we were all sad to see *Gilmore Girls* come to an end, but it's far more important to me, and I'm sure to the rest of us as well, that we'd had it to perform and invest in and celebrate in the first place.

And its ongoing impact, thanks to Netflix, still touches me to this day. I never cease to be amazed not only by the wide variety of people it continues to attract but also by the number of people who approach me about it.

When Lee and I were first dating in the late 1970s, I was primarily a stage performer, while Lee was a television personality making the transition from ESPN to CNN. It was a source of fascination to me that when we'd be introduced to people as a couple, they'd typically respond, "How do you do, Ms. Bishop? How do you do, Lee?" I finally asked Lee why he thought that kept happening, and his

theory made perfect sense: seeing me onstage meant getting dressed, traveling to a theater, and watching me from a distance. Seeing Lee, on the other hand, meant hanging out in your living room in your pajamas and turning on your TV. The more I thought about it, the more sense it made. Even during *A Chorus Line*, I was rarely approached by fans, and those who hung out by the stage door after shows were enthusiastic but always stayed a few feet away. But once I started showing up, as Lee put it, in people's living rooms, I became "part of the family" and much more approachable; so I get to hear fascinating feedback up-close-and-personal.

I've talked to many women who told me about binge-watching *Gilmore Girls* with their daughters, how it actually brought them closer and how exploring the dynamics between Emily, Lorelai, and Rory taught them lessons about their own relationships.

A growing number of men, who'd paid little attention to *Gilmore Girls* on the WB, probably because it had the word "girls" in the title, started becoming addicted to it when Netflix picked it up. My theory has always been, and still is, that the attraction for men (besides the loveliness of the female cast, of course) is the inherent decency of the male characters. Yes, they were flawed, as were the female characters, since the series did take place on this planet, after all. But there were no stereotypical misogynistic bad guys, no freeloading jerks or fast-talking con men, just guys who were going along doing the best they knew how, like everyone else. It was refreshing, and it was fair, and I'm always delighted when I hear that men have joined our growing crowd of admirers. I've even been told by more than one reliable source that soldiers coming home from

Afghanistan are some of the biggest fans of the show—reinforcing my theory about the innate decency of the show and its general fairness toward the male of the species.

A woman I know through my primary care physician called a few weeks ago to tell me that her eleven-year-old son has become "addicted" to *Gilmore Girls*, and she described his reaction to hearing she knows "Emily" as being identical to the Macaulay Culkin *Home Alone* poster.

Something similar happened when Jovany, the man who shovels snow off my driveway and sidewalks every winter, called one day and, with my permission, put me on the phone with his thirteen-year-old daughter, a *Gilmore Girls* binge-watcher.

Very often I'll go to the grocery store, unrecognizable (please, God), dressed like an eight-year-old boy in my baseball cap, sweats, and shades and not even be glanced at until and unless I open my mouth, on which there's invariably someone who'll spin around, look at me, and say, "Emily?!"

And I was nothing short of shocked when I was leaving a restaurant one evening and a young girl in her early twenties or so hurried up behind me to ask if I was Emily Gilmore. I confirmed that yes, I was, we chatted for a few minutes, she took a selfie of the two of us, and she couldn't have been sweeter and more excited. Why was I shocked? Because that particular encounter took place during my trip to Salzburg, Austria! Talk about "Who saw *that* coming?!"

I'll always treasure every bit of it and be so grateful.

. . . Especially to the teenage boy who happily and a bit shyly approached me at my local gas station one morning, when I was a

month or two into writing this book. I was completely immersed in the first few chapters about *A Chorus Line*, my childhood, and the incredible impact being a dancer had on my life, and I had pretty much decided that the title of my memoir was going to be *At the Ballet*. Then along came that sweet boy at the gas station, who recognized my voice (I was in my eight-year-old-boy errand-running ensemble) and was excited to tell me that he'd been binge-watching *Gilmore Girls* on Netflix, that Emily was his favorite character, and that, as far as he was concerned, Emily was and always will be "the third Gilmore Girl." I'd heard that from fans a few times before, but I guess, with this book and possible titles on my mind, it made a particular impression on me. I mentioned it to my agent, who mentioned it to the publisher, and thanks to a well-timed remark from a teenager who happened to have stopped for gas at the same time I did, *At the Ballet* became *The Third Gilmore Girl*.

The only fans I ignore, by the way, are the ones who send mail directly to my house. I *never* respond, or even open it. It seems rude and intrusive to me, and I immediately black out my address on the envelope and put it right back in my mailbox with "Return to Sender" written very clearly on the envelope. Other than that, I don't remember a single unpleasant experience with a single fan.

I've been asked more times than I can count about my favorite part of the whole *Gilmore Girls* experience. Right up there at the top of the very long list is the fact that we were a company. An ensemble. There was no "star," and there's something I've known about myself

since I was a little girl who was falling in love with ballet: I wanted to be a performer, but I never wanted to be a star.

It was an epiphany I trace back to, of all people, Marilyn Monroe. She was one of the biggest movie stars in history and undoubtedly one of the most famous women in the world, and I was fascinated by her. She was beautiful, and magnetic, and sexy, and when she was on-screen, you couldn't take your eyes off her. But when the grown-ups talked about the off-screen Marilyn Monroe, they seemed so dismissive of her, labeling her a "dumb blonde," just some vapid airhead who always happened to be on every magazine cover at the newsstand. And even as a child, I kept thinking, *That's what she plays in the movies, and she's great at it! It has nothing to do with who she is, so why would you disrespect her and make fun of her like that?* I came to equate fame and stardom with being set up to be laughed at, no matter how good you were as a performer, and I decided it wasn't worth it.

Throughout my career, I've seen and heard countless stories of how fame and stardom can become a full-time job. We dancers, for example, worked our asses off. We started the earliest, we stayed the latest, we made the least amount of money, and we weren't necessarily even known by name, but I swear we were also the happiest and had the most fun. In sharp contrast, a lot of Vegas headliners, and TV and movie stars, had to be intensely involved in everything from the lighting and sound system to the most flattering camera angles. They had to make sure they looked perfect every time they stepped out their front door, were seen talking to the right people, and were never caught in public in anything but the fanciest clothes and the

fanciest cars, and they had to monitor how close their assigned park-
ing space was to the set (and how the size of their trailer on the lot
compared to the size of their castmates' trailers)—in other words,
a long list of things I can't even relate to, let alone care about, and
hardly worth the price of forfeiting your fun and your happiness.

I've been blessed with a career that's had its disappointments,
but for the most part it's been a series of dreams come true. The fact
that I've done it on my terms, without compromising my privacy,
my integrity, and my relative anonymity, makes it even more grati-
fying. I can't imagine having done it any other way and still looking
back on it with the joy and the satisfaction I do today.

I'm sure another reason that *Gilmore Girls*, and especially *A Year
in the Life*, had such an impact not just on the general public but
also on me was something I never made an issue of to anyone but
myself—it was never too far from my mind that, as hard as I tried
not to think about it, sooner or later I might be living a form of
Emily's life myself . . . the life of a widow.

I prayed for "later."

I was given "sooner."

Chapter
Twelve

Lee was fighting his way through his sixth cancer, and they'd taken such a toll on his body that just walking was a challenge for him. But he never lost his Superman status with me, especially when I was blindsided by my own medical drama.

New Jersey was recovering from a typical East Coast winter ice storm, which didn't interrupt my daily routine of feeding the outdoor cats in the neighborhood. Early one morning, food in hand, I put one foot on a paver at the bottom of the wooden steps to our front porch, and next thing I knew, I was airborne and landed hard on my left side. My left leg was suddenly useless, and my right leg kept slipping on black ice when I tried to stand up. I finally managed to get on my feet and stagger back into the house, where I yelled for Lee. He was usually a light sleeper, but there was no response. I yelled again, and again, and again. Still nothing, while the pain in my left side kept getting worse.

I distinctly remember thinking, *Oh, great, I've broken my hip, and my husband's dead. These things happen in threes, so what's next?*

Then I heard a sleepy little mumble behind me and turned to discover, to my relief, that Lee had struggled out of bed and rushed as best he could to help me. My pain was getting worse, to the point where I could barely stand, so he put an arm around me to hold me up and grabbed one of the golf clubs beside the door for me to use as a cane (not very effective, if you're wondering). He then went to the garage to retrieve his walker while I put in an emergency call to the South Orange Rescue Squad.

Minutes later, a four-person team skidded to a stop in front of the house and got me to the hospital. Lee apparently forgot who he was married to, because he thought he was coming with us, as if I'd let him set one foot outside onto black ice. X-rays indicated that somehow I hadn't broken anything, so neighbors picked me up from the emergency room, drove me home, and helped me inside, and my husband and I became the cutest debilitated couple on our block. After watching that man go through six bouts of cancer without a complaint, I wasn't about to let him hear so much as a whimper out of me.

A few days later, though, I finally admitted, "This hurts too much to not be a break," and Lee's orthopedist ordered an MRI. I was right. I had fractured my sacrum and my pelvis in two places. For the next six weeks, I scuffed around with a walker, went up and down stairs on my butt, and figured out that I could just as easily feed the neighborhood cats and let our dog into the backyard from inside the house.

Lee did his damnedest to take care of me while I healed, but nothing made quite as much of a difference as the day he looked

at me and said, "I love you so much it makes me want to cry." Pain or no pain, walker or no walker, I'd never felt so powerful and so invincible in my life as I did in that moment. I still relive it, and it still fills me up.

Then 2018 came along, and so did lots of calls from my agent Robert Attermann, who had the patience of a saint. He was getting inquiries about my availability for all sorts of projects, and I kept teasing myself into thinking that maybe I could figure out a way to say yes. On one hand, I really wanted to work. On the other hand, Lee wasn't doing well, and while he had a wonderful team taking care of him, in the end I'd realize I was just kidding myself into believing I could leave him. Time after time, I'd tell Robert I'd think about it, come to my senses after a day or two, and then call him back and say no. Which meant that I was making life harder for my agent, and for the producers and casting people who were waiting to hear whether to keep me on their list of possibilities. Finally, reluctantly, with my permission, Robert put me on the "unavailable" list until further notice.

It was a tough time. If you've ever lived with a loved one whose health is declining, you know the drill: You'd sell your soul to make them better, but that deal's not on the table. Along with the doctors and caregivers, you're doing absolutely everything you can do to help, but some part of you knows that, unless you're suddenly given the power to work miracles, nothing you can do is really going to make much of a difference. When you find yourself feeling kind of

trapped, you recognize that the only way out is for that person you love to your core to check out, and the thought of that is unbearable. You do your damnedest to keep your spirits up because you don't want your loved one to worry about you, but privately, you're constantly on edge and emotionally exhausted. And every time you give in to admitting to yourself how tense and depleted you are, you feel as if you have no right to complain, since, compared to your loved one, you've got *nothing* to complain about.

I was hitting a breaking point with all of that going on when Robert called. Not with an availability inquiry, with an actual offer. To do an independent film, written and directed by a young movie maker named Alexander Lercher, whose directorial debut *Forward. Side. Close!* won the Emerging Filmmaker prize at the 2015 Hollywood Film Festival. The movie I was being offered was called *The Salzburg Story*, shooting in Salzburg, Austria, and my role would require my being gone for an unbelievable total of five days. Day #1: Travel to Austria. Day #2: Costume fitting, meeting with the hair and makeup people, followed by a private tour of Salzburg. Days #3 and #4: Work. Day #5: Fly home.

And oh, by the way, the offer also included one first-class round-trip plane ticket, or two business-class round-trip plane tickets, plus, of course, food and lodging for either one or two people in Salzburg for the three days I'd be there.

Lee didn't want me to go. I understood that, but as I told him, from the bottom of my heart, "This is a gift from God to me." He got that, and as hard as I'd tried to keep it from him, he also knew I desperately needed a break. Sheryl agreed to come from Virginia to

take care of her father while I was gone, and finally, unselfishly, Lee gave me his blessing.

The only remaining issue was whether it was a good idea for me, a seventy-four-year-old woman, to be traveling to Europe alone. Lee didn't think so. My agent didn't think so. I didn't think so. And thanks to the film company's generous offer, I didn't have to. I grabbed my cell phone, called my best friend, and asked, as casually as the question would allow, "Hey, Priscilla, would you like to go with me to Salzburg, Austria, for five days, all expenses paid?" As "luck" would have it, the travel dates didn't interfere with a play she was getting ready to do, her husband, Vincent Fanuele, thought it was too good an idea for her to pass up, and just like that, Priscilla and I were off to Europe.

It turns out the old saying, "If it sounds too good to be true, it probably is," has exceptions, and *The Salzburg Story* experience was definitely one of them. I was right, it was a gift from God to me—exactly the opportunity I needed to decompress, emotionally regroup, and be on the receiving end of Priscilla's fun, adventurous, unwavering friendship and support.

Priscilla and I were treated like royalty from the minute we stepped off the plane. First it was off to our hotel, the only hotel room I've ever stayed in that featured not one but two crystal chandeliers, one above the bed and the other one above the sitting area. From there we headed on to a tour of that unforgettably charming city, compliments of Alexander's parents, who were there to be supportive of their son and his cast and crew. They hired a personal tour guide for Priscilla and me, and it was magical. We visited a castle

called the Hohensalzburg Fortress that dates back to the eleventh century. A wealth of stunning baroque monasteries and churches. The historic residence of Mozart on the Makartplatz Square that also houses a museum featuring everything from the home's original eighteenth-century furniture to Mozart's own violin and clavichord. A footbridge over the Salzach River, where what seemed like a thousand "love locks" were clasped to the bridge's fencing, thanks to a timeworn tradition in which lovers inscribe their initials on little padlocks, attach the padlocks to the fence, and then toss the keys into the river to symbolize the permanence of their love. Countless little brass memorial plates installed in the sidewalks, bearing the names of victims killed by the Nazis and placed outside the victims' last homes or workplaces.

Sometimes Salzburg took my breath away, with its architecture and its views of the Eastern Alps, and sometimes it brought me to tears—partly because of its reverence for its past, and partly because I'd suddenly find myself thinking how enthralled Lee would have been with it everywhere he turned.

And then, as if they hadn't already done enough for us by treating us to that private tour, Alexander's parents took Priscilla and me to dinner at St. Peter Stiftskulinarium, the world's oldest restaurant that was originally a monastery built more than twelve hundred years ago against the side of a mountain. I remember loving the food, but I was so enthralled with the structure of that place, particularly the wall of mountain rocks, that I can't begin to recall what I ordered.

By the time Priscilla and I boarded a plane to fly home, the two of us had fallen in love with Salzburg, Austria, and we also unani-

mously declared Alexander Lercher's mom and dad to be the most supportive, generous parents we'd ever met. In addition to everything they did for their son, for us, and for everyone else involved in *The Salzburg Story*, I was especially touched at how they saw to it that Priscilla was included in everything as if she were a member of the film's cast.

We walked through our respective front doors five days later, as promised, so glad and thankful we went. I'll always think of it as one of the fondest memories of my life, and the trip that restored me enough to get through what was waiting for me at home.

First came the news that Lee's myeloma, after a few years in remission, had come roaring back. He started chemotherapy for the first time, and his oncologist was sure it was working. What he couldn't understand was the fact that Lee wasn't getting better. Then a chest X-ray finally revealed another tumor in his lung, followed by the discovery of more cancer and blockage in his urethra. Da Vinci (robotic) surgery was able to remove that, but there was nothing it could do about the scar tissue left behind by his prostate cancer.

Finally, the oncologist said the words we'd spent years silently bracing ourselves for: "Lee, I'm signing you up for hospice."

Lee didn't even flinch. He simply asked, "How long do I have?"

"Weeks to months."

I took a deep breath and said, "I want him home." It wasn't a request; it was a nonnegotiable demand, and the doctor didn't argue.

For the next four or five weeks, there were regular visits from the wonderful, compassionate hospice care professionals who kept Lee

as comfortable as they possibly could, while he and I continued to sleep in the same bed. He gradually stopped eating, getting weaker and weaker by the day. As heartbreaking as it was to watch him decline, I cherished every minute of getting to stay so close to him and knowing he was being well cared for.

But then one night I was jarred awake by the sound of a nearby thud and discovered that Lee had fallen out of bed. That was the end of our sleeping together.

I immediately arranged for a hospital bed to be delivered to the house and set up in the office beside the large window that looked out over the neighborhood he loved.

He was in that bed for one night.

The next morning, I stepped into the room to check on him and found him looking out the window, or at least *at* the window, with such intense concentration that he didn't even notice I was there. He was almost frowning, not as if he was unhappy but as if he was totally focused on something, or someone, and even though he'd had nothing to eat or drink, his mouth was moving as if he were tasting or chewing something. There wasn't a doubt in my mind that he was communicating with somebody, and I wasn't about to interrupt. I'd had other people tell me about a loved one who's nearing the end of their earthly life who think they're seeing someone, and in a panic they'll say, "No, that's not true, you're still here!" and break up their loved one's experience. I couldn't bring myself to presume that Lee was imagining whatever was going on with him, so I said nothing. Out of curiosity, I did move toward the end of the bed and step into his line of sight, but instead of acknowledging

me, he simply moved his eyes past me to continue focusing on who-ever/whatever had him so captivated. Then, still without making a sound, I left the room.

Before long a man named Samson, who was part of Lee's extraor-dinary hospice team, arrived at the house to check on him. He suggested we give him a bath, which sounded like a great idea. By the time we walked back into the room, Lee was lying there quietly on his hospital bed. His eyes were closed, and he looked so peaceful as I walked around to the far side of the bed to put my arms around him and help Samson carry him to his bath.

I held him for a few moments before I turned to Samson and almost whispered, "I can't feel a pulse."

Samson briefly examined him and then turned back to me and told me all I needed to know with his kind brown eyes and a word-less shake of his head.

It was December 16, 2018, when Lee left.

I've never said, nor will I ever say, "He's gone," or "He died."

It was, and always will be, "Lee left."

It had been more than two decades since that odd bruise appeared under the nail of Lee's index finger, a bruise that turned out to be mel-anoma. More than two decades of watching him be knocked down by one cancer diagnosis after another, get back up again, and go right on with his life and our lives together. I probably told myself many times in all those years that I was enough of a realist to be preparing for the inevitable day when my husband's body would finally give up. I was

wrong. As I discovered that morning, there's no way to prepare for what somehow felt so sudden. He was here. Then he wasn't. He never would be again, and there was nothing I could do about it. I couldn't wrap my head around it. But I had to, unbearable as it was—almost as unbearable as the thought of his continuing to suffer.

I called Priscilla once I'd had a few minutes to pull myself together. She and her husband, Vinnie, were there in no time, followed by a young funeral director friend of theirs who took Lee out of the house and made all those incomprehensible post-mortem arrangements I was in too much of a grief fog to deal with.

Lee wasn't an observant Jew, so finding a rabbi wasn't on the to-do list, nor was putting together a funeral, since Lee *hated* funerals. Vincent put me in touch with a reporter from the *New York Times*, Lee's favorite newspaper, and his obituary was published there. ESPN, CNN, and other news and entertainment stations he'd worked for did some lovely tributes. Veteran ESPN sports anchor and reporter Bob Ley, who'd been Lee's sidekick in the network's early years, described him so well in a couple of those obituaries:

"Lee brought a great deal of credibility and needed experience to ESPN at a critical time in the network's development. He was also a great dinner partner. . . . Sometimes he'd say, 'Let's get this show written so we can hang out and tell some lies.' He was a team player. He brought life to the newsroom. He didn't take himself too seriously. He didn't take the games so seriously. There was a lot to this guy, more than just anchoring *SportsCenter*."

I was determined to find a way to gather everyone who knew and loved Lee so we could celebrate his life in a way he would have

tolerated. The solution turned out to be a memorial service on what would have been his ninetieth birthday, April 3, 2019. It was perfect, essentially a large informal cocktail party at an event venue in Belleville, New Jersey, about a half hour from South Orange. No speeches, no sad music, just a warm, cozy room with lots of wood, a bar, and doors that opened onto a generous patio. We celebrated Lee with wonderful food and dozens of great pictures and hugs and happiness and an endless supply of anecdotes about that remarkable man, the love of my life.

A psychic medium even attended, a gifted, self-effacing woman I'd met through Priscilla. I asked her if she got any sense that Lee was there with us. She said, "Yes, he is, and he's very grateful."

Same here, Lee.

Having a psychic medium at Lee's memorial was in perfect keeping with my lifelong belief in spirituality, a deep certainty that there's a lot more to being human than this finite, mundane, earthbound world we live in, that we're really part of a much greater cosmic whole that's all around us. It's up to us to keep our minds and our hearts open to that possibility instead of being so quick to shrug off what could be signs that we're connected to higher dimensions than we pretend we are, and a couple of events in my life have stayed with me over the years to remind me.

One night, for example, not long after my first marriage ended, I left a group of friends on the Great Lawn in Central Park after a concert and walked to the bus stop at Central Park West and Eighty-First

Street, and headed back to my crappy one-room, roach-infested apartment that was all I could afford after Peter cleaned me out.

I was alone and lonely—not sad, not happy, just kind of existing in one of those empty phases where you put one foot in front of another only because it feels better than sitting around staring at the wall hour after hour.

I wandered up to join the six or seven people who were gathered at the bus stop and stood there a foot or two away, so lost in thought that I didn't even notice a nice-looking young man in his late twenties passing by, until he came up and stood right in front of me.

Without a word, he took my face in his hands and kissed me— not a quick peck, but a serious kiss on the lips that lasted several seconds. Then he simply dropped his hands and kept on walking.

It was sweet. It was gentle. It made me feel good, and special, and cared for, as if that young man, that total stranger, somehow knew what I needed right then, gave it to me without expecting anything in return, and moved on. The other people at the bus stop were staring at me, apparently as surprised as I was and expecting me to explain what just happened, but I had no explanation to offer. I couldn't explain him. I couldn't explain finding grace rather than revulsion in being kissed on the street by a man I'd never seen before in my life and would never see again.

Because it was such a once-in-a-lifetime, almost ethereal experience, I've wondered ever since if maybe he was my guardian angel, or my spirit guide. In the end, I'm not sure it even matters. What does matter is that those few moments deepened my faith that even at our loneliest, we're never really alone.

And then there was the day I was taking my dog Dixie for an off-leash walk in a forest reserve, not long after a ferocious hurricane had blown through New Jersey. As gorgeous as the weather was that morning, it seemed like sacrilege to see the devastation that hurricane left behind in such a perfect, peaceful place; of course, Dixie still thought it was a great opportunity to run around, so why let a sea of fallen trees and torn-up natural beauty ruin a good romp?

We were on our way down a dirt trail toward the car when something told me to come to an urgent, immediate stop. A few seconds later, while Dixie and I stood there, a huge branch came crashing down right in front of us and hit the ground so hard it bounced up again before it came to rest maybe ten feet away. It was like a bomb going off, and it took us several moments to regroup and proceed to the parking lot.

My heart was pounding all the way home. I'm not sure which was hitting me harder—the shock of that explosive near miss, or the undeniable fact that if something hadn't told me to stop walking at that exact instant, my dog and I would have been killed.

I can't count the number of times I've relived that morning and realized all over again how important timing and instinct are in our lives. I also started being intrigued by, and even taking pleasure in, replacing "something told me" with "some*one* told me." I love the idea that, whether it's a major message like the one I was given that day telling me to stop, or a minor one like whether to turn right or left at an intersection, or just to pick up the phone and make a call that's suddenly occurred to me, maybe it's my guardian angel, or my

spirit guide, giving me that cue and taking care of me rather than a meaningless "something."

There were still countless days when I desperately needed reassurance that Lee was "alive and well" and still around, so I called the same psychic medium who'd come to the memorial service and invited her to my house to give me a reading. I didn't want generalities; I wanted some kind of specific message, something this woman would have had no way of knowing that couldn't have come from anyone but him. And she and Lee didn't let me down.

She started by assuring me that he was doing great, and he was very happy, and he described walking into a room where a group of guys were applauding him and whistling and cheering because they were so glad to see him. Nice to hear, but kind of generic and predictable, I thought—I certainly didn't expect her to kick off the reading by telling me my late husband was miserable and alone.

She started to get my attention, though, when she added, "He's sitting in a cart, or something like a cart."

A golf cart. Of course. That's exactly where he'd be. Maybe Lee was communicating with her after all. Maybe . . .

She added, "He says there were two people with him when he died." Also true. Samson and me. I was getting more convinced.

Then, at some point, out of nowhere, the medium asked, "Did you or do you have a bench around here somewhere that the two of you sat on?"

I shook my head. It didn't even ring a distant bell, until she went on, rather emphatically.

"He's showing me a bench," she said. "The two of you are sitting on it, and you're singing."

Oh my God.

When Lee and I were first dating and starting to get serious, he took me to a beautiful golf resort in the Catskills. After dinner, we went outside to the pool area and casually sat down on, yes, a bench, where we did something we'd never done before—we started singing to each other, just random standards off the tops of our heads. It was sweet, and lovely, and romantic, and it took on extra significance when he told me later, "That's when I fell in love with you."

As if that wasn't amazingly specific enough, she got quiet for a couple of seconds, listening, and then announced, "Now he's talking about a ring. It must be a wed—" She stopped abruptly, in the middle of the word, and then continued, "Oh, no, no, no, he says he didn't wear a wedding ring."

No, he didn't wear a wedding ring, and I knew exactly what he was telling her about. It was an Erté ring I'd given him as a birthday gift that he loved, that was very special to both of us. It was a classic Erté art deco piece, brilliantly designed, three-dimensional, with a little square top, one side almost looking like a little fan opening up, and the other embedded with a small lapis stone, also known as "the Wisdom Stone." Lee only wore it on very special occasions, on the ring finger of his left hand.

Again, it was something the medium couldn't possibly have known about. She was definitely communicating with Lee, and he was definitely still around, watching over me and making sure I

knew it was him. It was comforting. It was soul-affirming. It was an experience I'll always treasure.

But sadly, it couldn't take the place of having him there with me, not only his spirit but also his whole self, climbing into bed with me; sitting at the dinner table with me talking about anything, everything, and nothing at all; laughing with me; holding my hand; just looking at me across a room as if he thought I was the most beautiful piece of artwork he'd ever seen.

Inevitably, a time comes after a loved one has left when all the distracting busyness ends. Friends who've been right by your side through the crisis head home and get back to their lives as they should, lawyers and accountants get the postmortem paperwork signed and filed away, the silence becomes deafening, and the full force of ugly, excruciating, inescapable grief crashes into you until you're afraid it might consume you.

So when, maybe a month after Lee left, I got an offer "out of nowhere" for a part in a TV movie called *Art of Falling in Love*, I immediately said yes and boarded a plane for Toronto to start filming. It put me in negative-four-degree weather on my birthday, which my body didn't appreciate, but my head welcomed the opportunity to focus on anything else.

Robert Attermann had been so supportive and kind and patient in my "absence," giving me all the space I needed but checking in from time to time to see how I was doing without ever pushing me. I've talked to several actors who strongly believe in changing agents

every two or three years. I believe just as strongly that if you've stopped trusting the agent you've got, get out. But if you've got a good one, as I've had with Robert, give them the same respect and loyalty they've given you and *stay put*.

So after the TV movie in Toronto, he left it up to me to let him know when and if I was in good enough emotional shape to work again, and the minute I told Robert I was ready, he got me a job playing fashion publicist Eleanor Lambert in an episode of a wonderful miniseries called *Halston*, with the delightful Ewan McGregor in the title role.

It felt great to have something to look forward to again, and to get out of my own head and into the head of this forceful woman. I did a little research on her when I was hired and fell in love with her and the role—Eleanor Lambert, I learned, had a vision, a determination to elevate American fashion to the forefront, and she made it happen. She was a genuine trendsetter. What made her even more fun to play was that while she lived in an elite, elegant world, surrounded by influential people, she also had what was universally described as "a mouth like a sailor."

It was February 2020, a week or two before I filmed my first scene, when I had to call my veterinarian to let my precious, elderly dog Dixie go. It was time, and it devastated me. Dixie had been my connection to "normal" since Lee left. She loved me, she needed me, and she provided me with a daily routine I wouldn't and couldn't get too self-involved to ignore. It's excruciating when you have to ask yourself if you love a pet enough to say goodbye to them when you know it's what they need, and sadly, thank God, the answer is yes, you do.

I've wondered many times since if it would have finished me off if *Halston* hadn't come along.

As with almost everything but theater and live sitcoms, the scenes weren't shot in order, and when we'd finish filming for the day, I'd always ask our director, Daniel Minahan, what my next scenes were so that I could thoroughly prepare and not hold up production.

So one night, shortly after we'd started shooting, I called to ask about my next scenes.

Impossible to say, I was told. "We're closing down because of COVID-19."

It was shocking, but not. Other productions had been shuttering all around us, and we assumed our turn was coming. Like everything else about the pandemic, it was scary, and completely disorienting. Everyone's lives on the planet were being turned upside down, with no way of knowing when, or if, it might end and what, if anything, we could do to protect ourselves, other than to stay as isolated as possible, get vaccinated, and wear a mask, all of which I did.

Compared to countless other people around the world, I had so little to complain about as the months of shutdown dragged on. In fact, I even found a way to give myself a reason to celebrate—in May of that year I had the honor (exactly what I believe it is, by the way) of adopting a six-year-old dog. Her name is Dolly. Like every other animal my mom and Lee and I have ever owned, she's a rescue, probably with plenty of foxhound in her, since she's a redhead with traces of white in her fur, and blond eyelashes. She's fascinat-

ingly stoic, she's never met a soft toy she doesn't like, and she fiercely prevents the mailman from coming into the house every day to steal everything I own. She's also given me the love and laughs and structure I'd so desperately needed since Dixie left, and all of us had been so desperately needing since that despicable word "COVID" entered our vocabularies.

Halston finally managed to finish filming, and it came out as beautifully as we all knew it would. It premiered on Netflix in May 2021 and led to Ewan McGregor's Emmy Award for Outstanding Lead Actor in a Limited or Anthology Series or Movie.

Again, I'll always wonder what my sanity and I would have done without it.

And speaking of preserving my sanity, my first trip to a restaurant since the shutdown was a lunch with Lauren Graham and Amy Palladino. The three of us had been staying in touch and checking up on each other during the pandemic, including those newly popular, bizarre conversations about Moderna versus Pfizer and which masks were most effective. Seeing those two women I adored but having to remain "socially distanced" from them took a lot of restraint, and being out in public again felt more awkward than liberating. Before long, though, we were chatting away and catching up as if no time had passed. Amy and her husband, Daniel, had moved to Brooklyn Heights and were enjoying great success on their hit series *The Marvelous Mrs. Maisel.* Lauren was her usual busy, incredibly talented self, writing and acting and happy. We were all cautiously

optimistic that the world looked as if it might be slowly crawling back to life again.

Then came the inevitable question to me: "How are you doing?"

My stock answer to that with almost everyone was some version of "I'm doing okay." But Amy and Lauren knew me much too well for me to even try to get away with that. They really wanted to know, so I opened up and told them.

"Honestly, when I look at my future without Lee, I see a blank, endless plain, like a desert with nothing on it, no matter where I look—no trees, no distant mountains, no colors, no nothing. I've gotten so lost that I can't even find myself."

And because Amy is Amy, two weeks later my agent got a call for me to make a guest appearance on *The Marvelous Mrs. Maisel*. That guest appearance evolved into three episodes, playing a character named Benedetta, whom Dan Palladino described as "Emily Gilmore on steroids."

As she'd done before, Amy Sherman-Palladino shook up my universe when I needed it most. That's friendship. That's loyalty. That's an example for all of us to learn from and follow.

Thanks to her, the future didn't look quite so empty anymore.

I also finally found the energy to seek out some kind of specialized help to get me through the profound emptiness I was feeling inside me and back to the strong, capable, self-sufficient woman I'd been accustomed to being all my life.

I'm not much of a "group" person, so the idea of grief groups didn't appeal to me. Instead, I decided to get back into individual therapy again. I got a referral to a cognitive behaviorist in New Jer-

sey who specialized in anxiety and depression and started seeing her once a week. The first time we sat down together I laid out what my goals were—and weren't.

"I'm not looking for happiness," I told her, "because I'm not sure I even expect that anymore. I'm not looking for love, because my late husband ruined that for anyone else who might come along. All I'm looking for is serenity, and peace of mind, and a way to 'reboot.'"

She got it. Then she gave me my first exercise: "I want you to write down five good things about you." I didn't say it out loud, but my immediate, impulsive thought was *Only five?* It was the first hint I'd had in almost two years that, what do you know, I was still "in there somewhere."

It took me back to a seemingly insignificant moment from many, many years earlier. Lee and I were living in Los Angeles while he was working for CNN. I was driving home to our apartment after a good long workout at the ballet studio in Toluca Lake, listening to the Doobie Brothers on the car stereo because they always made me happy. I was stopped at a stoplight on a freeway overpass when a thought suddenly hit me: *I'm so lucky to be me, because I get to hang around with myself.* It had nothing to do with ego and everything to do with a lifelong awareness that I've always enjoyed my own company.

I wanted more than anything to find my way back to that awareness, and I was ready and eager to do whatever it took to get there. I had the right therapist. Gradually, it was very helpful. As I told her one day, "I'm not sure what I'm getting out of this, but I know I'm enjoying it."

She smiled and replied, "I think it grounds you."

She was right. It was like being gently reeled back to solid ground and familiar territory. I was starting to like spending time with me again, and I wanted and needed to keep that healing going. And what better way to accomplish that than to return to that other therapy I could always count on to see me through—I needed to go back to work, not for a day here and a day there, but a real commitment that would challenge me and reunite me with myself.

Maybe I'd already used up all my wishes.

Or maybe not.

Chapter
Thirteen

And you guessed it, my phone rang. Robert Attermann's son, Jake, had become my agent by then, and my ringing phone was Jake calling to ask if I'd be interested in doing a two-episode guest spot on a new TV series in Pittsburgh, playing a beauty consultant. I read the scripts, and to be perfectly honest, the beauty consultant role seemed a little like an afterthought. But at that point, I wasn't about to pass up a chance to do something productive with my time and my mind, put that "vast, empty desert" image of my future out of my head, and, as the saying goes, "Trust in God, but row for the shore."

Then, a life-changing string of events unfolded I could never have predicted in a thousand years, apparently designed to test how willing I really am to "row for the shore," rather than just enjoy saying it.

Due to some production holdups, the Pittsburgh series was delayed indefinitely. My deal had never been finalized, though, so I was free to move on if something else came along.

It did.

"Something else" came in the form of a script for a mystery/thriller pilot called *The Watchful Eye*. It was created by a writer named Julie Durk for Disney/ABC Signature/Freeform. It was a weird, intriguing, well-written story, one of those scripts that make you wonder what's going to happen next, rather than being so predictable you can see it coming a mile away, roll your eyes when it happens, and change channels.

I was offered the role of Mrs. Ivey, a wealthy, powerful, haughty resident of a landmark high-rise apartment building called the Greybourne on the Upper East Side of New York City. Mrs. Ivey is a descendant of Mr. Greybourne, the man for whom the building was named, and while she doesn't own it, she's lived there all her life. As far as she's concerned, she rules the place. In other words, my kind of role. The pilot was being shot in Chicago, a less than three-hour flight from home, and if it was picked up as a series, it would be shot in Chicago and New York.

That vast, empty desert was starting to fill up a little. It was like being thrown a life preserver. Where do I sign?

Filming the pilot of *The Watchful Eye* in Chicago was exactly what my head and I needed—a change of scenery, waking up to a creative challenge every morning, a new character to work on and hopefully excel at, and a new group of people to get to know and invest in, including creator/writer Julie Durk, whom I liked very much.

Then, as always, it was back to New Jersey to wait for word of whether or not the pilot would be picked up as a series. And wait . . . and wait.

The good news: *The Watchful Eye* was picked up for ten episodes, to start filming in May 2022.

The bad news: While I don't think it was some kind of deliberate, insidious plan when the pilot was shot, a few bait-and-switch elements were in place when it came time to shoot the series.

Julie Durk was no longer involved.

One of the lead actresses was being replaced by a lovely actress named Mariel Molino.

And did we say the series would be shot in Chicago and New York? We meant Vancouver. About a six-and-a-half-hour flight from home. Oh, dear God. . . .

I suppose I could have put my hands on my hips and thrown a diva fit. "This is an outrage! This is not what I signed up for! Good luck finding someone else, you'll be hearing from my attorney, goodbye forever, blah, blah, blah!" Not a chance. I'd made a commitment, I liked the project, and I wanted to work. I *needed* to work.

So it was off to Vancouver in May, and there were too many pluses to appreciate about *The Watchful Eye* for me to complain about the length of the flight. I enjoyed the cast. The wardrobe and the sets were gorgeous. Amy Acker, who played Tory, the self-described "woman you love to hate," was terrific and an absolute delight to work with. And my character, Mrs. Ivey, was a powerful force of nature no one wanted to cross—obviously familiar and delectable territory for me.

I was set to appear in seven of the ten episodes, which would involve three round-trip flights from Newark, New Jersey, to

Vancouver, British Columbia. Unfortunately, COVID seeped into the cast and interrupted production, so those three round trips turned into four. I wasn't happy about it, but it also wasn't as if someone deliberately got COVID just to be ornery and inconvenience me. I absolutely enjoyed filming *The Watchful Eye* very much, but I was very relieved when filming ended and my fourth flight from Vancouver landed safely in Newark at the beginning of September 2022.

Then the long, inevitable waiting to hear if there would be a second season of the series began, and so did the beginning of a gradually developing disaster.

My first indication that something was wrong was the trouble I started having walking my dog Dolly in our rather hilly neighborhood. After three or four blocks, my legs would be aching and my foot would be so painful that I'd be very weak, almost limping, by the time we got home. I'd sit down and relax, and within two or three minutes, I'd be fine again. I got acupuncture, and I kept right on taking my Pilates classes; and since spells like these would come and go, over and over, as the months went on, I kept reassuring myself that whatever it was, it wasn't constant, so it would probably go away sooner or later.

I was even more reassured when I felt up to accepting an invitation from Amy and Dan Palladino to come to what Amy referred to as a "fake Thanksgiving" the first week in December. I didn't ask Amy what inspired her to throw a "fake Thanksgiving"—she's Amy;

she's creative as hell, she's fun, and she's unbelievably generous, so what possible difference did "why?" make? Speaking of generous, Amy even sent a car to pick me up in South Orange to drive me to her and Dan's fantastic five-story brownstone in Brooklyn, wait for me for as long as I wanted to stay, and then drive me home again. It was the loveliest couple of hours I'd spent in quite a while. My old pal from *Anything Goes* and *Bunheads*, Sutton Foster, was there. Also there was Chris Eigeman, who happened to live four brownstones from Amy and Dan, and who felt like family to me from his years of playing Jason in *Gilmore Girls* and Gabe in *The Marvelous Mrs. Maisel*. A few directors and writers Amy had worked with over the years were there, whose names I'm ashamed to say I don't remember. But it was an incredibly fun, down-to-earth, interesting group that gathered around the Palladinos' exquisite dining table for a catered traditional Thanksgiving dinner of turkey, mashed potatoes, sweet potatoes, and all the fixings. I was so grateful to be included, and, looking back, so grateful not to have known that a month later, I'd be in the hospital.

It was right before Christmas Sunday when, as hard as I tried to ignore it, the pain in my foot really intensified. On Friday, while I was doing my barre exercises, I talked to my Pilates teacher about it, and she was concerned enough to suggest I get it checked out. I promised I would, as soon as the holidays were over. Saturday evening I went to a neighbor's Christmas Eve gathering. Sunday was awful, but I couldn't convince myself that showing up at the hospital on Christmas Day would be a good idea.

On Monday, I was in agony, and I finally hit a wall—I grabbed my car keys, my purse, my Kindle, and my phone, and drove myself to St. Barnabas Hospital. As I got out of the car and locked the door, I said to myself, "Well, you've just had your last cigarette."

I'm embarrassed to admit that I've been a smoker all my life. I know. What did I think was going to happen, right? Believe me, I've scolded myself a million times over the years, and been scolded by one doctor after another; and there's not a smoker in this world who doesn't know they're doing a really wrong, really stupid, really self-destructive thing. No excuses, no sentence that starts with the word "but," and as I limped through the entrance to the emergency room and got in line, I was pretty sure that all those decades of being addicted to nicotine had finally caught up with me.

I don't remember being checked into a hospital room, but I definitely remember staying there for three weeks. I remember being wheeled downstairs for a variety of tests in the catheter lab and the room where I got three angioplasties. I remember my cardiovascular doctor happening to be there when I first arrived, and I remember hearing myself quietly say, "I'm really scared." And I remember, clear as a bell, the moment I was told I had blood clots in my leg and needed surgery.

In the midst of all that, I was also blessed with a lot of positives. My doctors took great care of me. My stepdaughter, Sheryl, came for a two-week visit and ended up staying for months once I got home from the hospital, and I can't imagine what I would have done without her. My friends rallied around me like the champions

they are, from Priscilla to my dog walkers to my agents, Robert and Jake, to my physical therapist, to my cognitive behavior therapist, to my Pilates teacher, to my thoughtful neighbors, one of whom showed up at the door one day with the best banana nut bread I've ever tasted. As much as I hated the circumstances, I'm genuinely humbled by how lucky I am.

And now, here I am, in midsummer of 2023, a fully recovered, healthy nonsmoker who's ready, willing, and eager to get back to work. I won't be taking any long plane trips in the future, since it's probable they contributed to those blood clots, and more flights to Vancouver definitely won't be an issue—in the last week of June, I got the call that *The Watchful Eye* wasn't being picked up for a second season.

I admit it, part of me was relieved that I wouldn't have to start checking train and bus schedules between New Jersey and British Columbia; or put my agent through trying to convince the production team to film my scenes in New York; or finding out that, God forbid, due to my logistical challenges, they were opting to replace me, or simply write my character out of the series.

But a much bigger part of me was disappointed, and sad—disappointed that my days with that terrific cast and crew on *The Watchful Eye* were over, as it was a job I'd enjoyed so much, and sad about the uncertainty I think every actor goes through when a project ends: Will I ever get to work again?

Still, as I keep reminding myself, how many times over all

these decades have I wondered if my career was over, starting with the "end of the world" when I wasn't accepted into the American Ballet Theatre? Lucia Chase made it dismissively clear that she didn't need me, but, as I discovered, I didn't need Lucia Chase. "The end of the world" turned out to be just the beginning.

And what about my awe at what started way back at Radio City Music Hall, the privilege of people being willing to actually pay me to do what I love, an awe that continues to this day? Last but certainly not least, how many women my age are still not just able but *yearning* to work again?

If someone had told me once upon a time that I'd be in this position as my eightieth birthday approaches, I probably would have told them they were out of their mind. It's true, though, and obviously, I'm *very* grateful. Then there's that relatively trivial but age-old (pun intended) question: As I turn eighty, my face is turning eighty right along with me, so should I be doing something about it?

It was right after the first season of *Gilmore Girls* that I was watching myself on TV and thought, *Okay, I don't mind not being a beauty, but that doesn't mean I have to put up with a disappearing jawline.* It was genetic, something my mother used to call "the Bishop jowls," which didn't make them any more endearing or acceptable. I made an appointment with a highly recommended New York plastic surgeon and gave him strict orders to be conservative. Just the

jawline. Nothing else. He followed orders, did a nice job, and I felt more comfortable on camera.

That was more than twenty years ago. Now, of course, "the Bishop jowls" are back. And God bless them, they've brought a generous crop of wrinkles and marionette lines along with them. On one hand, inevitable or not, I'm not in love with them. On the other hand, if it's a choice between what I look at in the mirror every morning and what a friend of mine calls being "one Botox shot away from the Macy's Parade," or a face pulled so tightly that I have that look of being perpetually startled, I'll stick with what I've got, thanks.

I also think about other actresses around my age whose work I admire—particularly my favorite, Helen Mirren—and realize that I wouldn't admire them one bit more if they looked younger. They may have had some tweaks here and there for all I know. That's a little something I call "none of my business," and it's completely irrelevant to how much I respect them. I've always appreciated the European filmmakers who, for the most part, seem to consider their older actresses to be perfectly viable, wrinkles or no wrinkles, and respect them enough to let them age naturally.

In the end, I've come to the conclusion that as long as I'm comfortable with myself, my work, and my life, I don't feel compelled to apologize for the fact that this is how old I am, and this is what I look like.

According to legend, it was the incomparable Bette Davis who famously observed, "Old age ain't no place for sissies." And in many ways, it certainly ain't. But I'm discovering blessings along the way that I'm learning to cherish.

One of the blessings that continues to bring me peace is breaking the habit of mourning the loss of times and experiences I'll never have again and insisting on celebrating them instead. It's not the easiest habit to break, and I can't claim to have broken it completely yet, but it's well worth the effort to keep trying.

The first time I remember making that transition from mourning the past to celebrating it—and it wasn't even a conscious effort on my part—was the magical, unforgettable night of April 16, 2015. The massively successful musical *Hamilton* was still at the Public Theater before going on to open on Broadway a few months later, and they honored the fortieth anniversary of *A Chorus Line* by inviting the original cast to the show.

Hamilton was spectacular. The cast was brilliant, and the music and choreography were new and creative, like nothing I'd ever seen before. There was one young dancer in the chorus my eyes kept going to, even when the principals were downstage with the chorus dancers behind them. She was just fantastic, so natural and talented and charismatic.

At some point while I watched her, I was blindsided, out of nowhere, by a deep ache of sadness as the thought hit me: *That used to be me up there.*

Then, just as suddenly, the same thought hit me with the greatest wave of joy and gratitude: *That used to be me up there!*

After the *Hamilton* curtain calls, their cast re-created the opening number of *A Chorus Line*, lining up across the stage, holding their headshots in front of their faces and singing, "Who am I anyway / Am I my résumé? . . ." Next, the *Hamilton* cast, led by the

show's composer and star Lin-Manuel Miranda, performed *A Chorus Line*'s iconic "What I Did for Love," and then we guests were invited onstage, where we all joined in for an abbreviated version of "One," us unrehearsed in our street clothes, the Hamiltonians in their costumes. There were lots of tears and hugs on that stage, followed by all of us mingling around, giving me a perfect opportunity to walk over to that young chorus dancer, that girl I used to be.

"I'm so excited for you," I told her. "This is thrilling. I know what it's like, and I want you to relish it. Inhale it. Live it, grab every moment of it. You're so talented, and I don't want you to ever get to a point where you think, *I don't really feel like doing the show tonight.* Do it. Give yourself a chance to be adored one more time, because you will be, and you'll carry this exquisite experience with you for the rest of your life."

I still recall how good that moment felt, a moment that wouldn't have happened if I'd stayed stuck in the sadness of that part of my life being behind me. Instead, I had the joy of realizing and embracing the fact that it *was* a part of my life, and I was able to "pass the torch" to that talented young chorus dancer with grace and not a hint of resentment that it was her turn now. I'd had my turn, and it wasn't my torch to begin with.

To this day, when I occasionally fall into that sadness trap, I think back on that night and that lesson: *Don't cry because you think your best days are gone. Smile because you had them in the first place.*

<p style="text-align:center">* * *</p>

I can almost hear Lee chuckling right now, and calling me "Pollyanna" for about the thousandth time. But I've been around too long to apologize for what I believe, and the advice I give when I'm asked, and I'll choose "Pollyanna" over "bitter" any day of the week.

A woman called me not long ago to ask for my help with her son. He had his heart set on a career in the theater. It was his dream, and he was currently studying theater arts.

"I would love it if you could sit down and talk to him," she said.

"I'd be delighted," I told her.

And I would have been, if she hadn't immediately added, "Good. I want you to talk him out of it. It's not a good choice for him."

Not a chance. No way would I try to talk someone out of their dream, no matter what it is. Whatever it is, I believe you immerse yourself in it, work hard at it, express yourself through it, challenge yourself with it, give yourself every opportunity to fall in love with it, and explore the adventures that come with it. If it's the right dream for you and it allows you to support yourself, so that you're not pursuing your dream at someone else's expense, it will probably last a lifetime. If it stops being enjoyable and fulfilling and you fall out of love with it—if it starts feeling like drudgery to the point where it becomes painful and depressing—there's nothing wrong with saying, "Okay, what else do I want to do with my life?" and start pursuing *that* dream.

When I went through that period in which I gave myself two years to make the transition from dancing to acting, I knew there

was no guarantee that it would work out, so I pondered various alternatives and came up with the idea of going into lighting design. I've always been fascinated by what lights can do, and the mood they can create, particularly in the theater, and there's not a doubt in my mind that that's what I would have explored if my acting career hadn't worked out.

I strongly believe that there's a satisfying field, a job, a career for everyone—it's just a matter of finding it, and the best way to do that is to head in the direction of what you love, whether it's the performing arts, or flower arranging, or farming, or plumbing, or whatever. Aren't we lucky that there's such a wide variety of dreams to choose from, and so many people who choose them? What on earth would we do if everyone dreamed of being a movie star or a famous rapper, but no one dreamed of being a health care worker, or a teacher, or a dentist, or a mechanic, or a veterinarian, or a police officer, or a soldier, or a carpenter, or a camera operator, or, or, or . . . ? What on earth would we all do without one another? Which is why you'll never see me look down on anyone who's earning an honest living exploring their passion.

I can't begin to count the number of people who've told me that they'd always wanted to be dancers, but they were from a small town where there were no dance instructors, or their parents couldn't afford lessons, or any number of other reasons. It makes me so sad, but I love pointing out, "There are two advantages you have here—one is, you can be a great audience, because you really appreciate it from your heart, and the other is, no matter what age you are, you can always go back and take

classes on the side. Find a place where you can go after work a couple of evenings a week and learn tap, or ballet, or jazz dance, or whatever touches your heart. You don't have to miss out on the joy of learning something you're passionate about. If it's in you, it's out there waiting for you."

I say that to all of us, myself included. I've still got a "Gee, I wish . . ." or two left in me, and I'll bet you do too.

W riting this memoir hasn't just inspired me to look back, it's inspired me to look forward too, perpetually enriched and propelled by the reminder that, as author John Maxwell put it so well, "Sometimes you win, sometimes you learn." I've learned, that's for sure. I haven't always done it gracefully, or even willingly, but the fact that learning is still very high on my list of things I'm zealous about and refuse to quit gives me confidence that, personally and professionally, I've still got a long way to go.

I've lived a life I'd envy if I weren't me.

I've loved and been loved deeply by the most extraordinary people I've ever known.

I found my passion when I was a child and was blessed to be good enough at it to make it my career.

I don't think about the many times I fell nearly as often as I think about the many times I got back up.

I'm surrounded by family, friends, agents, and colleagues I cherish.

And as I launch into a whole new decade, with a healthy mind and body, it will still never cease to touch me to my core that every minute, behind me and ahead of me, started "at the ballet."

Thank you, again and forever, Mom.

Kelly Bishop

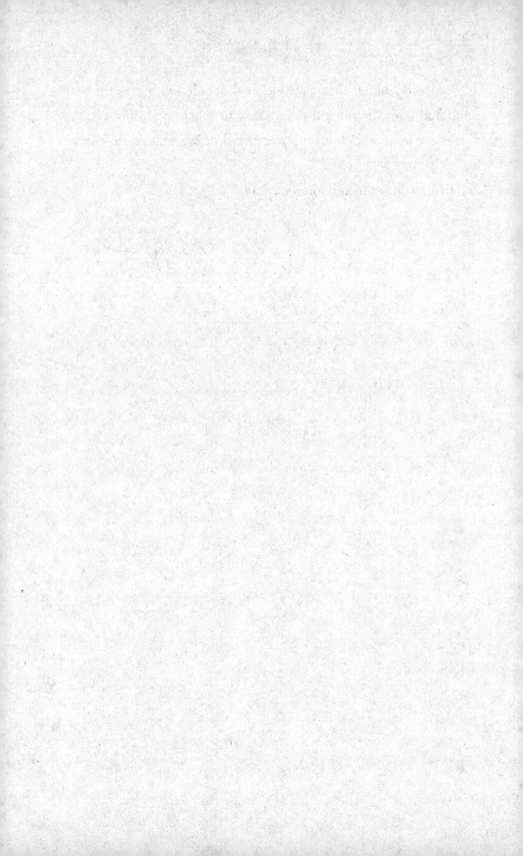

Acknowledgments

The Third Gilmore Girl won't be complete until I thank a few more people.

This book wouldn't exist without my collaborator, Lindsay Harrison. From the moment our respective agents connected us, we realized that there's a nice symmetry between us for this project—she doesn't act or dance, and I don't write. With more than twenty-five books to her credit, several of them *New York Times* bestsellers, Lindsay walked me through the process of writing a book that would have been impossible for me without her. And as an added bonus, through more phone sessions than either of us can count, we became such close friends—with everything in common from our senses of humor, to our love of animals, to golf, to our admiration for our extraordinary moms—that we're convinced that if we didn't live on separate coasts, we'd hang out together all the time. Thank you, Lindsay, for your skill, your hard work, and all the laughter and the many deeply personal conversations it took to make *The Third Gilmore Girl* a memoir and an experience I'll always treasure.

Acknowledgments

To my agent Robert Attermann and his very efficient assistant, Maureen Howard . . .

To Mia Vitale and Sarah Passick, my agents at Park & Fine Literary and Media, who took on the challenge of convincing me to write my memoir to begin with . . .

To photo editor Susan White . . .

And to Sarah Schlick, Hannah Braaten, Aimée Bell, and the rest of the talented team at Gallery Books . . .

My thanks, always, for your efforts and your enthusiasm for *The Third Gilmore Girl*—both the book and me.

Credits

Photographs

Pages 1, 2, 3 (top): Photos courtesy of the author

Pages 3 (bottom), 4: From the author's personal collection

Page 5: Photos courtesy of the author

Pages 6, 7, 8 (top): Photos courtesy of the author; source unknown

Page 8 (bottom): Photograph by Kenn Duncan. Billy Rose Theatre Division. The New York Public Library Digital Collections. 1976.

Page 9 (top): Photograph by Martha Swope. Billy Rose Theatre Division. The New York Public Library Digital Collections. 1975.

Page 9 (middle): Lynn Karlin/WWD/Penske Media/Getty Images

Page 9 (bottom): Photographer: Adger Cowens. © Vestron Pictures Ltd./ Photofest.

Page 10: From the author's personal collection

Page 11 (top left): Photograph by Martha Swope. Billy Rose Theatre Division. The New York Public Library Digital Collections. 1991.

Page 11 (top right): Photo courtesy of the author; source unknown

Page 11 (middle): Brian Zak/Gamma-Rapho/Getty Images

Page 11 (bottom): WENN Rights Ltd./Alamy Stock Photo

Page 12 (top): Photo courtesy of the author; source unknown

Page 12 (bottom): Photo courtesy of the author

Page 13: Photos courtesy of the author

Page 14 (top): © WB. Photograph by Ron Batzdorff. WB/Photofest.

Page 14 (bottom): © WB Television. Photograph by Patrick Ecclesine. WB/Photofest.

Credits

Lyrics